Treasures of the Southern Sky

Robert Gendler • Lars Lindberg Christensen • David Malin

Colophon

The Authors
Robert Gendler
Lars Lindberg Christensen
David Malin

Design & Layout
ESO education and Public Outreach Department/
André Roquette

Library of Congress Control Number: 2011935373

Springer Science+Business Media, LLC, © 2011
All rights reserved. This work may not be translated or copied in whole or in part without the written permission of the publisher (Springer Science+Business Media, LLC, 233 Spring Street, New York, NY 10013, USA), except for brief excerpts in connection with reviews or scholarly analysis. Use in connection with any form of information storage and retrieval, electronic adaptation, computer software, or by similar or dissimilar methodology now known or hereafter developed is forbidden. The use in this publication of trade names, trademarks, service marks, and similar terms, even if they are not identified as such, is not to be taken as an expression of opinion as to whether or not they are subject to proprietary rights.

Printed on acid-free paper.
9 8 7 6 5 4 3 2 1

springer.com

ISBN: 978-1-4614-0627-3
e-ISBN: 978-1-4614-0628-0
DOI: 10.1007/978-1-4614-0628-0

Cover: The Orion Nebula
As in the familiar pictures of the Orion Nebula taken in visible light, this infrared image shows its distinctive bat-like form in the center of the picture, as well as the fascinating surrounding area. At the very heart of this star-forming region lies the compact Trapezium Cluster. This group of very hot, young stars radiates searing ultraviolet light that is clearing the surrounding gas and dust and making it both warm and luminous. Infrared light reveals the warm interstellar material, and also penetrates the dust to show many other young stars that remain unseen in visible light.

Frontispiece: NGC 602
The star cluster NGC 602 in the Small Magellanic Cloud is surrounded by its natal gas and dust. This image was taken with the NASA/ESA Hubble Space Telescope. Also see p. 192 which shows a different view of NGC 602 with the same dataset.

To all those who have gazed at the stars and wondered at them

Table of Contents

Preface	6
Introduction	8
The Discovery of the Southern Sky	10
Star Maps	28

The Southern Summer — 30

NGC 1531 and NGC 1532	32
NGC 1672	34
LHA 120–N11	36
NGC 1909	38
LHA 120–N44	40
The Large Magellanic Cloud	42
The Orion Nebula and the Trapezium Cluster	44
Supernova 1987A	48
NGC 1999	50
Tarantula Nebula	52
The Flame and Horsehead Nebulae	56
Messier 78	60
The Monoceros R2 Association	62
IC 2177 and NGC 2327	64
NGC 2359	66
CG 4	68
NGC 2442	70
NGC 2440	72
NGC 2467	74
The Toby Jug Nebula	76
Vela Supernova Remnant	78
NGC 2997	80

The Southern Fall — 82

Carina Nebula	84
NGC 3293	88
NGC 3521	90
NGC 3576 and NGC 3603	92
NGC 3621	94
IC 2944	96
The Antennae Galaxies	98
The Sombrero Galaxy	100
The Coalsack	102
The Jewel Box	104
NGC 4945	106
Centaurus A	108
Omega Centauri	110
NGC 5189	112
Messier 83	114
NGC 5426 and NGC 5427	116

The Southern Winter 118

IC 4592 and IC 4601	120
The Rho Ophiuchi Nebula	122
NGC 6164–6165	124
NGC 6188 and NGC 6193	126
The Dark Tower	128
NGC 6302	130
The Cat's Paw Nebula	132
Towards the Center of the Milky Way	134
NGC 6357 and Pismis 24	136
Messier 7	138
The Trifid Nebula	140
The Lagoon Nebula	142
NGC 6559	144
NGC 6589 and NGC 6590	146
Messier 16	148
Messier 17	150
NGC 6520 and Barnard 86	152
Messier 22	154
Messier 11	156
NGC 6726	158
NGC 6744	160
NGC 6769–NGC 6770–NGC 6771	162
NGC 6822	164

The Southern Spring 166

The Helix Nebula	168
NGC 7424	170
NGC 7793	172
NGC 45	174
NGC 55	176
47 Tucanae	178
The Cartwheel Galaxy	180
NGC 247	182
NGC 253	184
The Small Magellanic Cloud	186
NGC 300	188
NGC 346 and LHA 115–N66	190
NGC 602 and LHA 115–N90	192
Messier 77	194
NGC 1097	196
NGC 1232	198
NGC 1313	200
NGC 1300	202
NGC 1316	204
NGC 1365	206

Books About the Southern Sky	208
Object List and Figure Credits	210
Index	212
About the Authors	218

Preface

Because of their diverse backgrounds and experience the authors of this book have arrived at their passion for astronomy from different directions. Nonetheless their love for the subject has converged in a synergistic way within this volume, which celebrates the southern sky in words and with world-class astronomical images. The motivation for assembling this unique visual anthology is to both celebrate the southern skies and to pay homage to the many individuals who have contributed to the advances in southern astronomy. Although the task was formidable we have attempted to accomplish this ambitious objective by searching through many hundreds of images from a variety of professional sources and from renowned amateurs with a southern hemisphere presence.

The professional sources reflect not only the huge growth in ground-based southern facilities in recent years but also the influence of Earth-orbiting satellites that have no hemispheric allegiance. Some amateurs live in the southern hemisphere, while many others are virtual visitors, using remotely operated telescopes from half a world away. We have carefully selected the finest images, covering the full range of objects, some well known and some less familiar, but all equally intriguing. Many of the images have not been widely published before or are being presented in print for the first time. The authors have assembled the text and captions from the most current scientific data available. Just as importantly, the book sheds light on the human story of southern sky exploration by way of an engaging and informative chapter on southern astronomical history.

The images were made from data taken by a wide range of telescopes — from wide-field amateur instruments to professional telescopes with small coverage of the sky — and through a range of different filters — from broadband filters that approximate true color, to narrowband filters that selectively pass light from specific elements. The latter are used to create elaborate images where colors are assigned specifically to map the chemical and physical properties that define that particular object. Regardless of technique, this book brings to print some of the most visually compelling portraits of the night sky seen from the southern hemisphere.

This book was first conceived as a photographic atlas of iconic astronomical objects of the southern hemisphere. There seemed to be few books dedicated to the visual exploration of the southern sky, so it seemed natural to follow this path. As the concept evolved further it became clear that the story of southern astronomy was more than a scientific one. It was a human adventure as well, characterized by exploration and the search for understanding, and not only in astronomy. It reflects the struggle of many individuals, the gradual advancement of knowledge, and a favorable cooperation among people, institutions, and nations of the southern hemisphere. It became obvious that to do justice to the subject would require a more challenging and extensive treatment. *Treasures of the Southern Sky* became a celebration of southern astronomy through images *and* words. The centerpiece would be a visual celebration showcased by the most outstanding and inspirational professional and amateur images of selected southern objects available today. Around this centerpiece the human story would be told through a chapter detailing the history of southern sky exploration. Added to this would be engaging and informative text describing the images, written in everyday terms, but with sufficient detail to satisfy both the serious amateur and the dedicated armchair observer.

This book is arranged by season with objects presented in order of right ascension. We feel that the seasonal approach provides a more fluent experience for the reader and can more effectively serve as a practical guide for observers and photographers who want to conduct their own explorations of the southern sky. The objects featured were carefully selected by the authors for their beauty, visual impact, and scientific interest.

The authors wish to express their gratitude to editor, Maury Solomon of Springer Publishers, New York for believing in and nurturing this project from its conception, and to André Roquette for doing a sterling job on the design. In addition the project would not be possible without the support of the European Southern Observatory.

It is our hope that the pages ahead will do justice to a cherished natural resource, the portal to our larger home in the Universe, which many generations of inhabitants of this small planet have held dear, the night sky.

Robert Gendler, Connecticut, USA, April 2011
Lars Lindberg Christensen, Munich, Germany, April 2011
David Malin, Sydney, Australia, April 2011

Introduction

On November 1, 1520 the Portuguese explorer Ferdinand Magellan and his crew began to navigate the treacherous strait that would later bear Magellan's name. Four weeks later, as they became the first Europeans to reach the Pacific Ocean by an eastern route, they at last had time and leisure to contemplate a new world. This was a world where nature played strange tricks. At these latitudes the Moon appears upside down, Orion is on his head and the height of summer occurs in December. At night, with anchors cast, and freed from more mundane tasks, the crew undoubtedly gazed upward at the blackness of an undisturbed and pristine nightscape. Nowadays we can only imagine the sublime spectacle witnessed by Magellan's men as they gazed at the staggering celestial paradise above them. Well versed in celestial navigation, they were of course familiar with the constellation of the Southern Cross, which had undoubtedly helped guide them throughout their southern oceanic voyage. For millennia the reassuring stars of the Cross served countless ancient and indigenous explorers, who relied on this celestial compass to survive in uncharted seas.

There would have been other wonders of the southern night sky to both tantalize their imagination and fuel their sense of discovery. They may have noticed the collective light of the compact cluster we now know as the Jewel Box. As they gazed north of the mysterious Coalsack, the black patch separating the two brightest stars of the familiar Cross, the men with the best vision may have noticed the small bright patch of light representing the million stars of Omega Centauri or even the faint smudge of light we now call the Carina Nebula. To the west, occupying a sprawling ocean of sky, the vast and luminous star clouds of the southern Milky Way must have offered an imposing vista unspeakable in its beauty and grandeur. Finally, further south, two odd clouds, seemingly detached portions of the Milky Way, must have challenged the familiarity of even the most experienced sailors among them. These companion galaxies of the Milky Way were to become known as the Magellanic Clouds.

It would be centuries before we understood the true nature of these curious and magnificent objects, but even well before the age of modern astronomy these nighttime wonders infused each generation of sky watchers with a rich sense of nature's grandeur and mystery. During the period of Magellan's circumnavigation and for several centuries thereafter, most people lived north of the equator and early northern astronomical observers enthusiastically embraced and charted much of the northern sky, while just beyond their horizon the southern sky remained mostly out of reach. Only those southern objects closest to the celestial equator could be cataloged. Anything further south remained hidden from view, and for a long time the southern sky below a declination of −30 degrees was considered virgin territory.

The main contributors to the astronomical knowledge of the ancient world and the pre-modern era accomplished their work from northern latitudes, and their names have been indelibly stamped into the history books of astronomical exploration. The pioneers and observers from southern latitudes, although highly proficient and accomplished in their own right, were less often the subjects of fame and recognition than their northern counterparts and even today are not quite such familiar names in astronomical history. Contributors to the exploration and charting of the southern skies included observers such as the Abbé de Lacaille, Edmond Halley, James Cook, Charles Green, William Dawes, James Dunlop, Carl Rümker, and John Tebbutt. They and many others advanced southern astronomy and conducted their systematic charting and cataloging of the southern sky from observatories in Australia, New Zealand, and South Africa.

Eventually several renowned northern observers made their way to southern latitudes, mostly to complete work primarily focused on the northern sky. Sir John Herschel, probably the most recognized name in observational astronomy, traveled to the Cape of Good Hope in 1834 and spent four years charting the southern sky. It wasn't until the age of the large professional observatories of the 20th century that objects of far southern declination were intensely studied. In the 1970s David Malin's photographic portraits of southern showpieces taken from the Anglo-Australian Observatory showed once and for all that the southern sky was not only a valuable source of potential astronomical knowledge and discovery, but also of astounding beauty.

The Southern Cross

Crux, the smallest constellation of all, contains some of the brightest stars of the southern sky. The kite-shaped asterism of the Southern Cross appears on many of the flags and national symbols of southern hemisphere nations, and is visible at some time of the year from everywhere south of the Tropic of Cancer, and at some time of every night of the year from south of the Tropic of Capricorn. See also p. 102.

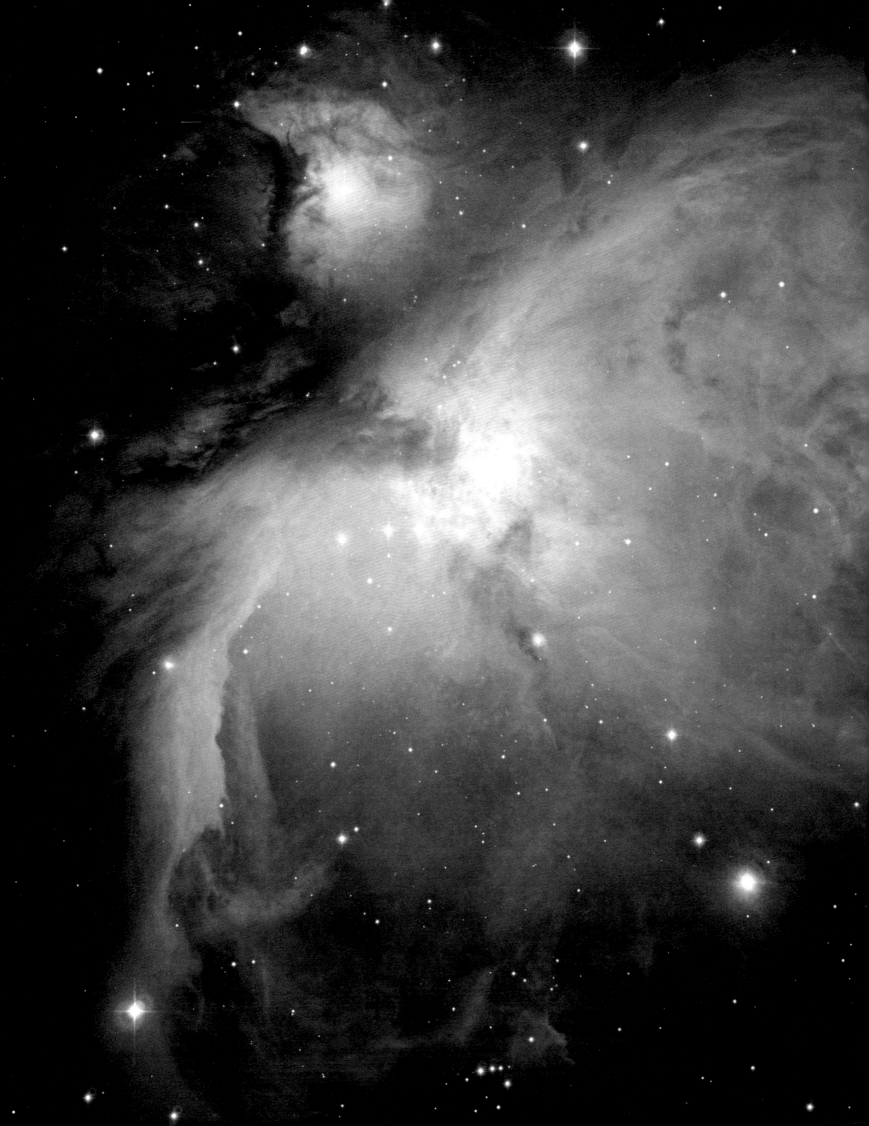

The Discovery of the Southern Sky

Compared to the northern hemisphere, the southern half of our planet is mostly ocean. What land there is, is sparsely populated, with few major cities and hardly any heavy industry. Fortunately, the modern air-borne industrial dust pollution that affects most of the northern hemisphere does not cross the equator, and what little pollution that is created in the south is cleansed by the immense oceans. This is one reason why the southern stars are mostly seen through clear air that neither dims nor scatters their splendid light.

However the relative scarcity of land and vast tracts of turbulent ocean also explain why the southern (and western) hemisphere remained largely unknown to Europeans until improved ships and relentless curiosity, driven by trade and conquest, encouraged intrepid mariners to sail far out of sight of land. They began to sail down the west coast of Africa, south of Cape Bojador, which is 26 degrees north of the equator on the coast of Morocco. There the forbidding seas were long considered to mark the edge of the ancient world, a view that had evolved from familiarity with the safe inland waters of the Mediterranean.

The Orion Nebula
The magnificent and memorable constellation of Orion the Hunter is bisected by the celestial equator, and the Orion Nebula itself is just within in the southern hemisphere. It is easily visible to the unaided eye under dark skies and can be seen as a misty patch in the sword handle of Orion from all permanently inhabited parts of the globe. It is described in more detail on p. 44.

Sailing south

These explorations began in earnest in the 15th century, when the names of Christopher Columbus (1451–1506), Ferdinand Magellan (1480–1521), and Vasco da Gama (~1460–1524) appear in the record. While these sailors would have had a close professional interest in the stars, and Magellan (posthumously) gave his name to the Magellanic Clouds, these are not the most obvious or distinctive celestial features visible from southern latitudes. That honor goes to that rich part of the Milky Way that extends through the southern part of Centaurus and into Crux and Carina and includes the most conspicuous part of Gould's Belt.

The glory of the southern sky, and especially the Southern Cross, first seems to have been mentioned by Dante Alighieri (1265–1321), in his *Divine Comedy*, written around AD 1300. Although the sight was not visible from northern Italy, Dante probably worked from ancient legends to describe four stars near "the other pole," and the deprivation of those who have never seen them:

> *To the right hand I turn'd, and fix'd my mind*
> *On the other pole attentive, where I saw*
> *Four stars ne'er seen before save by the ken*
> *Of our first parents. Heaven of their rays*
> *Seem'd joyous. O thou northern site! Bereft*
> *Indeed, and widow'd, since of these deprived.*

(Dante Alighieri: *Purgatorio Canto* I:1–27)

In describing four stars seen only by "our first parents," Adam and Eve, Dante ignores the existence of the indigenous peoples of the southern hemisphere, probably because he was unaware of them. However, he assigned the four principal virtues — Justice, Prudence, Fortitude, and Temperance — to these stars, and these are all well-known attributes of those who live in the southern hemisphere! The four stars in Crux were also noted by the Italian explorer Amerigo Vespucci (1454–1512) in 1501 and the Portuguese aristocrat Bartolomeu Dias (1457–1500), who was the first to sail round the Cape of Good Hope in 1488. However, the Cross was named by the Florentine Andrea de Corsali (1487–?), who, in a letter written in southern India in 1516, described it (in a later English translation) as "...*this crosse is so fayre and bewtiful...*". His letter also includes the first drawing of the Southern Cross and the Magellanic Clouds.

The Southern Cross
Akira Fujii's classic photograph of the Southern Cross and the dark shape of the Coalsack, silhouetted against the Milky Way. The whole scene is ornamented by the two pointers to the Cross, alpha and beta Centauri (top). White alpha is the nearest bright star and one of very few bright stars with a color (and thus temperature) similar to the Sun.

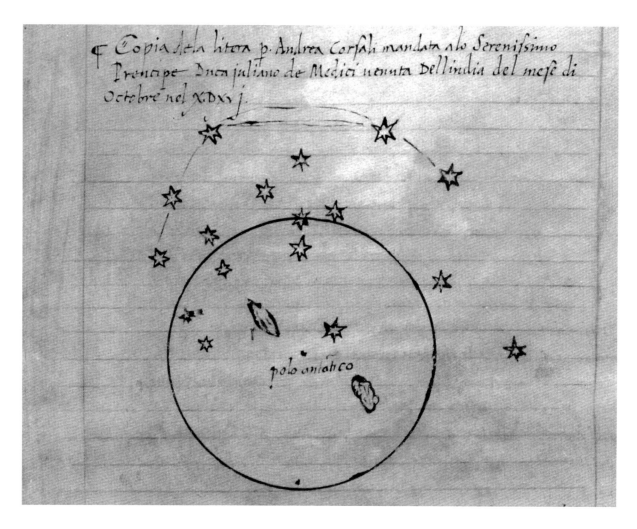

The First Drawing of the Southern Cross

Corsali's sketch of the Southern Cross, the Magellanic Clouds, and the *polo antartico* (south celestial pole), drawn in 1516.

The few ancient constellations that both extend substantially below 50 degrees south and contain many bright stars were known to Ptolemy and include Ara, Argo Navis (now split into Carina, Puppis, and Vela), and Centaurus (which included Crux). The extensive part of the sky south of 50 degrees that is mostly devoid of bright stars remained uncharted in ancient times. That changed with the southern voyages of exploration, and significant additions were made by the Dutch navigators Pieter Dirkszoon Keyser (1540–1596) and Frederick de Houtman (1571–1627) on trading expeditions to the spice islands of the East Indies (south and southeast Asia). Their new constellations were Apus, The Bird of Paradise (sometimes Apis, The Bee), Chameleon, Dorado, Grus, Hydrus, Indus, Musca, Pavo, Phoenix, Triangulum Australe, Tucana and Volans. They were defined and named by Johann Bayer (1572–1625) and appear in his famous *Uranometria* of 1603. However Crux had already been outlined in 1597–98 as the Christian Cross by the Dutch mapmaker Petrus Plancius (1552–1622), who had encouraged Keyser and Houtman to chart the southern skies on their voyages.

Edmond Halley and the Abbé de Lacaille

The first recognized astronomer to do any systematic work in the southern hemisphere was Edmond Halley (1656–1742) of comet fame. He went to the remote island of St Helena, 16 degrees south of the equator in the South Atlantic, and was there for 18 months in 1677–78. Though his main motivation was to make a catalog of southern stars to match Flamsteed's northern catalog, he also observed and precisely timed a complete transit of Mercury across the Sun's disk.

This was to have a profound effect on the pursuit of astronomy for 200 years, in both hemispheres. Later, Halley wrote, *"On observing this I immediately concluded, that the sun's parallax might be duly determined by such observations, … though Mercury is to be frequently seen within the sun's disk; he will scarcely be fit for the present purpose."* The "present purpose" was measuring the solar parallax, and from it an accurate value for the astronomical unit, the distance to the Sun from Earth. From this distance the scale of the whole Solar System could be derived. But the planet that would be most suitable for transit measurements was Venus, which offered the prospect of achieving greater precision, despite its less frequent transits. The other main outcomes of Halley's first southern sojourn was a catalog of 341 southern hemisphere stars and his discovery of the globular cluster Omega Centauri.

Seventy years elapsed before the next major astronomical explorer ventured south of the equator. This was the Abbé Nicolas de Lacaille (1713–1762). Although he had a Jesuit education, Lacaille (as he is usually known) was mainly interested in mathematics and astronomy, and like Halley he was diligent, persistent and imaginative. He had new ideas for a catalog of the "fixed stars" in the southern hemisphere and was keen to make the first measurement of an arc of the meridian south of the equator. While this sounds like surveying (and was), it had a very strong astronomical flavor, since observations of the stars from two accurately defined, but well separated, points could reveal the true shape of the Earth. This was a French obsession at the time, since the meter was defined as one ten-millionth of the distance from the equator to the pole. But which pole, and along which meridian? And did it matter? It did, since the validity of the metric system depended on its universality — and a precise definition of its most fundamental unit, the meter. It also mattered to Lacaille, because this definition of the meter was partly his idea.

Lacaille arrived in what is now Cape Town in April 1751 and set up a small observatory in the Dutch settlement. As with Halley, one of his priorities was to measure the scale of the Solar System, for which he made detailed observations of Mars, the Moon and the Sun itself. Although he worked intensively on these projects, today it is Lacaille's catalog of the positions of almost 10,000 stars that we recall, and his invention of 14 new southern hemisphere constellations. His stellar observations were made with a telescope of 13 mm (half-inch) aperture, and all of his considerable body of work in South Africa was accomplished in less than two years.

A chart with the new constellations was published with his star catalog after his death in 1763, and they cover a particularly barren area of the southern sky. Among the more interesting groupings are Mensa (for Mons Mensa, Cape Town's Table Mountain) between the Large Magellanic Cloud, the south celestial pole, and Reticulum (originally Reticulum Rhomboidalis), which refers to the ingenious lozenge-shaped cut-out that he used in his telescope to speed the measurement of numerous star positions. Most of the other constellation figures are assembled from undistinguished stars and represent scientific instruments and machines invented in the Age of Enlightenment, of which Lacaille was an important figure.

Lacaille's careful measurements of the Sun, Moon and Mars did little to establish an accurate value for the solar parallax and the precise size and scale of the Solar System remained uncertain. Careful timing of transits of Venus from widely spaced latitudes, as advocated by Halley, was the obvious approach and for the 1761 transit no fewer than 120 observations were planned, some in the southern hemisphere. At the Cape of Good Hope, which was still a Dutch colony, the observers were a pair of British surveyors, Jeremiah Dixon and Charles Mason, who were later to survey and give their names to a line that symbolically divided North from South in the United States. Despite the large number of widely spaced transit watchers, the results from 1761 event were erratic, with Mason and Dixon among the best; great expectations were held for the next transit, due in 1769. After that there would not be another until 1874.

James Cook and James Dunlop

British hopes for the 1769 transit were largely pinned on a junior naval officer, Captain James Cook (1728–1779), who was instructed by the British Admiralty to sail to the island of Tahiti, newly colonized by the French, about 18 degrees south of the equator in the Pacific Ocean. He traveled with some simple telescopes, a clock and a Greenwich astronomer, arriving in mid-April 1769 after a voyage of eight months. The transit itself was not until early June, but the ship's crew found many diversions in this tropical paradise, many of them little to do with constructing a temporary observatory. As with previous transit observations, the exact timing of the event was difficult and the overall results showed little improvement on earlier efforts. By the time of the next pair of Venus transits, in 1874 and 1882, photography had been invented and many of these persistent observational problems had been overcome.

After the main scientific purpose of this voyage was completed, Cook opened his sealed orders, which instructed him to continue westwards to map *Terra Australis Incognita*, the unknown southern continent. He first mapped the islands of New Zealand and then Australia's east coast, claiming both for Great Britain. It is interesting to speculate on how different the demographics of the southern hemisphere would have looked today if the Portuguese navigator Magellan had continued west after rounding Cape Horn instead of heading northwest to his death in the Philippines.

In April 1770 James Cook entered Botany Bay, close to modern Sydney, in search of supplies, finally leaving Australian waters four months later after a near-fatal shipwreck on the Great Barrier Reef. Cook's astronomically oriented expedition had dramatically increased the size of the British Empire and paved the way for the First Fleet to establish the Colony of New South Wales in January 1788. Most of the first European inhabitants of Australia did not arrive voluntarily, but a simple observatory was established on the shores of Sydney Harbour within a few weeks, both to establish local time and place, and to seek a comet, predicted by Edmond Halley. However, no comet appeared, and the observatory quickly fell into disrepair.

It was not until 1822 that another new observatory was established in Australia. This was in Parramatta, close to Sydney; the observatory and its assistants were personally funded by Thomas Makdougall Brisbane (1773–1860), Australia's sixth governor, a Scotsman and avid astronomer. He brought with him a fellow Scot, James Dunlop (1793–1848), as a general handyman, and German astronomer Carl Rümker (1788–1862). Dunlop quickly made a name for himself, being the first to see the reappearance of Encke's Comet, only the second example of a predicted return of a comet being verified, the first being Comet Halley in 1758. These three disparate characters did not get on; Rümker left Parramatta in 1823 and Brisbane was recalled to Britain in 1825. Dunlop remained, and while he was interested in astronomy, and had made telescopes for Brisbane, his education was rudimentary and he was not a trained astronomer.

Despite his shortcomings, Dunlop was a diligent observer, and by 1826 he had created a well-known catalog of 7385 stars (known as the Brisbane Catalogue), including about 170 double stars. This was enthusiastically presented to the Royal Astronomical Society in 1827 by John Herschel (1792–1871), son of the famous discoverer of Uranus. Dunlop later expanded his double star catalog and made a catalog of nebulae and clusters using his 9-inch aperture 9-foot reflector. He writes:

"I trust this catalogue of the nebulae will be found an acceptable addition to that knowledge respecting that important and hitherto but little known portion of the heavens."

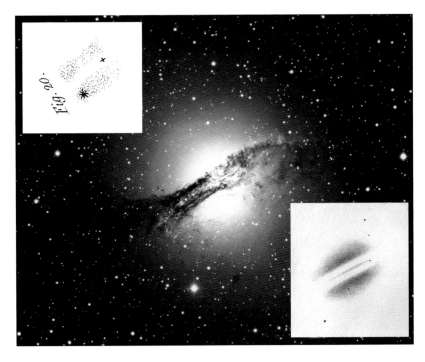

Centaurus A Through History
AAT color photograph of NGC 5128 (Centaurus A), with Dunlop's discovery drawing (upper left) and Herschel's drawing at lower right.

His trust was well placed. Among his drawings was number 482, *"A very singular double nebula....."* This was John Herschel's number 3501, observed several times almost a decade later and described in his Cape Observations (see below) as *"A most wonderful object ... The internal edges have a gleaming light like moonlight touching the outline in a transparency"* and *"two semi-ovals of elliptically formed nebula appearing to be cut asunder..."* and elsewhere as *"A very problematic object...."* The "problematic object" was NGC 5128 and is now better known as Centaurus A. It was one of the first radio galaxies, discovered by Australian radio astronomers in 1948–49. Its discovery opened up a whole new science, radio astronomy, in which Australia is still a leading player.

Dunlop's fame was largely due to Herschel's endorsements, and it would have been more enduring had it not been for Herschel himself, who was the next major figure to spend time under southern skies. Dunlop was eventually made Government Astronomer for New South Wales, in part because there were no other applicants for the job, but lack of support, ill health, and isolation undermined him. Australia has roughly the same area as the contiguous United States, but its total European population in 1826 was about 50,000 and was widely scattered. The observatory at Parramatta slowly fell into disrepair and was demolished in 1847, and Dunlop himself died shortly afterwards.

John Herschel, Gould's Belt, and the Discovery of Photography

The British Government had established the Royal Observatory at the Cape of Good Hope in 1820, only a few years after they gained control of the colony from the Dutch. It was intended as the southern counterpart to the Royal Greenwich Observatory, but it was not well funded in its early years, and, like Australia, South Africa was not seen by aspiring astronomers as an attractive post.

The reluctant third director, Thomas Henderson (1798–1844) was thought well suited to the post because he was unmarried and thus unencumbered by the extra expense and inconvenience of a family. On his arrival in 1831 he described the observatory as located in an unpromising, dismal swamp. Reluctant or not, within a year he had measured the parallax of, and thus the distance to, Alpha Centauri, the nearest bright star. Sadly he doubted his result and did not publish, and was distraught to hear in 1838 that Friedrich Wilhelm Bessel (1784–1846) had published the first measurement of the distance to a star (61 Cygni). Henderson did not enjoy the climate or the deprivations of South Africa, and his health failed. He returned to Scotland in 1833 and only published his measurement of the distance of Alpha Centauri after Bessel's result had appeared.

By 1834 the observatory was expecting its fourth director, Thomas Maclear (1794–1879), and he was joined shortly afterwards by his 16-year-old assistant, the talented and eccentric Charles Piazzi Smyth (1819–1900), who a decade later became Astronomer Royal for Scotland. Smyth's enduring claim to astronomical fame is his demonstration that high mountains were the best places for astronomical observatories. He was also a pioneer photographer who took some of the earliest photographs in South Africa, and was the first to publish a book of stereoscopic photographs.

These interesting characters arrived in Cape Town almost simultaneously with the independently wealthy and independent-minded John Herschel (1792–1871), son of the famous William. Although he and Maclear were close, Herschel set up his own observatory, determined to extend his father's detailed survey of the northern sky (which he had repeated) into the south, using an 18-inch speculum reflector similar to the one that his father had constructed. John Herschel may be unique in having surveyed and cataloged both hemispheres in detail, by eye, using a powerful telescope.

Naturally, Herschel had arrived familiar with everything that had been published on southern hemisphere astronomy, but despite his previous enthusiasm he became very critical of Dunlop's work, especially his astrometric positions and most particularly the right ascensions of Dunlop's double star discoveries. Herschel could not find many of them; he was not a vindictive man, and he was right (and righteous) about the errors. While many errors could be traced to the faults in Dunlop's telescope, a few of the listed objects appear to be the result of Dunlop's imagination.

The fruits of Herschel's epic observing habits are in his famous book, *Results of Astronomical Observations made during the years 1834, 5, 6, 7, 8, at the Cape of Good Hope; Being the completion of a telescopic survey of the whole surface of the visible heavens, commenced in 1825*. The title reflects Herschel's prose style, never using one word where a dozen would do. This wonderful catalog and the graphic descriptions of non-stellar objects and double stars is better known as Herschel's *Cape Observations* and was published in 1847. It is the source of most of the southern objects that appear in the NGC and includes many interesting and beautiful drawings of iconic southern hemisphere sights, including the Magellanic Clouds and the Carina Nebula.

Like his father before him, Herschel was an astute observer, and not only with the telescope. In his *Cape Observations* he describes a broad band of bright stars inclined at about 20 degrees to the Milky Way and including the brilliant constellation stars of Taurus, Orion, Canis Major, Puppis, Vela, Carina, Crux, Centaurus, and Scorpius, among others. This broad band is most obvious from the southern hemisphere and is one reason why the southern sky seems much richer than the northern, even to the casual onlooker.

Not much was made of this until it was rediscovered by Benjamin A. Gould (1824–1896). Now known as Gould's Belt, this was an important discovery, reflecting the local stellar structure of the Milky Way, and was published by Gould in 1879 while he was director of the Argentine National Observatory (now the Cordoba Observatory) that he founded in 1868, and from where, in 1884, he made the last sighting of the Great Comet photographed by David Gill, who we will meet later. Gould was the founder of *The Astronomical Journal*, still a leading scientific journal after 160 years of publication, and he was the first American to receive a PhD in astronomy, from Göttingen University in Germany. There he studied under Carl Gauss (1777–1855), who gave his name to the unit cgs of magnetic field strength. Gould also worked with the French physicist and politician Francois Arago (1786–1853) in Paris.

Arago also deserves a mention here because it was he who proposed that Louis Daguerre (1787–1851), the main inventor of photography, should receive a generous lifetime pension from the French government if he made the details of his remarkable process public. Arago was an astronomer as well as a member of the French House of Deputies (lower house) and was briefly prime minister of France. His 1839 description of the potential uses of photography was surprisingly prescient, and included mapping the Moon, charting the positions of the stars, and stellar photometry.

Since this book is about imaging it is worth emphasizing the link between John Herschel and photography. The essence of photography is fixing the image to make it permanent. In 1820, as a student of chemistry and long before photography appeared, Herschel discovered that a solution of sodium thiosulfate (hypo) would dissolve the normally extremely insoluble, but light-sensitive silver halides (silver chloride, bromide, iodide). Shortly after his return to England from South Africa in 1838, he learned of Daguerre's invention, and within a short time Herschel had produced his own photograph, a glass negative of his father's famous 40-foot telescope, just a few weeks before it was dismantled. Herschel was close to William Henry Fox Talbot (1800–1877), the Englishman who was also busy inventing a silver-based photographic process, and both the daguerreotype and Fox Talbot's negative–positive process were enormously improved by the adoption of a quick and reliable means of fixing the image. It was also Herschel who invented the terms "negative" and "positive" used in a photographic sense, although Herschel himself never took a photograph through a telescope and died in 1871, before the pioneering work of David Gill and Ainslee Common.

Detecting the unseen and mapping the sky

Born in 1843, into a family of clock and watchmakers, David Gill (1843–1914) became a moderately prosperous Aberdeen businessman when he took over the family firm, but his main interest was in science, and especially astronomy. In 1869 he took a highly acclaimed photograph of the Moon with his 12-inch reflector, and this brought him to the attention of Scotland's professional astronomy community. By 1871 he was the director of the Dun Echt Observatory near Aberdeen and rapidly gaining prominence because of his exceptional observational skills. In 1879 he was appointed as Her Majesty's (i.e., Queen Victoria's) Astronomer at the Royal Observatory at the Cape of Good Hope (i.e., director), which had by then fallen into a dilapidated state. By the time Gill retired in 1906, as Sir David Gill and laden with honors, it had become the premier observatory in the southern hemisphere.

In September 1882 a bright comet suddenly appeared in the southern sky, and brightened rapidly to be easily visible in daylight as it passed close to the Sun. David Gill wrote that *"…it resembled very much a star of the 1st magnitude seen by daylight."* Gill had the idea of attaching a portrait camera to a telescope mounting and using the telescope itself to guide on the cometary nucleus. The resulting pictures taken on the then-new dry gelatin plates, in November 1882, were the best ever made of a comet and the first guided astronomical photographs.

In that same year Gill received the highest award of the Royal Astronomical Society (RAS), its Gold Medal; not for his photography, but for his precise measurement of the solar parallax from his observations of the planet Mars some years before. These measurements were made from Ascension Island, which is (just) in the southern hemisphere. Gill remained dedicated to this fundamental problem and later measured the solar parallax by observing asteroids, making extremely demanding visual measurements with a precision heliograph.

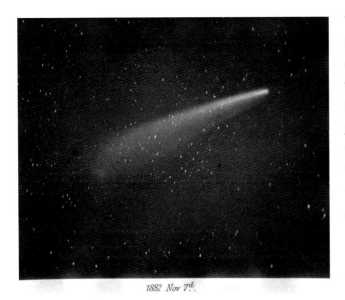

1882 Nov 7ᵈ.

The Great Comet of 1882

Photograph of the Great Comet of 1882, as seen from South Africa. David Gill's photograph was at that time the best ever made of a comet, and the first guided astronomical photograph.

The award of the RAS Medal was important as it recognized the contributions of southern hemisphere observers, and the following year (1883) it was awarded to Benjamin Gould (of Gould's Belt), who made many southern hemisphere photographs from Argentina. A year later, in 1884, the Medal was awarded to Ainslee Common, for his photograph of the Orion Nebula, which, for the first time, showed stars too faint to be seen by the eye using the same telescope. In J. L. E. Dreyer's *History of the Royal Astronomical Society (1820–1920)*, Dreyer says, *"In 1883, Common proposed to Gould, who had photographed about seventy stars clusters at Cordoba, a joint arrangement for photographing the whole heavens..."*

Common's Medal is also significant because it recognized the pivotal moment when photography was transformed from a recorder of the visible into a detector of the unseen. In that role photography went on to revolutionize the design of telescopes and indeed the way astronomy was done. It allowed the fledgling science of astrophysics to flourish and opened up all the fields of astronomy we take now for granted — astrometry, spectroscopy, photometry, and of course direct imaging. And finally, David Gill was to receive a second RAS Gold Medal in 1908, specifically for his contributions to southern hemisphere astronomy and as *"...a way of recognising Gill's power of inspiring others to take part in advancing [astronomy]..."*

While David Gill's 1882 comet photograph was remarkable enough, the thing that most excited him about it was the many faint stars that it revealed. It was clear that long exposure, tracked photographs could be used to map the stars, and this led to his vigorous promotion of two related international projects. One of these was a photographic survey of almost half a million stars in the southern hemisphere done in collaboration with J. C. Kapteyn, which is known as The Cape Photographic Durchmusterung (Survey). This work extended Argelander's earlier Bonner Durchmusterung to the South Celestial Pole. Gill was also a powerful advocate of the Carte du Ciel (CdC), a photographic map of the sky of the kind envisaged by Ainslee Common. This project was agreed on in 1887 at an international meeting of astronomers in Paris, and eventually 20 countries were involved in the preparation of the CdC and the associated Astrographic Catalogue.

The most prolific contributors to the CdC were the southern hemisphere observatories in Cape Town and Sydney, which measured about a million star positions between them. The Sydney work started in 1892 under the direction of the Government Astronomer, Henry Chamberlain Russell (1836–1907) and was continued intermittently until 1948. The refracting telescopes for the CdC were standardized, with a focal length of 3.4 meters and an aperture of about 330 millimeters, producing an image on 130 mm square plates covering about 2 x 2 degrees. Such was the demand for these telescopes that orders to the only suppliers, Paul and Prosper Henry in Paris and Howard Grubb in Dublin, were subject to considerable delays.

Russell had the tube, mount, and an innovative electrical drive system made for his astrograph in Sydney, and it was finished and installed long before the telescope optics arrived. Anxious to do some serious photography, he mounted a portrait camera fitted with a 6-inch lens on the mount and made some long exposure, wide angle photographs of the southern sky. In 1890, the night sky in Sydney was still dark enough to see the Milky Way and the Magellanic Clouds, and these were his targets. He noted that the structure of the Keyhole Nebula around Eta Carinae, carefully sketched by John Herschel 60 years before, had changed, and commented on what he noted was the spiral nature of the Large Magellanic Cloud (LMC). These were important and insightful observations; Eta Carinae is still under close scrutiny and the structure of the LMC remains controversial 120 years later.

Melbourne Observatory also took part in the CdC, and at 38 degrees south, it was the most southerly institution involved. It was assigned the region from −65 degrees to the south celestial pole. Melbourne Observatory was also home of the Great Melbourne Telescope, which, with its 48-inch speculum mirror, was for some years the largest steerable telescope in the world. However, it was designed by a British committee in the 1860s, installed close to sea level in Melbourne, and was difficult to use and maintain. It was also completely unsuitable for photography. Like all the state observatories in Australia, Melbourne was often both under-funded and overburdened with non-astronomical activities such as weights and measures, meteorology and tide tables. All of these state observatories have now closed or are used for popular astronomy education. The Great Melbourne Telescope was transferred to the Mt. Stromlo Observatory in Canberra in 1944 and was extensively damaged in the bush fires of 2003. What remains of it has now been moved back to Melbourne and is being restored by Museum Victoria and the Astronomical Society of Victoria with the aim of returning it in working order to its original building in Melbourne's Botanical Gardens.

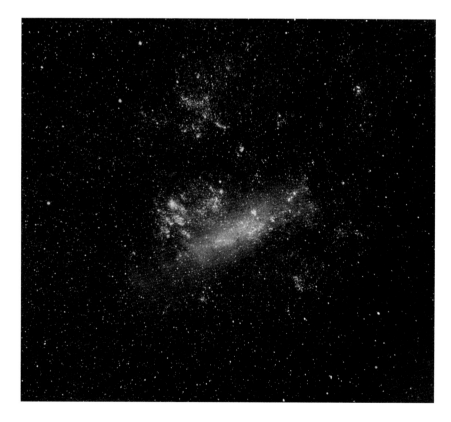

The Large Magellanic Cloud
The first wide field photograph of the Large Magellanic Cloud, made by H. C. Russell in 1890 using a portrait camera at Sydney Observatory. This image combines three of Russell's photographs.

The Carte du Ciel was in some ways too ambitious an undertaking for many of the observatories involved and it was never fully completed, mainly because the measurement of star positions from thousands of glass plates was difficult and slow. However, it served to emphasize the importance of photography in astronomy and the international nature of the astronomical enterprise and so strongly influenced the formation of the International Astronomical Union (IAU) in 1919. This is still based at the Observatoire de Paris, where the CdC was instigated, and it is the coordinating body for professional astronomers. It should be mentioned here that while the United States did not take part in the Carte du Ciel project it joined the IAU in 1920.

The urge to look south

In addition to Benjamin Gould's presence in Argentina, several other South American countries had established national observatories and many of them were involved in the CdC, with varying degrees of success. However, probably the most prominent South American observatory in the early 20th century was at Arequipa in Peru, an institution with a great history of photographic achievement in both hemispheres, the legacy of which is an archive of half a million plates — none of them connected with the CdC project. Arequipa was almost entirely as a result of the involvement of the Harvard College Observatory, of which it was an outstation.

Among these are the numerous photographs of the Magellanic Clouds that Henrietta Swan Leavitt (1868–1921) used to establish the period–luminosity relationship of Cepheid variable stars between 1908 and 1912. Cepheids are bright stars and abundant in these nearby galaxies, which are sufficiently far away that the stars in each galaxy could all be assumed to be at the same distance from Earth. From Leavitt's work came the first solid step in the extragalactic distance scale, a marvelous extension of the solar and stellar parallax endeavors that had taxed generations of astronomers who had labored in the southern hemisphere. Sadly, it is thought that Henrietta Leavitt never saw the Magellanic Clouds for herself, but knew them intimately from the plates returned from Peru.

Many of these plates were from the 24-inch Bruce Astrograph, an F/5.6 photographic refractor made by Alvan Clark and Sons, which was later moved from Peru to Bloemfontein in South Africa, where it was used by Harlow Shapley for a survey of southern galaxies. In its day this aperture and focal ratio was considered remarkable, but in 1950 the Bruce telescope was replaced by a 91-cm Baker Schmidt telescope.

The design of the telescopes that bear his name was the result of the genius of Bernhard Schmidt (1879–1935), an optician of Estonian birth, who invented the Schmidt camera in 1928–29. A conceptually simple design with a spherical primary mirror and aspheric corrector plate, the Schmidt camera was the first wide-field, fast focal ratio telescope to be used in astronomy. However, the focal surface is curved and is inside the telescope, inaccessible to a human observer (hence the common name, Schmidt camera). The focal surface could be used with photographic plates if they were thin enough to conform to the curvature. And the image quality was superb over a very wide field, and completely free from the aberrations of refractors.

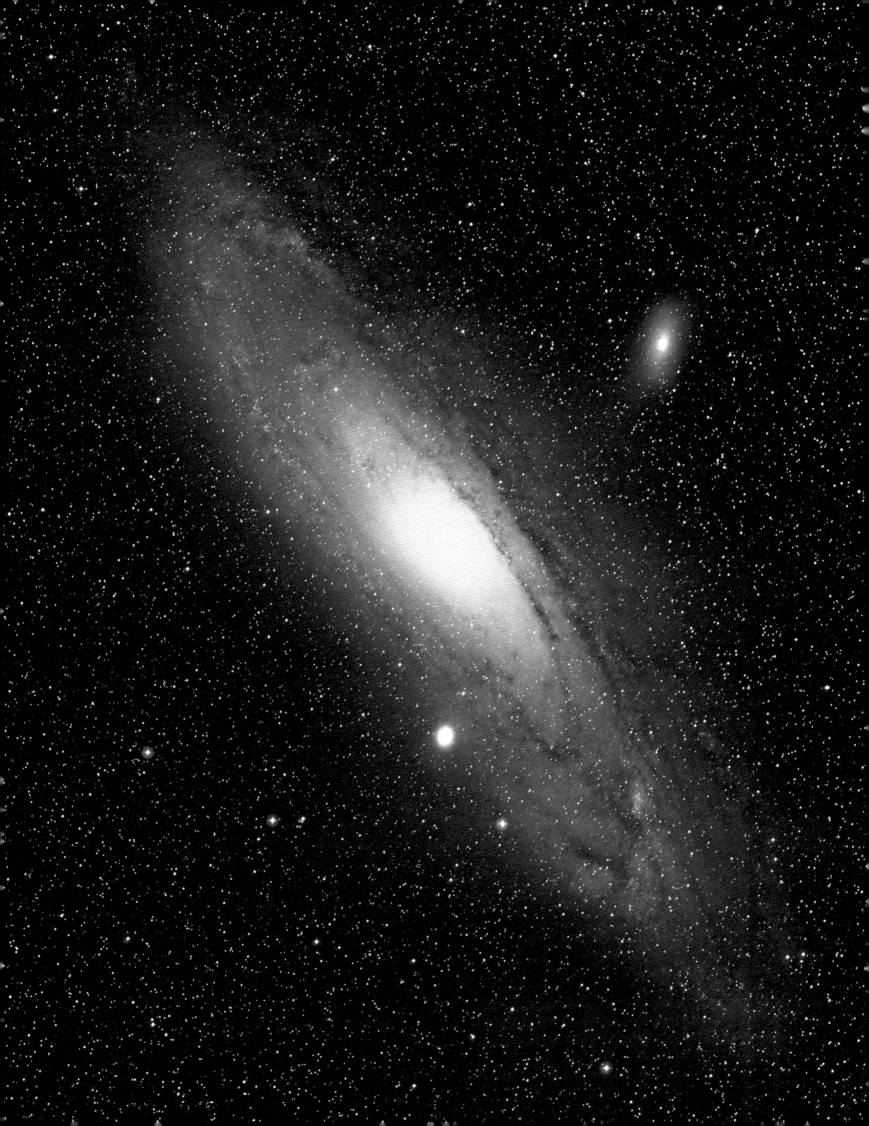

Ever larger Schmidt-type telescopes were built, culminating in the 48-inch (1.2 m) Palomar Schmidt, commissioned in 1948. This is now known as the Oschin Schmidt, and its basic specification is still remarkable. It has a focal length of about 3 meters, works at a focal ratio of F/2.5 and recorded a 6 x 6 degree patch of sky on 356 mm (14-inch) square glass plates, with a plate scale of about 60 arcseconds per millimeter. Between 1948 and 1958 it was used to make a photographic survey of all of the sky reasonably accessible from Palomar in two colors, red and blue, down to a declination of –33 degrees. This was extended even further south, to –45 degrees on the initiative of John Whiteoak, an Australian radio astronomer, but only in one color, red.

Pushing a northern telescope into its declination limits was an indication of the urgent need for substantial telescopes based in the southern hemisphere, which we will come to shortly. However, among the Palomar Schmidt's many accomplishments we should mention here were some of the first color photographs of the night sky. These were taken by Bill Miller (1910–1981), a photographic scientist at what was then Mt Wilson and Palomar Observatories, using Super Anscochrome transparency film, with a then-astonishing snapshot speed roughly equivalent to ISO 100. This fell to about ISO 7 during a long exposure.

Although rarely mentioned today, Miller's achievement was considerable, and he put a good deal of effort into understanding and correcting the notoriously unpredictable color balance issues that affected long exposures on color film. It was clear to Miller and others at this time that the special Kodak photographic emulsions that had been used for the first Palomar Sky Survey did not make the best use of the finely detailed images and fast focal ratio of Schmidt telescopes. These emulsions had been designed in the 1930s under the direction of C. E. Kenneth Mees (1882–1960), the founder of the Kodak Research Laboratories. They were the most sensitive photographic emulsion then known and were specially sensitized for long exposures. However, they were also grainy and had poor resolution, but this was not a serious problem with long focal length telescopes and their generous plate scales.

In the late 1960s Miller had been involved in testing a new type of astronomical emulsion from Eastman Kodak. It had fine grain, high contrast and excellent resolution, ideally suited to the new generation of 4-meter telescopes being planned for the 1970s — and for Schmidt telescopes.

Three of these new telescopes were intended for the southern hemisphere. The Cerro Tololo 4-m Blanco Telescope (whose twin is at Kitt Peak National Observatory in Arizona) and the European Southern Observatory (ESO) 3.6-meter at the La Silla Observatory were both built in Chile, while the Anglo-Australian Telescope (AAT) was built at Siding Spring in Australia. ESO would also have a 1-meter Schmidt Telescope and a 1.2-meter Schmidt, based on the Palomar Schmidt design, and would be constructed close to the AAT. All these telescopes were commissioned in the early to mid-1970s, and at last large, modern telescopes had access to the southern skies, 300 years after Halley prepared the first southern star catalog on St. Helena. All of these instruments have been highly successful and have been followed by even larger and more successful instruments, such as the four 8-meter telescopes of ESO's Very Large Telescope, Gemini South, in Chile, and the Southern

Miller's Important Color Photo of Messier 31
One of the first color astronomical photographs, a 120-minute exposure of Messier 31 made by Bill Miller with the Palomar (now Oschin) Schmidt telescope in 1958. It was taken on 4 x 5 inch film and remastered digitally by David Malin in the 1990s.

African Large Telescope in South Africa. Since 2007 ESO's telescopes in Chile have each year collectively provided data for more scientific papers than any other observatory on the planet, or above it — a testament to the extremely clear skies of the southern hemisphere. For the future, the next generation of "extremely large" optical telescopes is now being planned. Two of three will be constructed in Chile in the south, and one in the north in Hawaii. The largest of these, the 40-meter European Extremely Large Telescope (E-ELT), will be built on a mountaintop adjacent to the Very Large Telescope in Chile's Atacama Desert.

Significantly, no new large optical telescopes are planned for Australia, mainly because Australia's highest mountains are too far south to offer clear weather — and not high enough, as Piazzi Smyth would have known. New Zealand has much higher mountains, but is even further south, buffeted by the wild winds and storms of the Roaring Forties. Australia's astronomical strength is today in radio astronomy, which benefits from a long tradition and the enduring success of the Parkes Radio Telescope, completed in 1961. Australia has a small population, most of which lives on the coast. The interior is largely empty — and radio-quiet — and this is perhaps the advantage that Australia's astronomical future will be based on. The Square Kilometer Array (SKA), a radio telescope with a collecting area of a million square meters, is an enormous international project to build a vast, innovative multi–frequency, ultra-sensitive radio telescope. It is planned for construction between 2016 and 2023 and will look back to the dawn of time itself. Its final location is not yet decided, but it will be in the southern hemisphere, either in Australia or South Africa.

To end this celebration of southern hemisphere advances in sky observing, we should remember that astronomy is a completely international science, and the fact that astronomy was late in establishing itself in this hemisphere is simply an accident of history and geography and the limitations of 15th-century ships. The southern advantages of clear air and dark skies are still real and very important, as witnessed by the large investment in ground-based telescopes here in recent years and in the plans for the enormous E-ELT and Giant Magellan Telescope in Chile. However, much astronomy now depends on data from the more than 100 telescopes that have been launched into Earth orbit, such as the Hubble Space Telescope, and scores of orbiting telescopes and detectors that can observe the whole sky at wavelengths from gamma rays to microwaves and beyond. Eventually, Hubble's big sister in the infrared, the James Webb Space Telescope, will be parked (literally) a million miles away from our planet, in an orbit around the Sun. By then, hemispheric chauvinism will be a very distant memory.

The European Extremely Large Telescope
The European Extremely Large Telescope is planned for construction on Cerro Armazones in Chile and will have a 40-meter diameter segmented mirror — the largest of a new generation of Extremely Large Telescopes. The telescope's "eye" will be almost half the length of a football field in diameter and will gather 15 times more light than the largest optical telescopes operating today.

The Square Kilometer Array
A conceptual sketch of the Square Kilometer Array layout. About 150 stations, about half the SKA area — will be distributed across continental distances (~3000 km), either in Australia or South Africa.

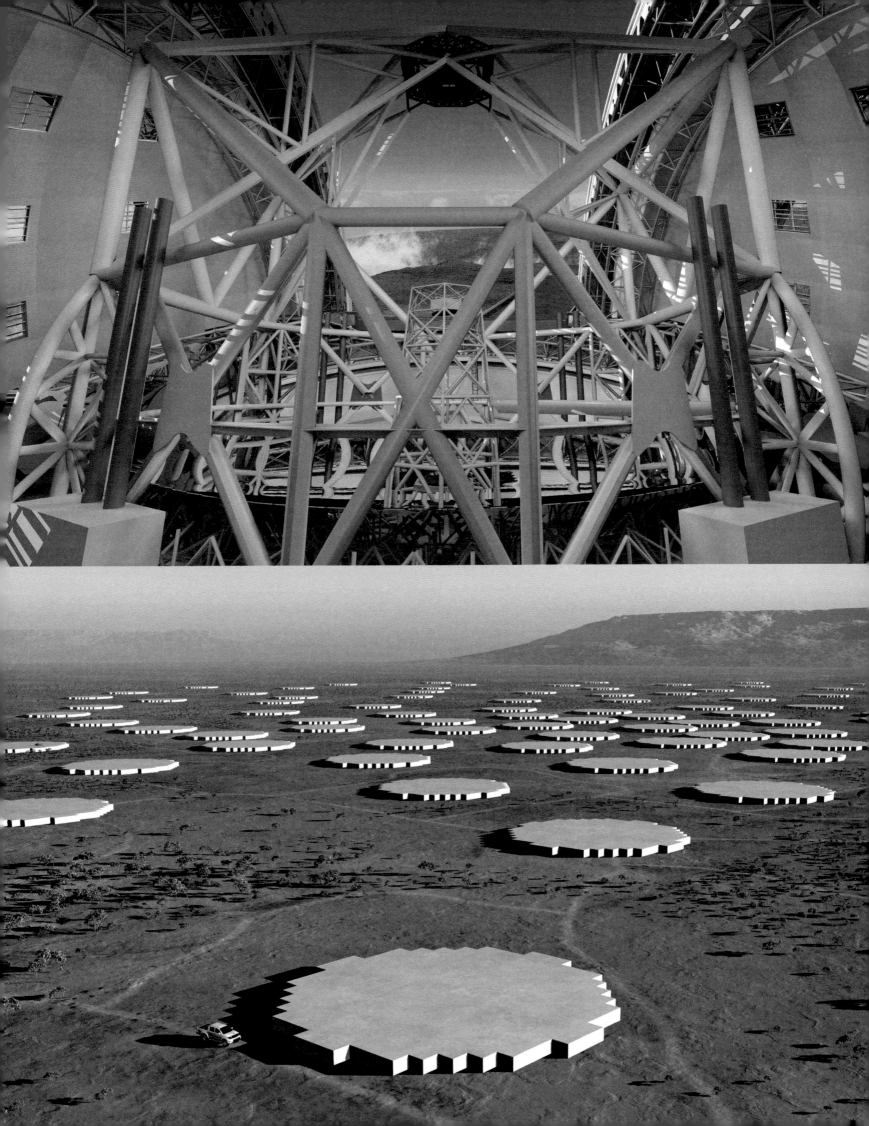

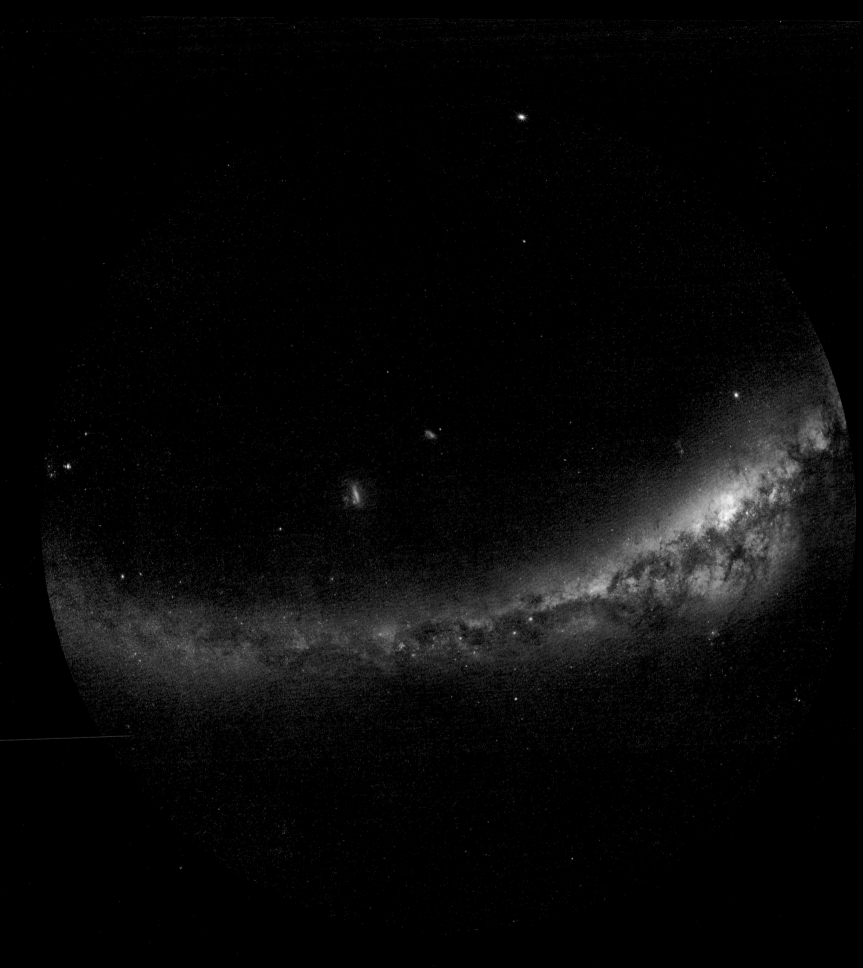

The Southern Sky

This image on the right shows a 180-degree view of the entire southern hemisphere as it would look to a spectator at the South Pole. From this vantage point, the general components of the Milky Way come clearly into view, including its disk, marbled with both dark and glowing nebulae, and which harbors bright, young stars as well as our galaxy's central bulge (right) and its satellite galaxies, the Large and Small Magellanic Clouds (middle).

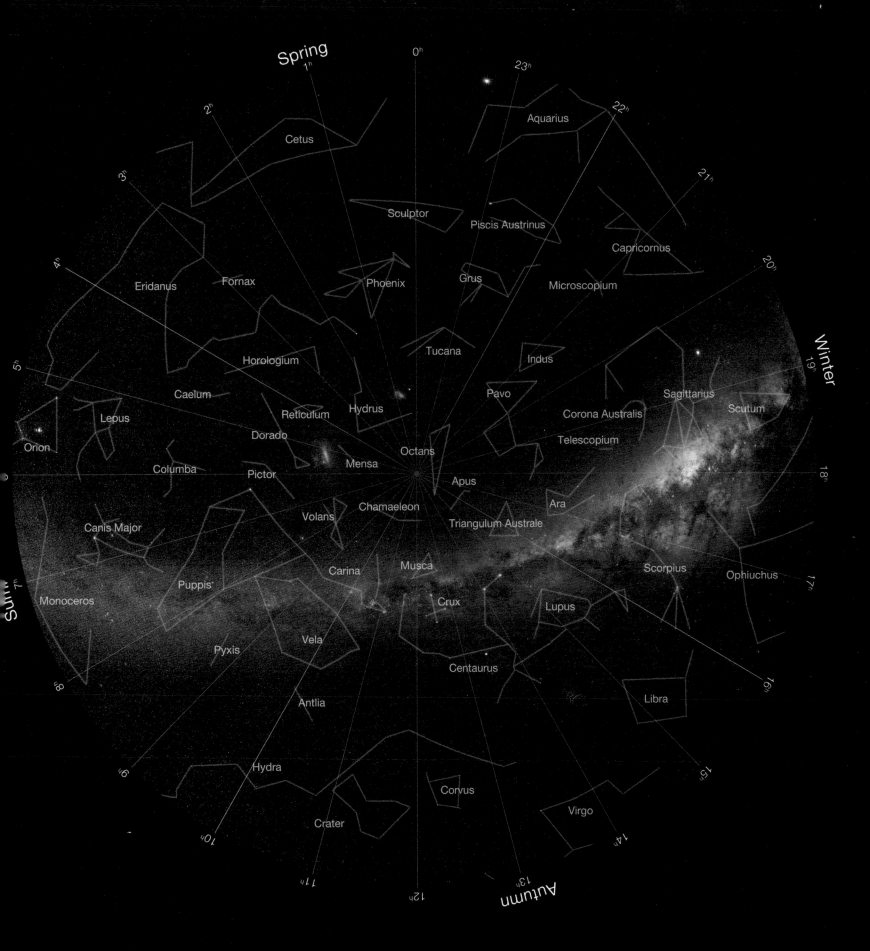

The image came about as a collaboration between the European Southern Observatory (ESO), the renowned French writer and astrophotographer Serge Brunier, and his fellow Frenchman Frédéric Tapissier. Brunier spent several weeks capturing the sky, mostly from ESO's observatories at La Silla and Paranal in Chile. On the right the southern constellations are overlaid on top of the image. Also marked are the four parts of the sky that are the most prominent in the four southern seasons: summer, fall, winter, and spring.

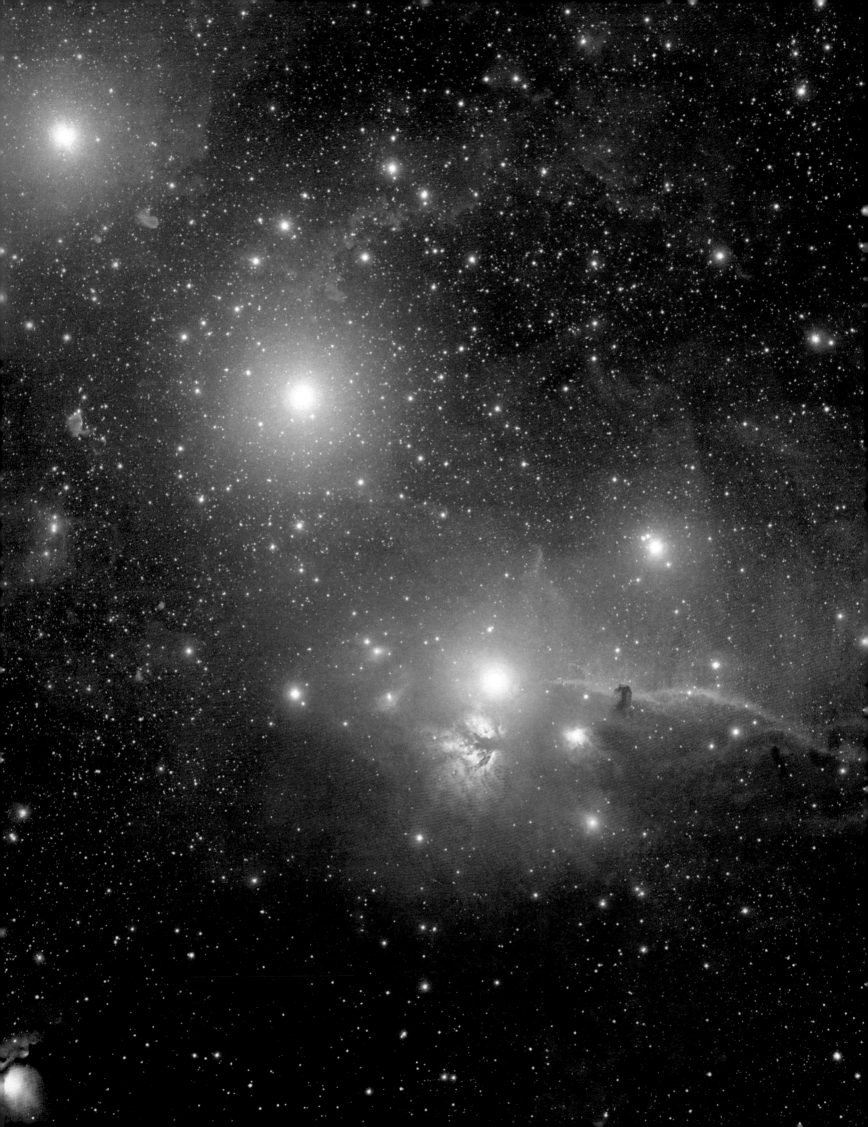

The Southern Summer

04.00 to 10.00 Hours Right Ascension

The Southern Summer

This is the time of year of Orion on the celestial equator with a pale ghost of the Milky Way traversing the northern sky. However, south of the celestial equator the warm nights of summer bring both Magellanic Clouds high into the sky. We also see the rich and starry regions in Carina, Puppis, Vela and Pyxis, the remains of the ancient Greek ship Argo Navis, dismantled in the southern Milky Way. This deep image, recorded with a small refractor, reveals the assortment of extraordinary star-forming regions that have emerged from the Orion Molecular Cloud complex. Iconic objects such as the Orion and Horsehead Nebulae are essentially thin blisters of glowing gases over the surface of vast molecular clouds, illuminated by massive stars.

NGC 1531 and NGC 1532

This intriguing pair of interacting galaxies lies about 55 million light-years away in the direction of the constellation of Eridanus (The River). The larger galaxy is NGC 1532, and it is a dusty spiral system rather like the Milky Way, seen almost edge-on. It appears to be interacting with a smaller companion, NGC 1531. This latter is a largely gasless spiral. The interaction is mostly indicated by the anomalous burst of star formation in the nearest spiral arm in NGC 1532 and some curiously displaced emission nebulae that appear to be close to NGC 1531, which seems to be in the background. Less obvious here are large plumes and recently formed clusters of blue stars in the outer arms of NGC 1532. All these features are signatures of the immense tidal forces stirred up as galaxies collide.

We only see a snapshot of this system, so there is no reason to think that this interaction is the first that NGC 1532 has experienced, and it is unlikely to be the last. In orbit around the large spiral are several other dwarf galaxies, visible on wide-angle photographs of the group. They are themselves probably the result of ancient mergers in what is believed to be a hierarchical process that has been building ever-larger galaxies (and reducing the number of smaller ones) since the beginning of time.

NGC 1531 and NGC 1532
The pair of galaxies NGC 1531 and NGC 1532 were imaged with the Danish 1.54-metre Telescope at ESO's La Silla Observatory. The cannbalistic nature of galaxy interactions is evident as the larger spiral is gradually consuming its smaller companion.

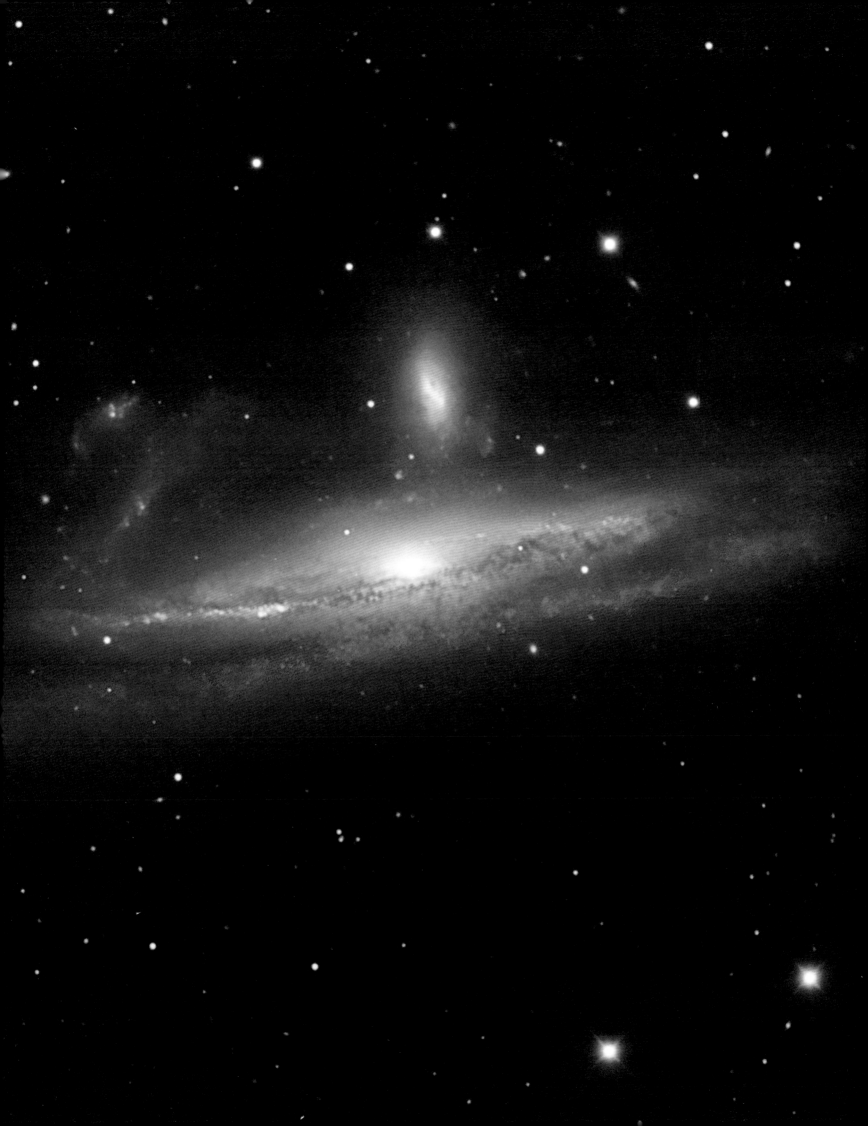

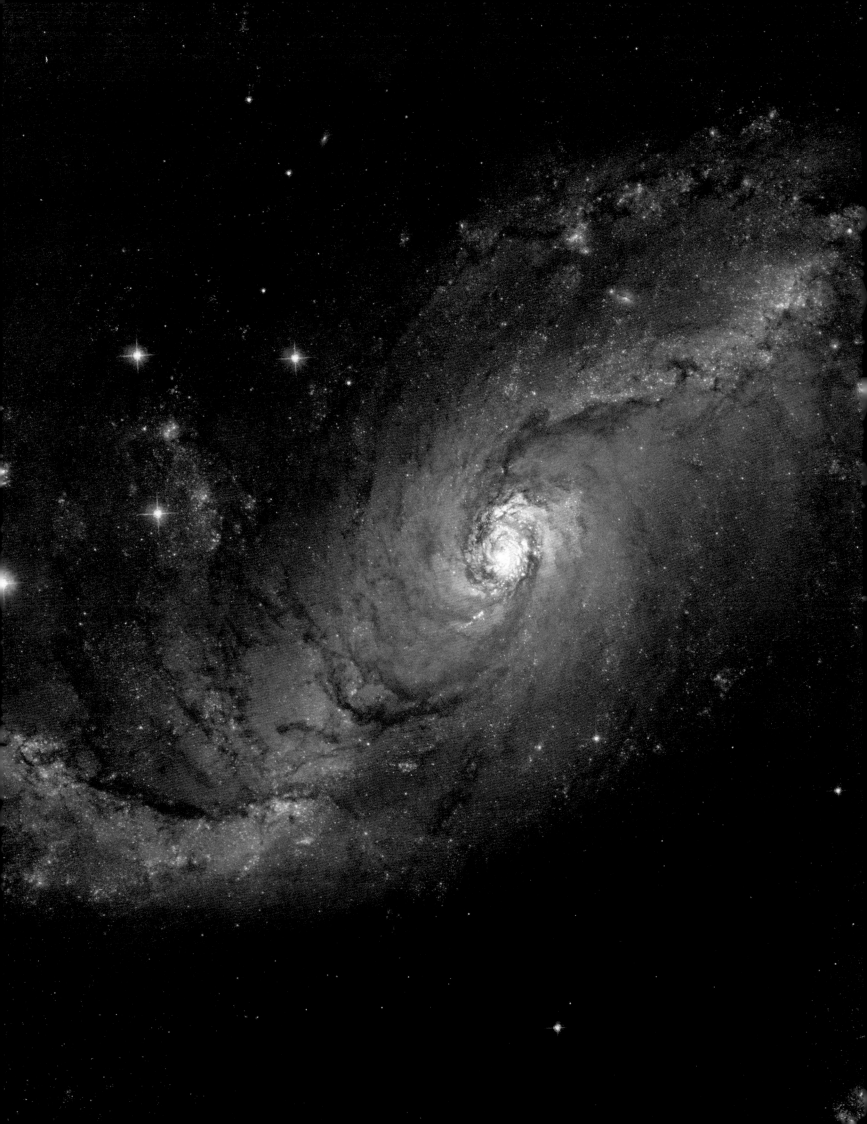

NGC 1672

NGC 1672 is another variation on a broad theme that can be summed up as "nearby barred spiral galaxies." While NGC 1672 has many features in common with the twin prototypes of this class, NGC 1300 and NGC 1365 (p. 202 and 206 respectively), this denizen of Dorado, in the far southern sky, offers some interesting and revealing differences.

The galaxy has two main spiral arms, delineated by well-defined, curved regions of star formation, indicated by red nebulae and patch clumps of stars. These are clearer in the southern (lower left) arm than in its northern counterpart, but on the inner sides of both arms are the dust lanes from which the hot new stars and pink nebulae emerge. However, neither of the outer dust lanes appears to reach the central bulge. Instead, the inner dust lanes seem to arise out of nothing before spiraling into the very luminous nucleus, and at their ends lies a pair of stubby arms with chaotic star clusters and nebulae.

We can offer no authoritative explanation of this, except that on very deep images the outer parts of the galaxy (not seen here) are disturbed in a way that is strongly suggestive of a recent merger or gravitational encounter. The active and very compact active nucleus of the galaxy and the brilliant starburst ring around it strongly hint that the galaxy's central black hole is being fed, possibly with material deflected by some kind of minor merger or disturbance.

Astronomers believe that barred spirals have a unique mechanism that channels gas from the disk inwards towards the nucleus. This allows the barred portion of the galaxy to serve as an area of new star generation. It appears that the bars are short-lived, begging the questions: Will galaxies without a bar develop one in the future, or have they already hosted one that has disappeared?

NGC 1672

These observations of NGC 1672 were taken with Hubble's Advanced Camera for Surveys (ACS). This composite image was made from data taken through filters that isolate light from the blue, green, and infrared portions of the spectrum, as well as emission from ionized hydrogen.

LHA 120–N11

The Large Magellanic Cloud contains many bright bubbles of glowing gas. One of the largest and most spectacular has the name LHA 120–N11, and it has much in common with LHA 120–N44 (p. 40). The "N" designation comes from a listing in the catalog compiled by an American astronomer and astronaut, Karl Henize, in 1956, and so LHA 120–N11 is also informally known as N11. The dramatic and colorful features visible in the nebula are the tell-tale signs of star formation, and it is a well-studied region that extends over 1000 light-years. After the Tarantula Nebula (p. 52), which is at the opposite end of the LMC's distinctive bar, it is the second largest star-forming region within the LMC and has produced some of the most massive stars known.

It is the repetitive, self-perpetuating, but erratic process of star formation that gives N11 its distinctive look. Several successive generations of stars, each of which formed further away from the center of the nebula than the last, have created shells of gas and dust, the largest of which contains a substantial star cluster. These shells were blown away from the newborn stars in the turmoil of their energetic birth and early life, creating the ring- and bean-like shapes so prominent in this image.

Other energetic star clusters abound in N11, including NGC 1761 seen at the bottom of the image to the right. Although it is much smaller than the Milky Way, the LMC is a very active star-forming galaxy. Studying these distant stellar nurseries helps astronomers understand a lot more about how stars are born in different environments and how these early events affect their ultimate development and lifespan.

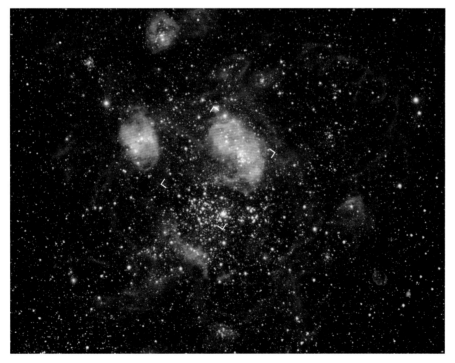

Overview of N11

This image taken with a small amateur telescope reveals the full extent of the star-forming complex N11. The dynamic structures of the complex are shaped by the intense radiation of its progeny of young massive stars.

Hubble Image of N11

This vista of N11 shows the central part of the object and was captured by the NASA/ESA Hubble ACS. This picture is a mosaic of ACS data from five adjacent fields and covers a region about six arcminutes across, whose outline is indicated in the small image above. The star cluster NGC 1761 is seen at lower right.

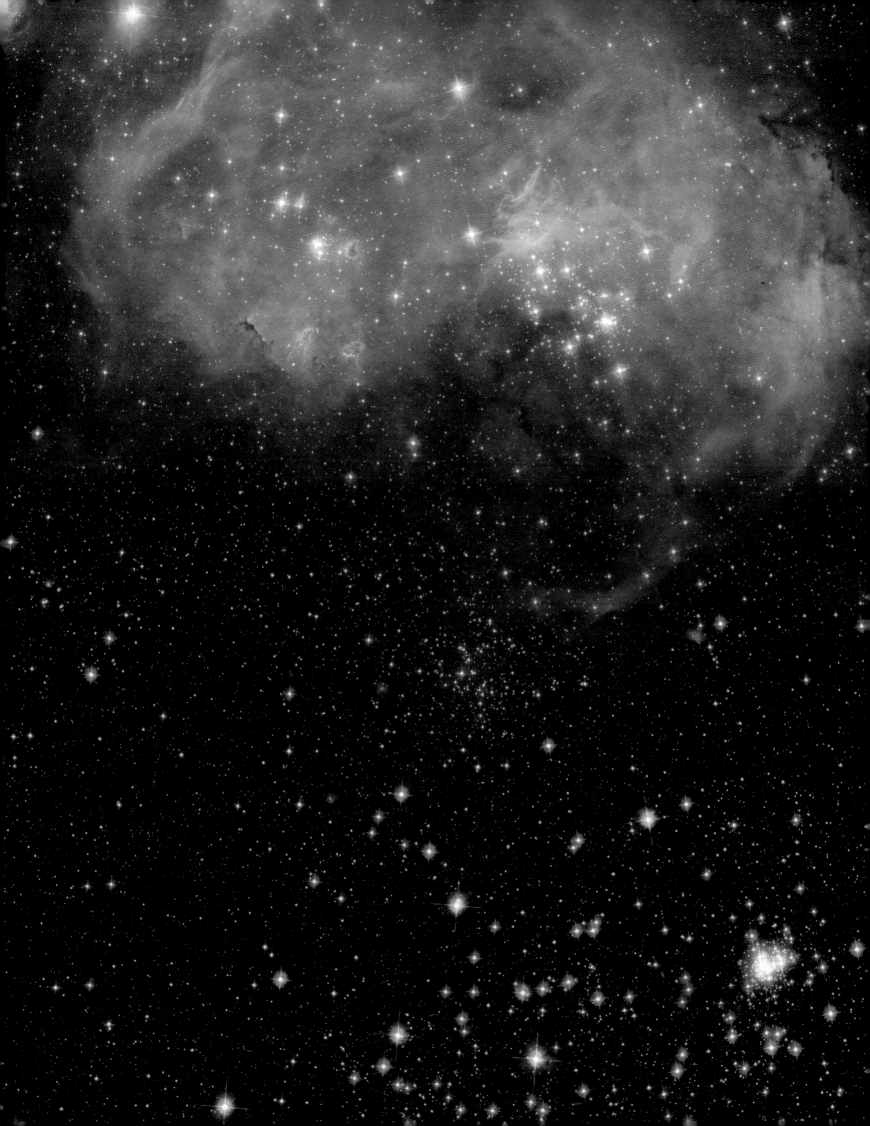

NGC 1909

The classic reflection nebula NGC 1909, also known as IC 2118, lies 2 degrees northwest of the bright supergiant star Rigel, the bright star lower left, which is thought to be the main source of illumination for the nebula. The huge glare around the star is produced by the scattering of its plentiful light in Earth's atmosphere and in the telescope. Rigel is truly a big star and is almost 90,000 times as luminous as the Sun. It is about 800 light-years away, and therefore NGC 1909 is at about the same distance. The next brightest star in the picture is Cursa (Beta Eridani), to the north of the nebula. It is only 90 light-years from the Sun, and much too far from the nebula to illuminate it.

NGC 1909 is also known as the Witch Head Nebula, and it certainly has a ghoulish shape, although a more benign interpretation of this scene would have the witch warming her gnarled hands on the glow from Rigel. However, the dust that reflects Rigel's light remains cool inside, except for some signs of star formation that are only detectable deep within the nebula by means of infrared observations. About ten protostars and T-Tauri stars have been found, and these will eventually disperse the cloud from within.

The molecular clouds of NGC 1909 probably lie towards the outer boundaries of the vast Orion-Eridanus bubble, a giant supershell of molecular hydrogen to the west of the Orion OB association and blown by winds from the high mass stars of the Orion OB1 association. To the east of Orion this interaction with the interstellar medium is seen as Barnard's Loop, but here the influence is seen in the shape of the delicate cometary clouds of NGC 1909.

The Witch Head Nebula
This reflection nebula is associated with Rigel, the bright star in Orion's lower right foot. The blue color is caused not only by Rigel's high temperature but also by dust grains scattering blue light more efficiently than red. The same physical process causes Earth's daytime sky to appear blue.

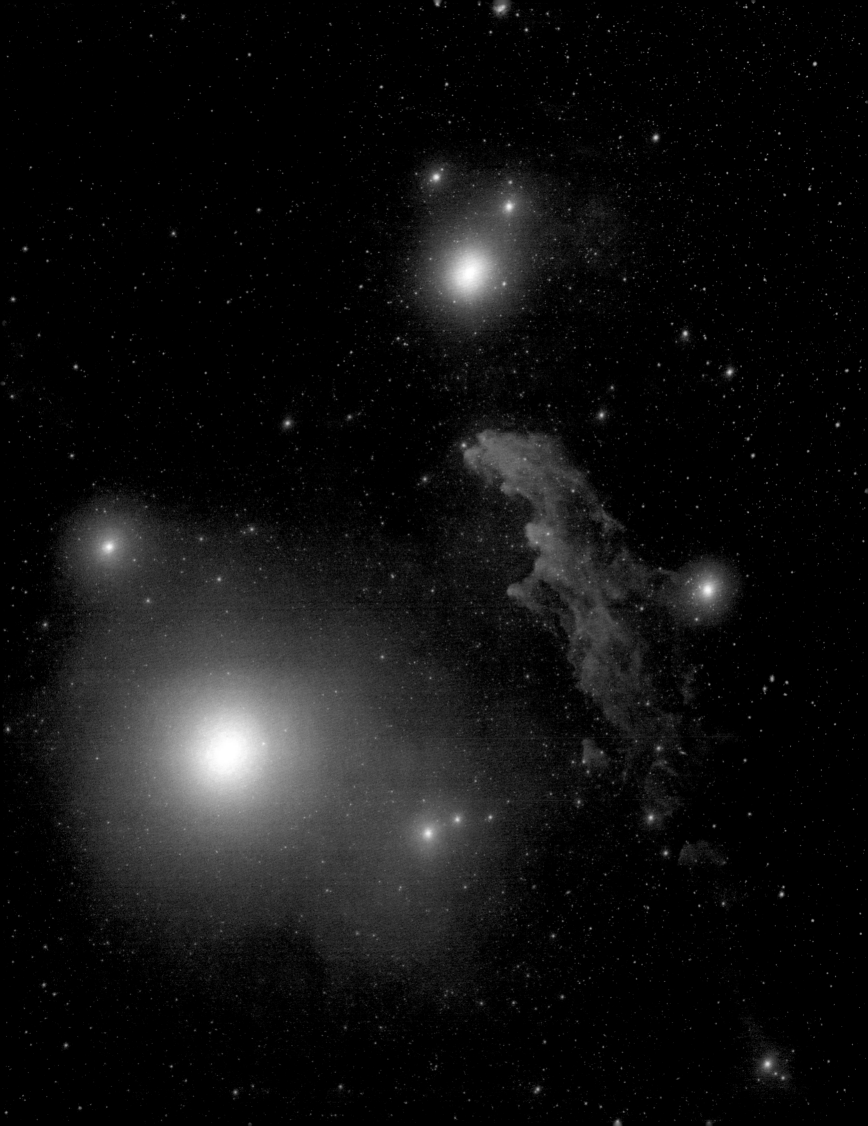

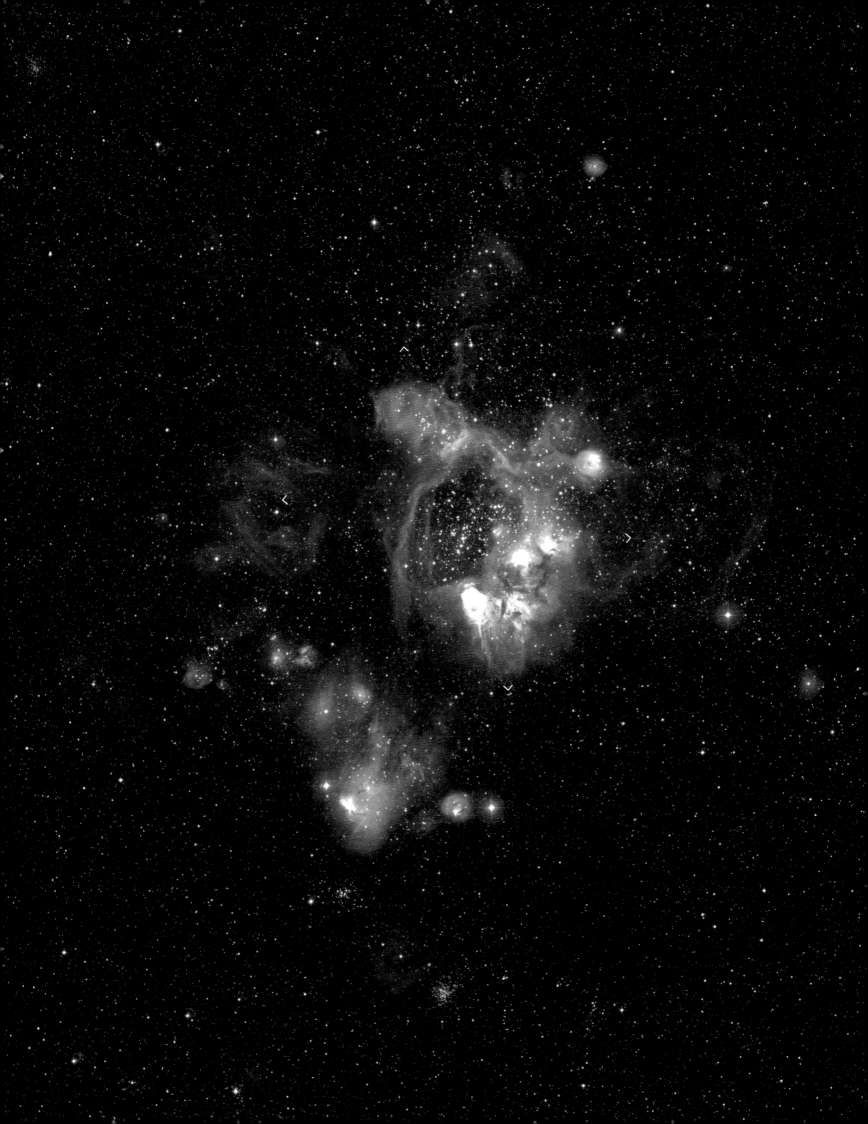

LHA 120–N44

This complex assembly of bubbles, filaments, and bright knots lies in the Large Magellanic Cloud (LMC) and the faintest filaments extend over 1000 light-years. LHA 120–N44, or N44, is a large star-forming region, but not the largest in the LMC. It has given birth to several generations of massive stars and their inevitable supernovae, and it is these stars and their violent ends that have sculpted the nebulosity. The most obvious feature of N44 is an irregular ring, within which is a cluster of about 40 bright stars. These stars are the origin of powerful stellar winds that blow away the surrounding gas, piling it up and creating gigantic interstellar bubbles. Structures of this type are common in the Magellanic Clouds, but rare in the Milky Way.

It is very likely that supernovae have already exploded in N44 during the past few million years, thereby sweeping away the surrounding gas and compressing nearby molecular clouds to continue the star-forming process. This can be seen around the central wind-blown cavity, with smaller bubbles, filaments, and bright, compact emission nebulae scattered throughout, all evidence of young stars.

In the detailed image (below), softly glowing filaments that stream from some of the hot young stars in N44 are seen. The network of nebulous filaments surrounds a rare Wolf–Rayet star. Such stars are characterized by an exceptionally vigorous stellar wind of charged particles, and they are rare because such disruptive behavior cannot be sustained for long. The shock of the wind colliding with the surrounding interstellar medium causes the gas to glow.

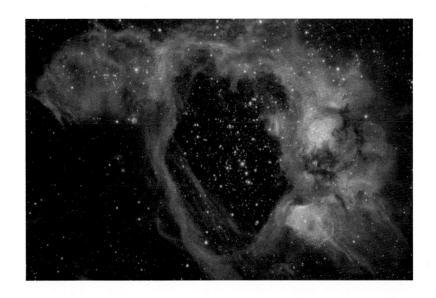

N44 Detailed Image

Gemini Legacy Image of LMC superbubble complex N44 as imaged with the Gemini Multi-Object Spectrograph on the Gemini South Telescope in Chile. The picture was made from narrow wavebands of light emitted by oxygen, sulfur, and hydrogen. It is not possible to make a true-color image from this combination.

N44 in the Large Magellanic Cloud

This wide-field image was made with a relatively small, ground-based telescope, the MPG/ESO 2.2-metre Telescope. The green color indicates areas that are particularly hot. The picture was made from three separate exposures made in broadband green and blue light and narrowband H-alpha (red light) from fluorescent hydrogen excited by adjacent hot stars

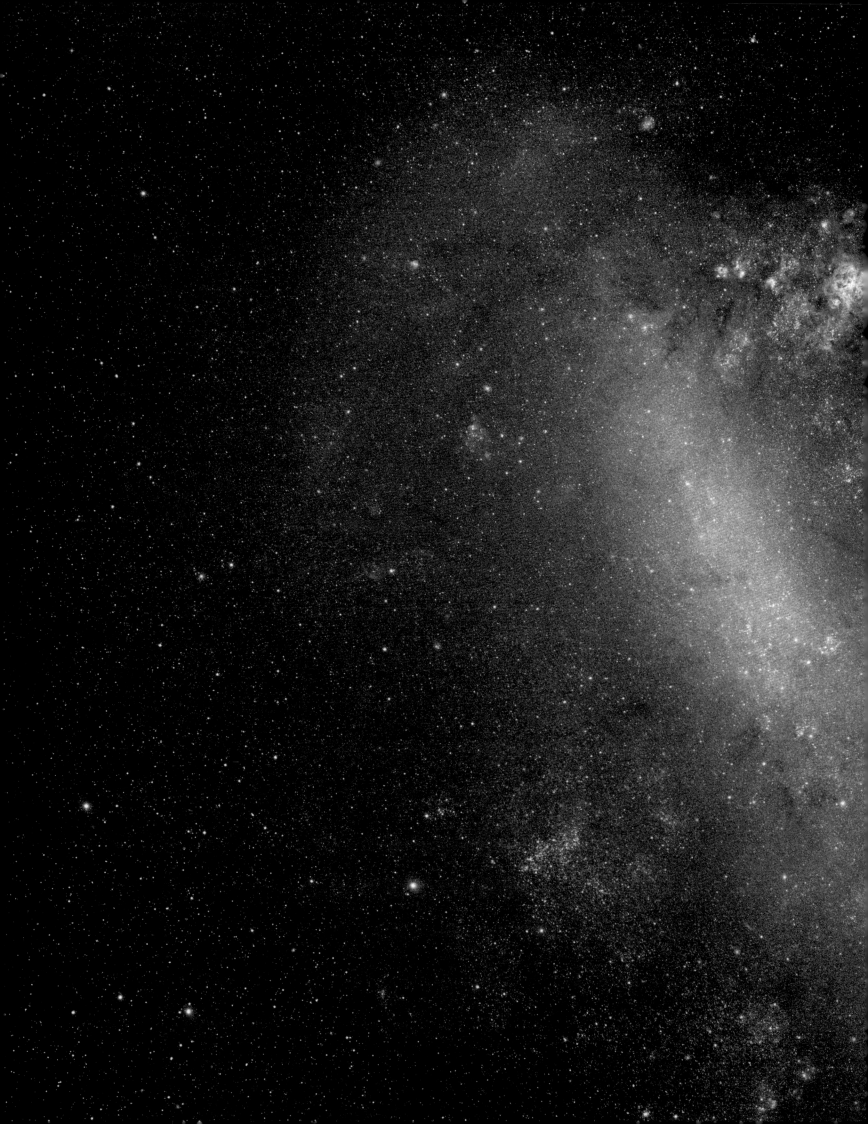

The Large Magellanic Cloud

B oth the LMC and its smaller companion, the Small Magellanic Cloud (SMC), are easily seen with the unaided eye and have always been familiar to people living in the southern hemisphere. The credit for bringing these galaxies to the attention of Europeans is usually given to the Portuguese explorer Fernando de Magellan and his crew, who observed and named them on their 1519 sea voyage. However, the Persian astronomer Abd Al-Rahman Al Sufi and the Italian explorer Amerigo Vespucci recorded their sighting of the Large Magellanic Cloud in AD 964 and AD 1503, respectively.

The Magellanic Clouds are a binary system of dwarf irregular galaxies that orbit our Milky Way and are interacting with it. These nearby galaxies look like detached parts of the Milky Way, and although their optical boundaries are indistinct, the LMC is some 15 000 light-years across, making it the fourth largest member of the Local Group of galaxies, and, at about 160,000 light-years, the third closest galaxy to our own. The most massive Local Group member is the Milky Way itself, followed by Messier 31 and Messier 33.

The origin of the LMC remains uncertain, but its destiny is assured — it will eventually be absorbed by the Milky Way, though at present it seems to be moving away from our galaxy at about 100 kilometers per second.

The Large Magellanic Cloud
The LMC is about one sixth the diameter of the Milky Way and contains about one-tenth its mass. Although it is classified as an irregular galaxy it shows traces of spiral structure and has an off-center, featureless bar of older stars. Sporadic star formation occurs all over the galaxy, but is concentrated towards the eastern end (right), and at its heart — where the spectacular Tarantula Nebula is situated (p. 52). This lopsided concentration of star formation in an otherwise fairly symmetrical galaxy is the result of ongoing gravitational interactions with its companion galaxies, the SMC and the Milky Way. Many interesting objects are visible in the LMC with the brightest and most spectacular described elsewhere in this book.

The Orion Nebula and the Trapezium Cluster

Lying a few degrees south of the celestial equator, and in one of the best-known constellations, the Orion Nebula can be seen from every inhabited part of the world. It is also visible to the unaided eye, as the slight fuzzy central "star" in the sword-hilt of Orion. However, its fame rests on its astonishingly radiant beauty as seen in astronomical images and its scientific importance as one of the nearest, very young star-forming regions in the sky. The nebula itself is a bright condensation of young stars of the Orion Molecular Cloud. The cloud is at a distance of about 1500 light-years; it extends far beyond the Orion Nebula, and includes the equally famous Horsehead Nebula, among others.

Although it is 40 light-years across, the highly luminous, ionized gas of the Orion Nebula, or Messier 42, is a remarkably thin blister on the irregular surface of the thick and dusty molecular cloud, which is illuminated by the newly-formed Trapezium stars. Until recently, these intensely hot stars were embedded in the nebula, and their radiation is burning into the gas and dust from which they so recently emerged. Fortunately, they have blown away the opaque material along our line of sight, but much remains, and the streaks of light and color that give the Orion Nebula its distinctive appearance reveal the course of the stellar winds whipping through it.

The Trapezium stars are all within 1.5 light-years of each other, which is unusually close for neighboring stars, and several are multiple stars. Their combined light is about 250,000 times that of the Sun. By far the most luminous of the Trapezium stars is known as Theta-1, which provides most of the ultraviolet energy. Theta-1C is an enormous star of 40 solar masses and a surface temperature of 40,000 degrees C. If Earth were located within the Trapezium Cluster the night sky would be dominated by extraordinarily bright stars. But that would be the least noticeable effect — if Earth were there it would be rapidly vaporized.

The enormous brightness range of the nebula, from the highly luminous center to the feeble reflections at the periphery, have long been a serious challenge for astrophotographers — the Orion Nebula was the first nebula to be photographed, in 1882.

The Mighty Orion Nebula
This is a wide-field infrared image of the Orion Nebula made with the VISTA infrared survey telescope at ESO's Paranal Observatory in Chile. The picture is composed from images taken through Z, J and Ks filters in the near-infrared part of the spectrum. The total exposure was about 30 minutes, and the image covers a region of sky about 1 degree by 1.5 degrees.

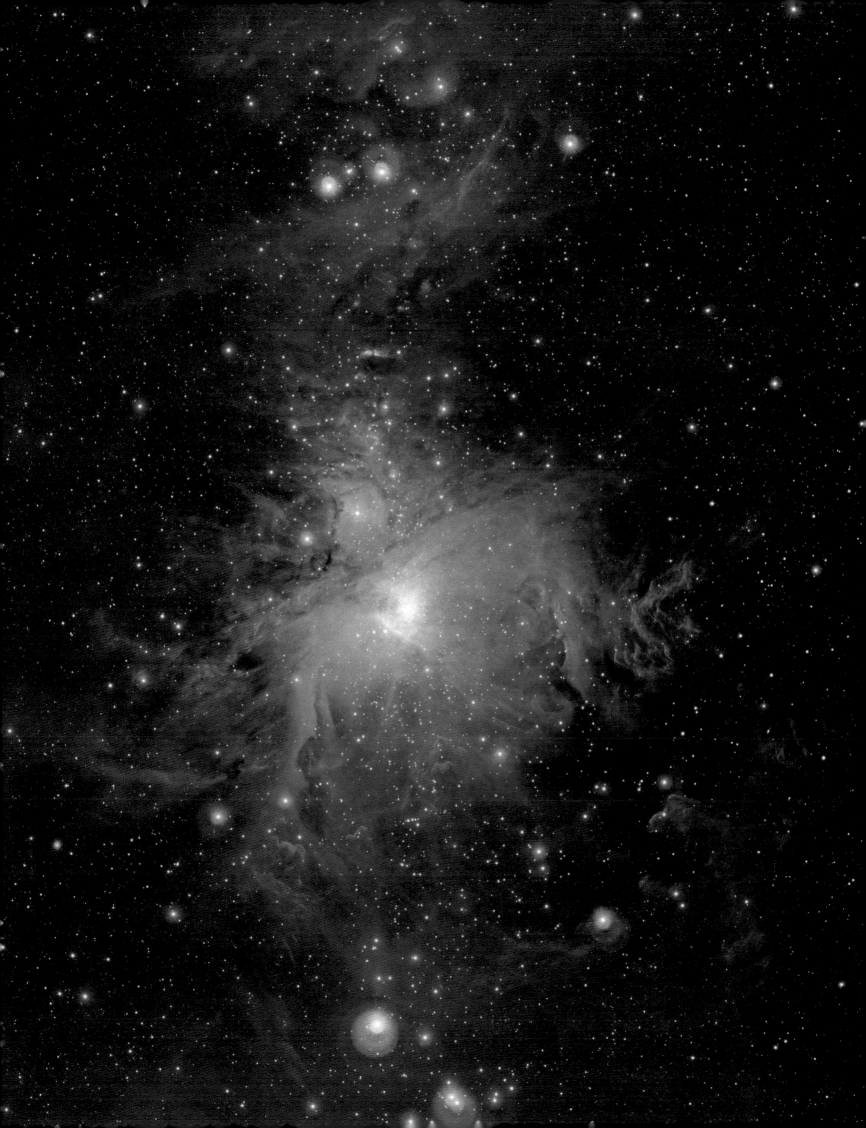

The Trapezium Cluster

Directly in the foreground of the Orion Nebula is a compact group of hot O- and B-type stars known as the Trapezium Cluster. If they were not associated with the Orion Nebula they would be scarcely visible to the eye. However, they are physically near the surface of the Orion Molecular Cloud, and their intense radiation makes it glow, creating the brightest part of the Orion Nebula.

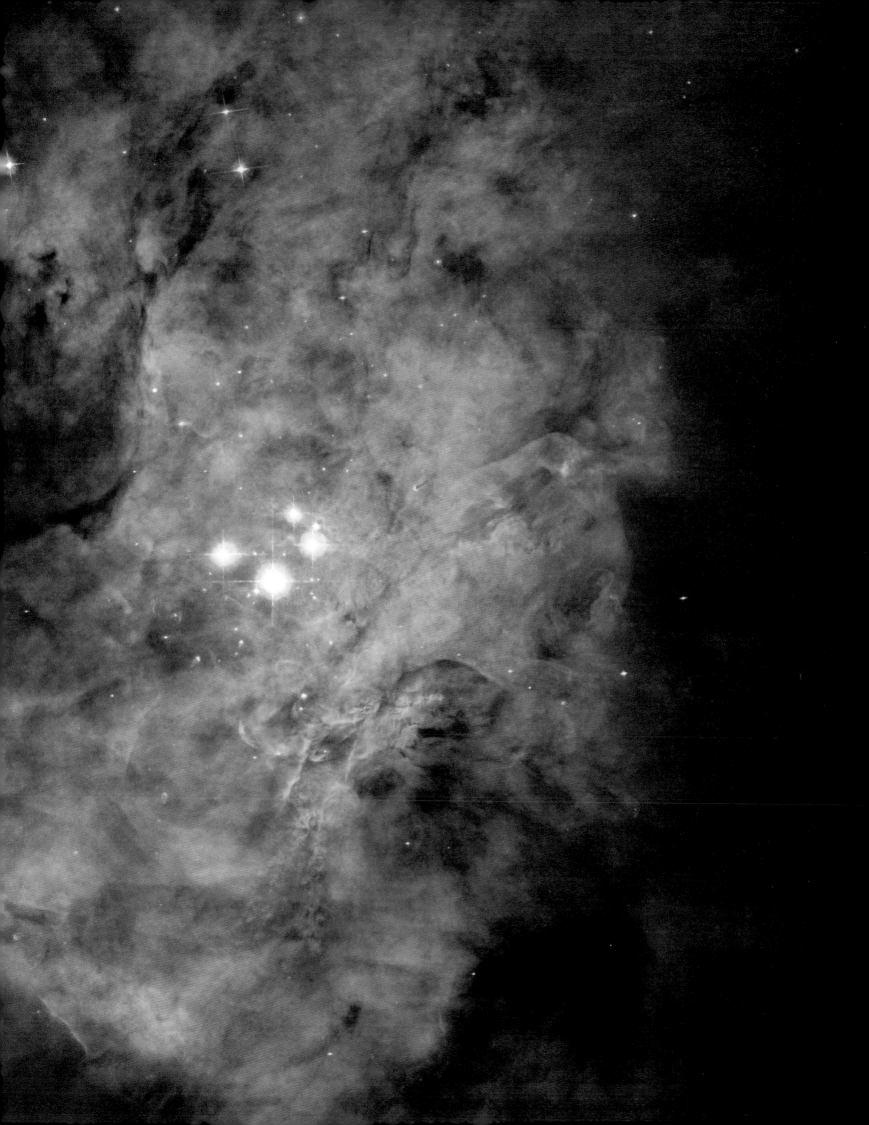

Supernova 1987A

In 1987 astronomers spotted the brightest naked-eye supernovae seen in more than 400 years. Since that first sighting, the doomed star, called Supernova 1987A, has continued to fascinate astronomers with its spectacular light show.

The most prominent feature in the area is a ring with dozens of bright spots. A shock wave unleashed by the stellar blast is slamming into material along the ring's inner regions, heating them up and causing them to glow. The ring, about a light-year across, was probably shed by the star about 20,000 years before it exploded. Astronomers detected the first bright spot in 1997 but have since seen dozens of spots around the ring. In the next few years, the entire ring will be ablaze as it absorbs the full force of the crash. The glowing ring is expected to become bright enough to illuminate the star's surroundings, providing astronomers with new information on how the star expelled material before the explosion.

The pink object at the center of the ring is debris from the supernova blast itself. The glowing debris is being heated by radioactive elements, principally titanium 44, created in the explosion. The shattered remains of the star will continue to glow for many decades.

The origin of a pair of faint outer red rings, located above and below the doomed star, is a mystery. The two bright objects that look like car headlights are a pair of stars in the Large Magellanic Cloud where the supernova remnant is located, but probably not associated with it. The presence of bright gas clouds is a sign of the youth of this region, which still appears to be a fertile breeding ground for new stars.

Close-up of SN 1987A

When looking at SN 1987A in detail with Hubble the inner glowing ring becomes obvious. The ring was probably shed by the star about 20,000 years before it exploded and is now lit by the shockwave from the explosion. The two outer rings remain a mystery. Just how a supernova explodes is not very well understood, but the way SN 1987A exploded is imprinted on the inner material seen in this image. Astronomers today believe that the material was not ejected symmetrically, but rather seems to have had a preferred direction.

Overview of the Supernova 1987A Region

Glittering stars and wisps of gas create a breathtaking backdrop as a massive star self-destructs in the Large Magellanic Cloud to become Supernova 1987A. Astronomers in the southern hemisphere witnessed the brilliant explosion of this star on February 23, 1987. Shown in this Hubble image, the supernova remnant, surrounded by inner and outer rings of material, is set among ethereal, diffuse clouds of gas.

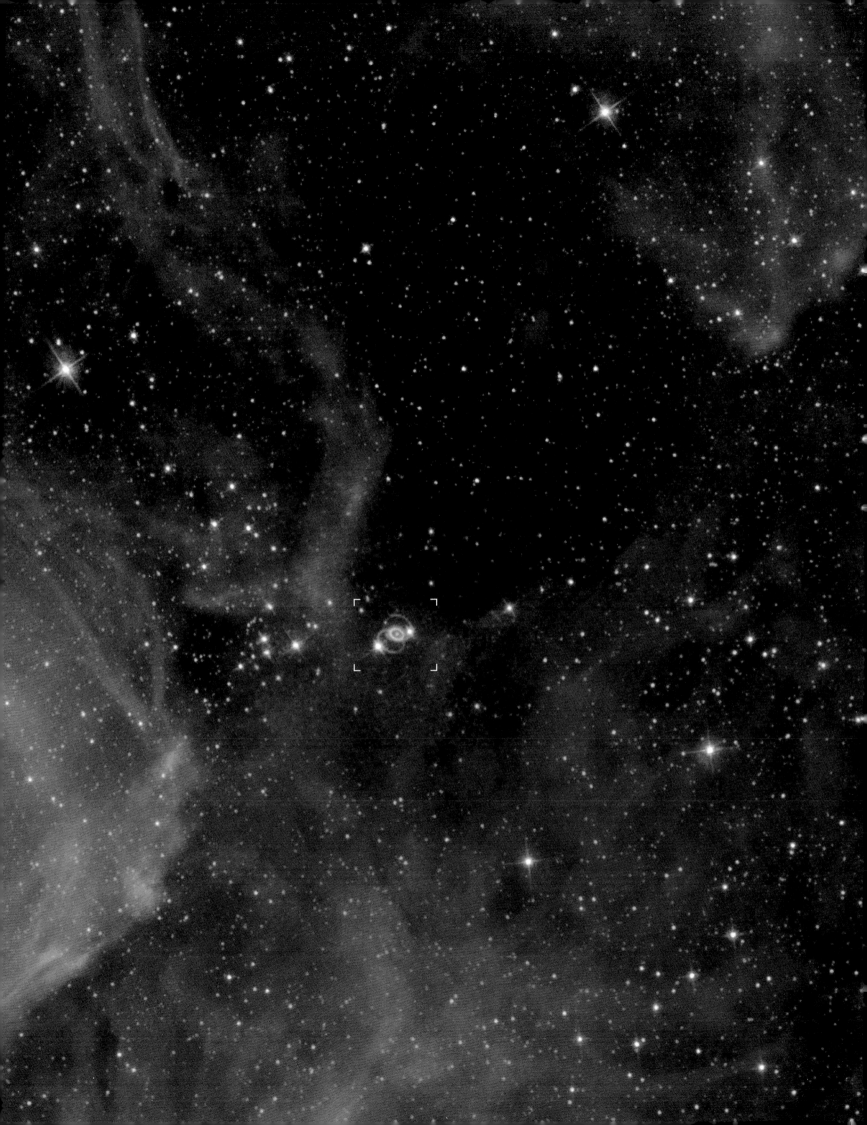

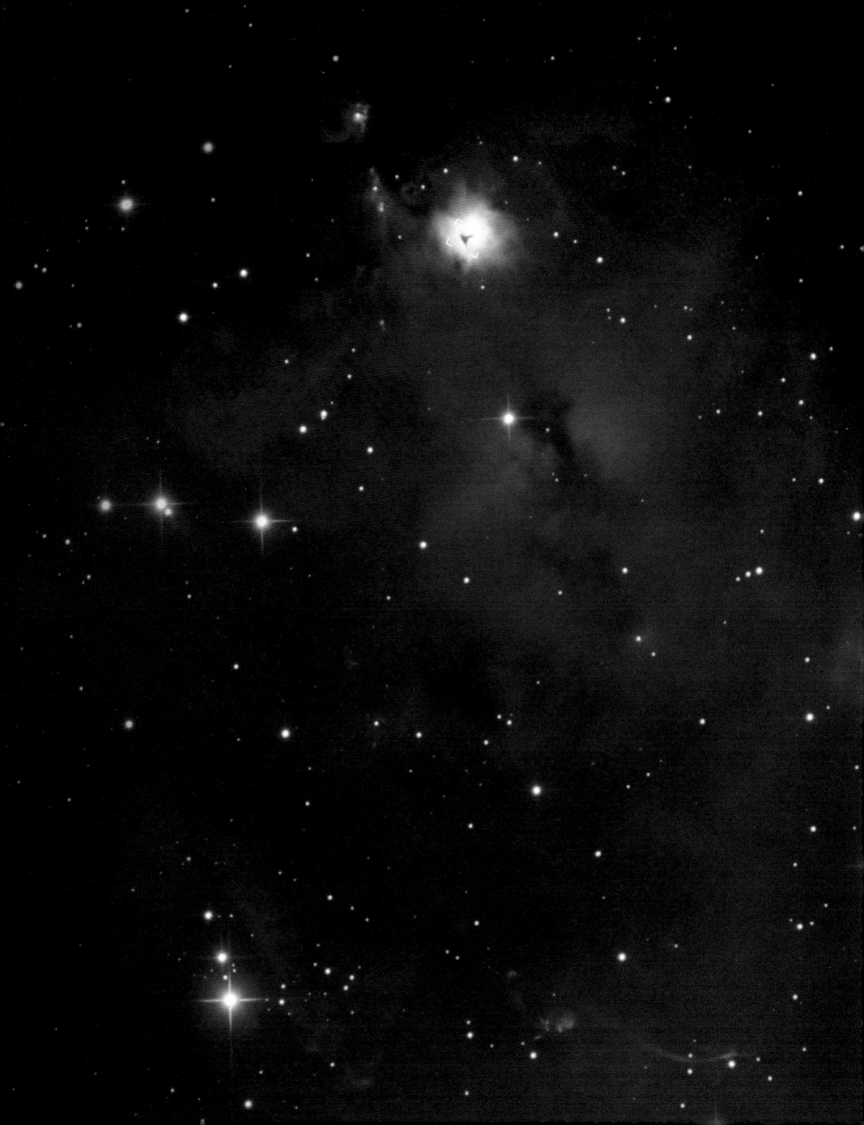

NGC 1999

NGC 1999 is the unusual small reflection nebula at the top in the full-page picture. It is 1500 light-years away, about 2 degrees south of the Orion Nebula, and is part of the same molecular cloud. This striking object is obviously involved in a wider field of turbulent red emission nebulosity strongly suggestive of star formation.

This is confirmed by the two bright, compact emission nebulae to the upper left of NGC 1999. These are Herbig–Haro objects, discovered 60 years ago and created by extremely high velocity jets from protostars buried in the dust. They also happen to be the prototypical Herbig–Haro objects, HH-1 and HH-2, a class of small nebulae named for their joint discoverers, George Herbig and Guillermo Haro. So energetic are these jets that as they interact with the relatively stationary interstellar medium they produce temperatures of a million degrees, generating X-rays. Other, much larger, cone-like features centered on this region are probably the fading traces of older protostellar outbursts.

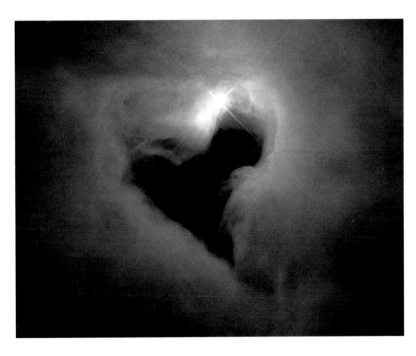

NGC 1999 Seen with Hubble

Close up NGC 1999 offers another, quite different sight — the small dark heart-shape seen against the very bright reflection nebula, itself dust-scattered light from the variable star V380 Orionis that illuminates this space. This ethereal shape is only seen clearly using the superb resolution of the Hubble Space Telescope, and the dark shape is an illuminated cavity rather than some kind of foreground obscuration. The grains of dust are small, more like smoke than the dust of the desert, and like smoke, these grains scatter blue light more efficiently than other colors.

The Area Around NGC 1999

This image shows a wide field around NGC 1999 (top). The nebula is an example of a reflection nebula. Like fog around a street lamp, a reflection nebula shines only because the light from an embedded source illuminates its dust; the nebula does not emit any visible light of its own. NGC 1999 lies close to the famous Orion Nebula, about 1500 light-years from Earth, in a region of the Milky Way Galaxy where new stars are being formed. NGC 1999 was discovered some two centuries ago by Sir William Herschel and his sister Caroline.

Tarantula Nebula

The Tarantula Nebula, the bright core of which (outlined) is also known as 30 Doradus, is the largest and most vigorous stellar nursery known in the local Universe. It is also the nearest extragalactic star-forming region to Earth. It is because of its proximity, the favorable inclination of the Large Magellanic Cloud (LMC), the absence of intervening dust, and its prodigious rate of star formation that we see the Tarantula Nebula as a vast, seething cauldron of young, luminous stars.

It is a staggering 1000 light-years across and is situated 170,000 light-years away. Although it is 100 times further away than the Orion Nebula, itself a large nebula, this milky patch of light at the eastern end of the LMC appears just as bright to the eye. In fact if the enormous Tarantula complex of stars, gas, and dust were at the distance of the Orion Nebula it would be visible during the day and cover a quarter of the sky.

Astronomers believe that the smallish, irregular LMC galaxy is currently going through a violent period in its life cycle. It is orbiting the Milky Way and has had several close encounters with it. It is believed that the interaction with the Milky Way has caused an episode of energetic star formation — part of which is visible as the Tarantula Nebula.

The striking honeycombed appearance of the Tarantula Nebula, seen in a telescope, is without a clear counterpart in our own galaxy. The unique form of the nebula suggests a series of giant interlocking shells surrounding hollow cavities. The inner shells are tightly arranged and are expanding at more than 100,000 km/h, while the diameters of the outer shells increase towards the outer parts of the nebula. The shells are believed to have formed from the collective stellar winds of successive generations of powerful hot blue stars and their supernovae carving deep cavities in the surrounding material by etching away the hydrogen gas cloud in which the stars were born. The Tarantula Nebula's name refers to its appearance when seen through a telescope, where the edges of the bright shells look like the spindly legs of a spider. It is estimated that the complex has experienced at least 40 supernovae within the last 10,000 years, including the most recent, SN 1987A (see page 48).

Tarantula Nebula

The Tarantula Nebula is here seen in all its splendor in a one square degree image. The spidery nebula is seen in the upper-center of the image. Slightly to the lower-right, a web of filaments harbors the famous supernova SN 1987A (see p. 48). Many other reddish nebulae are visible in the image, as well as a cluster of young stars on the left, known as NGC 2100.

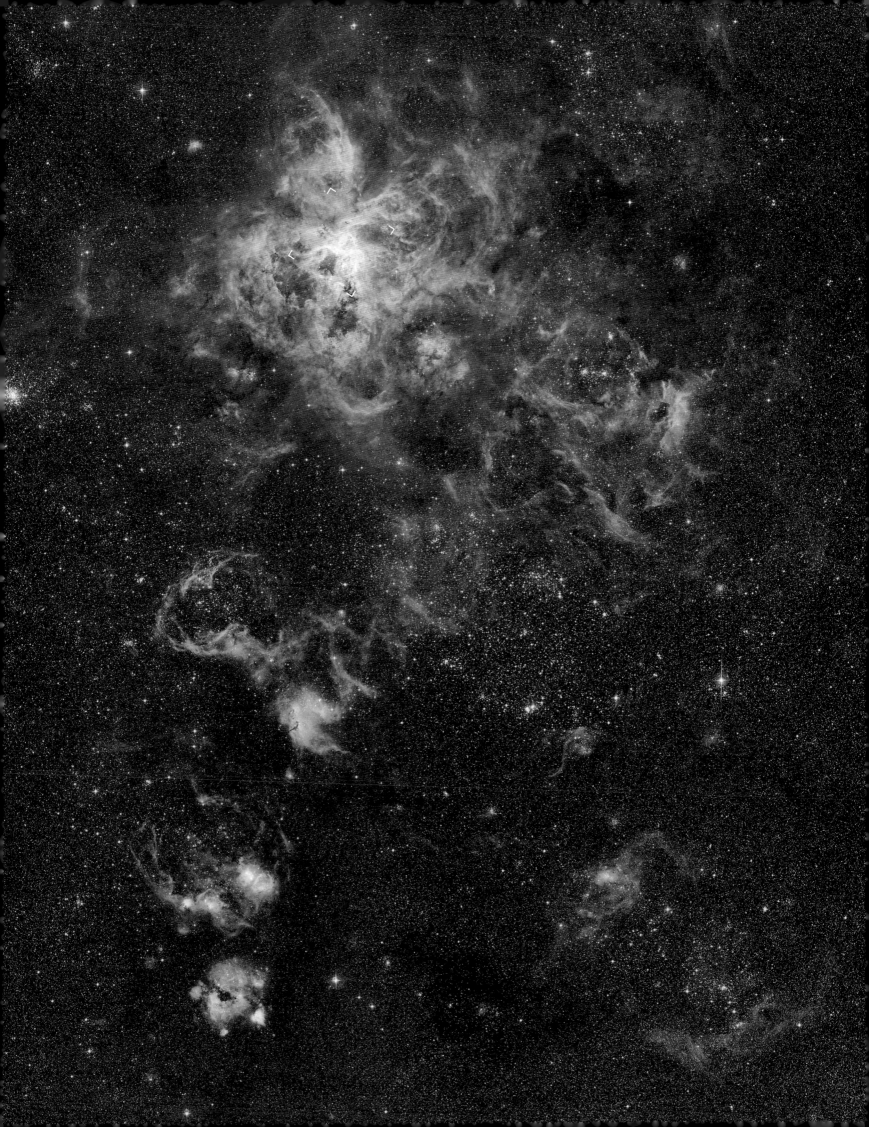

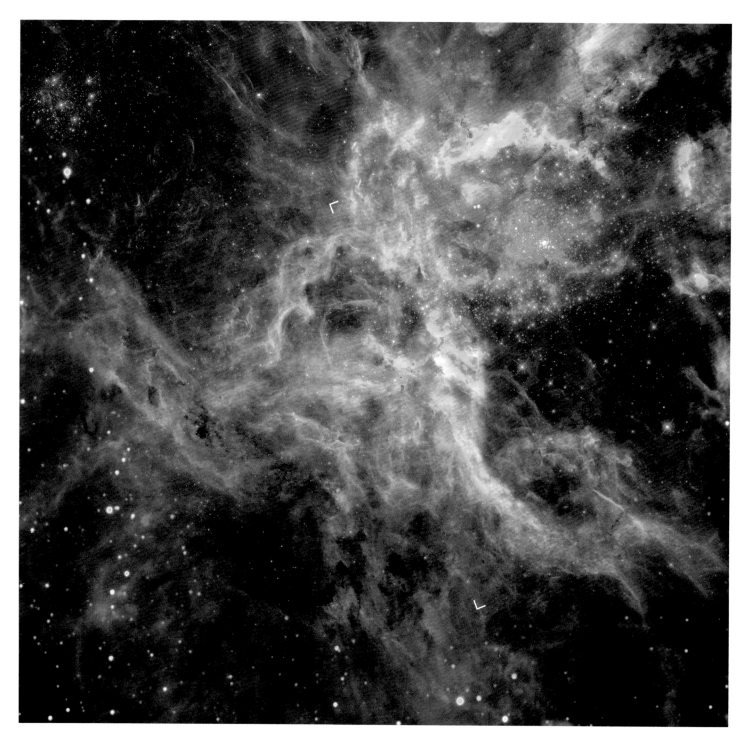

The Center of the Tarantula Nebula

The image above was taken with Hubble's Wide Field Planetary Camera 2 (WFPC2) and reveals a fantasy landscape of pillars, ridges, and valleys in the center of the Tarantula Nebula. Besides sculpting the gaseous terrain, the brilliant stars in the nebula can help create the next generation of stellar offspring. When the stellar winds hit the dense walls of gas and dust, they create shocks, which may initiate a new wave of star birth. The reddish haze of stars above represents the densest concentration of newly formed stars and is known as 30 Doradus, seen in more detail on the next page. At its heart is RMC 136a, like 30 Doradus, once thought to be a single star.

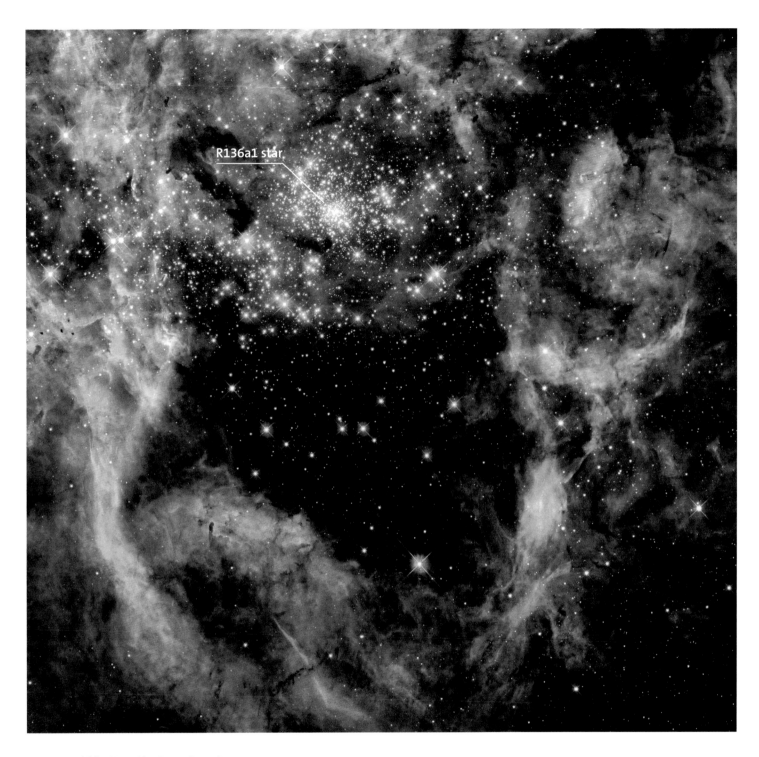

Stars Within Stars, the R136 Grouping

The massive, young stellar grouping, called RMC 136a, or R136 for short, in the center of the Tarantula Nebula is shown in detail above, as seen with Hubble's Wide Field Camera 3 (WFC3). R136 is a remarkable compact cluster only a few million years old, and many of its blue stars are among the most massive and hottest stars known. Several of them are over a hundred times more massive than our Sun, and the star R136a1 is, so far, the most massive star ever found, with a current mass of about 265 solar masses and a birth weight of as much as 320 times that of the Sun. These hefty fast-burning stars are destined to explode as supernovae in a few million years.

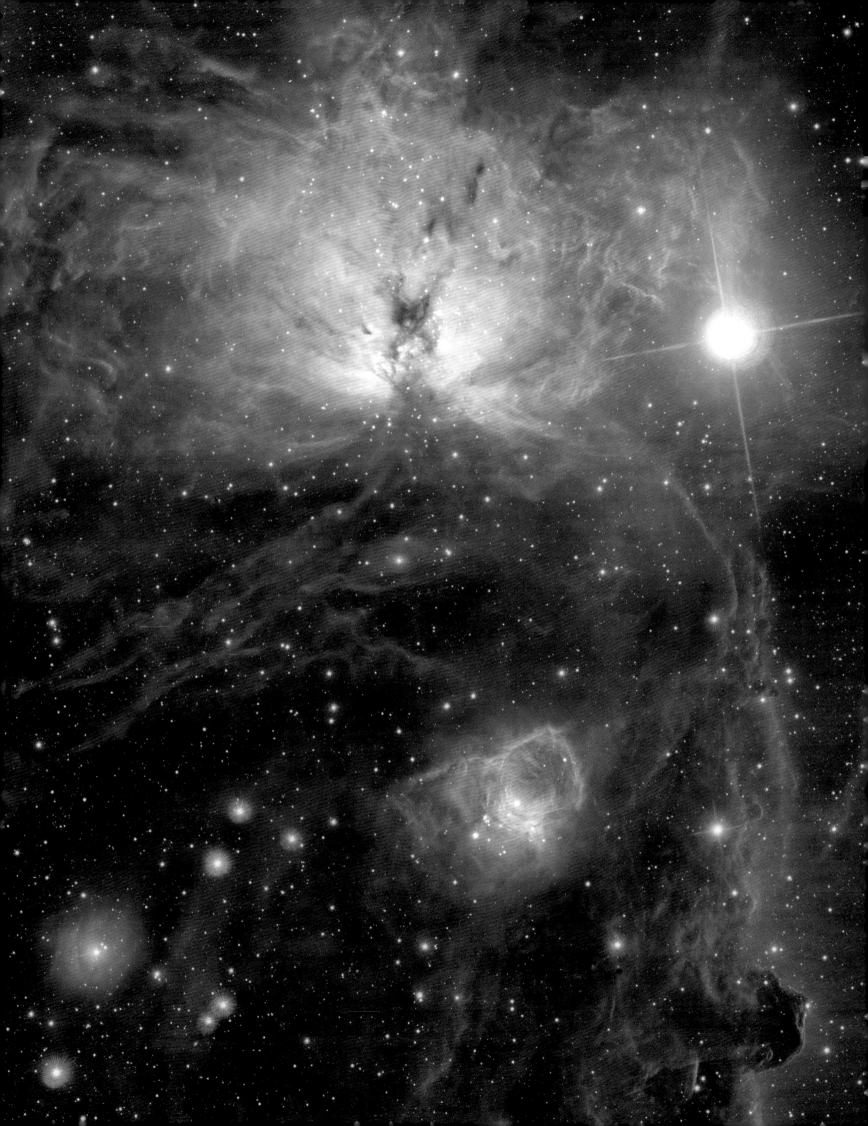

The Flame and Horsehead Nebulae

The mighty constellation of Orion (THe Hunter) is situated on the boundary between the southern and northern hemispheres on the sky's equator. It harbors an impressive molecular cloud with a complex of nebulosity that includes the Orion Nebula (p. 44), the Flame Nebula, and the Horsehead Nebula.

The picture on the left is a wide view of the eastern part of Orion's Belt, seen in the near-infrared wavelengths that can penetrate the cosmic dust, and combined with a visible-light image to provide context. The upper part of the image is dominated by the voluptuous Flame Nebula (NGC 2024), containing a hidden cluster of young stars not seen in visible light. Their radiation is scattered by the dust that surrounds them in a way that shows these stars to be the main energy source in the Flame Nebula.

The Flame Nebula is bright and has an unusual bifurcated dusty structure that is mostly opaque to visible-light telescopes. Infrared light penetrates the dusty veil to reveal the otherwise unseen structures inside the nebula. The rich star cluster behind the thick dark lane that divides the visible nebula consists of new stars all less than one million years old. Many of them seem to have circumstellar accretion disks, possibly the precursors of Earth-like planets. Recent work has identified a central massive star, either a late O-type or early B-type, as the sole ionizing source of the Flame Nebula.

In the better-known Orion Nebula, the young ionizing stars of the Trapezium in its center have relatively recently blown away the obscuring dust along our line of sight, which is why we see them. Behind the Trapezium, the strikingly bright nebula is opaque to visible light, but it also contains a cluster of young stars. It is tempting to speculate that the Flame Nebula is a smaller version of the Orion Nebula, but seen from the dusty side.

The brightest star here is Alnitak (zeta Orionis), a star easily visible to the naked eye as the eastern of the three Belt stars. It is 800 light-years away, in the foreground, and has no part to play in this dramatic scene.

The Flame and Horsehead Nebulae
The image shows the Flame Nebula (NGC 2024), a spectacular star-forming cloud of gas and dust in the familiar constellation of Orion and its surroundings. In visible light the core of the object is hidden behind thick clouds of dust, but in this image, taken at infrared wavelengths with ESO's VISTA survey telescope, which can penetrate the murk, the cluster of hot young stars hidden within is revealed. The wide field of view of the VISTA camera also captures the glow of NGC 2023 (below the middle) and the ghostly form of the famous Horsehead Nebula (lower right). The bright blue reflection nebula NGC 2023 is partly embedded in the molecular cloud and is itself associated with shreds of red nebulosity from complex organic molecules. In visible light the Horsehead Nebula is a dark nebula absorbing light, whereas in the infrared it glows slightly as the light absorbed at shorter wavelengths is re-emitted in the infrared.

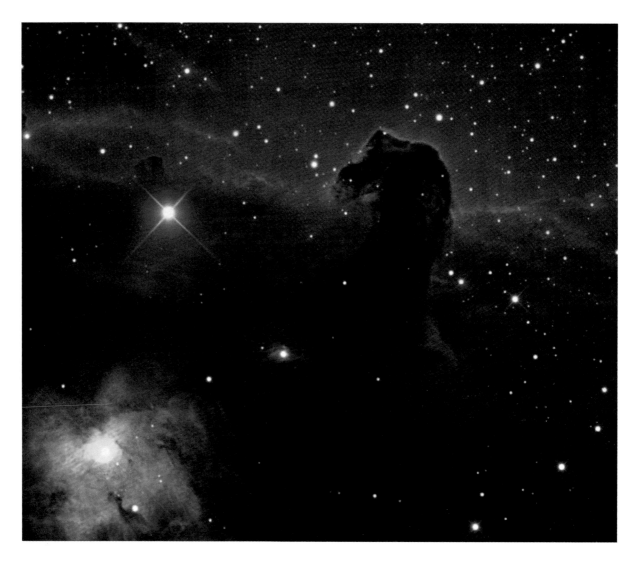

The Horsehead Nebula

A conventional, visible-light view of Orion's majestic Horsehead Nebula is seen here. The reason for the name of this object is obvious, and the horse's head is seen in silhouette against the red glow of the emission nebula IC 434. This is an edge of the Orion Molecular Cloud, excited by the hot, five-component star sigma Orionis, which, like the Horsehead itself, is 1200 light-years away (and to the west, off the top of this image).

Detailed View of the Horsehead Nebula

The Horsehead Nebula seen in its full glory with one of ESO's four 8.2-meter Very Large Telescopes. Minute grains of dust and the molecules of gas absorbed on their surfaces can exist in cold regions of interstellar space that are shielded from starlight by the dust itself. Astronomers refer to elongated structures, such as the Horsehead Nebula, as "elephant trunks" (never mind the zoological confusion), and these dark, edge-lit molecular clouds are common features on the boundaries of star-forming regions. They can also be seen elsewhere in this book, sometimes as Bok globules. Such structures are being constantly eroded by the expanding region of ionized gas and are destroyed on timescales of typically a few thousand years. The Horsehead Nebula is one of the most photographed celestial objects in the sky. The dark protrusion of the horsehead shape is known as Barnard 33, which is part of a molecular cloud known as Lynds 1630, and the bright rim is the edge of a strip of emission nebulosity known as IC 434.

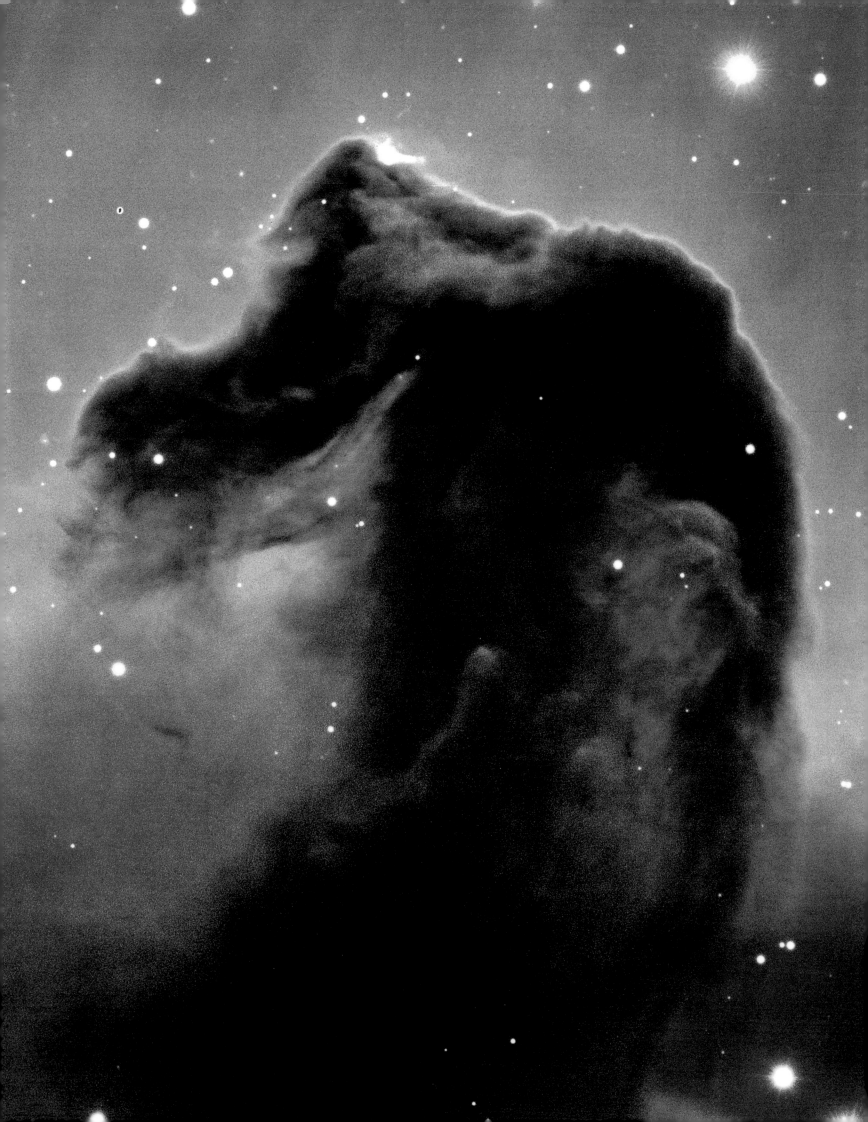

Messier 78

The bright nebula Messier 78, also known as NGC 2068, is almost exactly on the celestial equator, but precession has recently carried the nebula into the northern hemisphere, so it should, strictly speaking, not appear on these pages. Messier 78 is not actually moving across the sky — precession is the gradual shift of the Earth's axis of rotation that, when seen against the distant stars, shifts the astronomical reference frame.

Messier 78 is an example of a reflection nebula, since the ultraviolet radiation from the stars that illuminate it is not energetic enough to ionize the gas, which means that the nebula doesn't generate any light — its dust particles simply reflect what is already present. Despite mostly shining by reflected starlight, Messier 78 is one of the brightest reflection nebulae in the sky and can be seen well with a small telescope. It lies about 1600 light-years away in the constellation of Orion and can be found northeast of Alnitak, the most easterly star of Orion's Belt.

Messier 78 is embedded in a detached fragment of the Orion B Molecular Cloud called Lynds' Dark Nebula 630, the main part of which also includes the Horsehead Nebula and the Flame Nebula (p. 56), three degrees away to the southwest. LDN 1630 also embraces several other impressive nebulae in the same vicinity, including NGC 2064, which is to the upper left in the image.

The illuminating stars of Messier 78 are early B-type supergiants — very hot stars. Aside from the brighter luminaries, infrared studies have revealed about 45 low mass, young stars (less than 10 million years old) in which the cores are still too cool for hydrogen fusion to start. These stars, known as T Tauri stars, are hidden within the cloak of thick dust pervading the region. Some nascent stars in the Messier 78 region exhibit dramatic Herbig–Haro outflows — narrow, powerful jets of energy that produce small emission nebulae, seen as glowing red patches in the bottom right corner. These are indicators of young stars still in their formative stages.

Messier 78
This image is composed from exposures taken with the MPG/ESO 2.2-metre Telescope, using broadband blue (B), yellow-green (V) and red (Rc) filters, supplemented by exposures through a narrowband H-alpha filter that only passes the light from glowing ionized hydrogen.

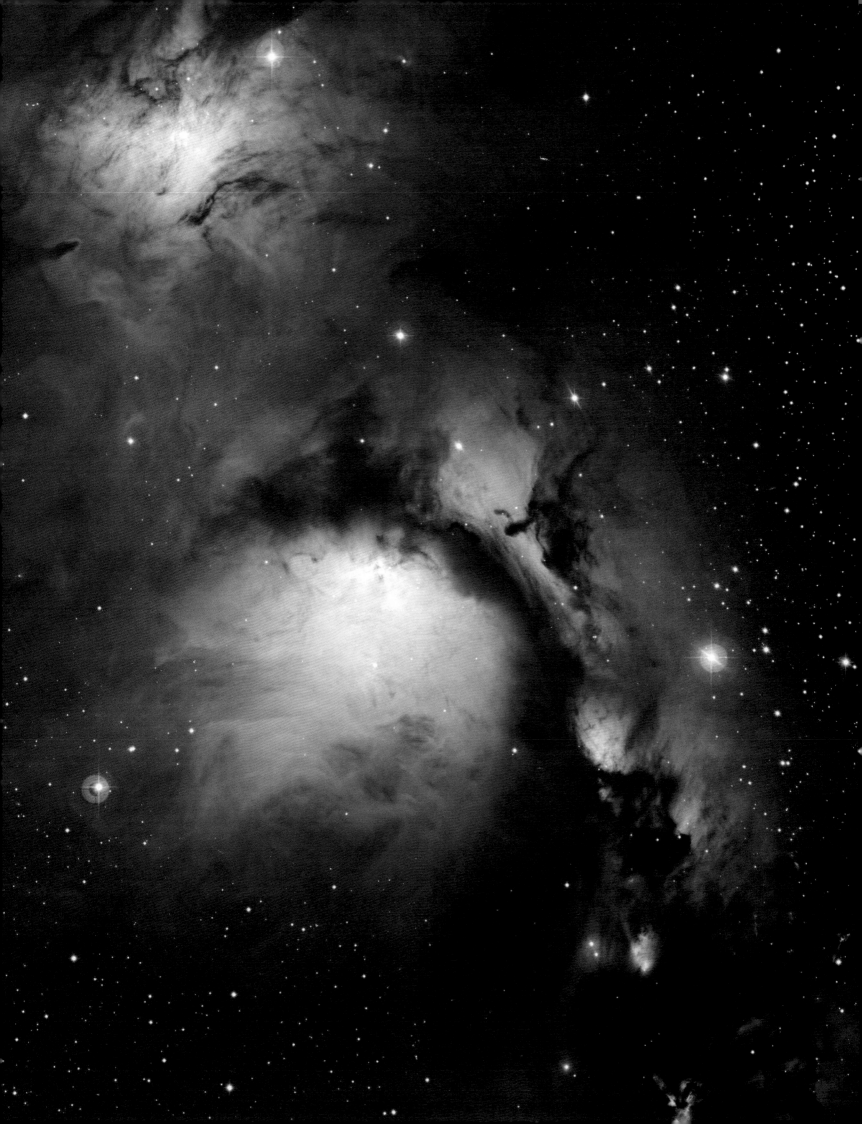

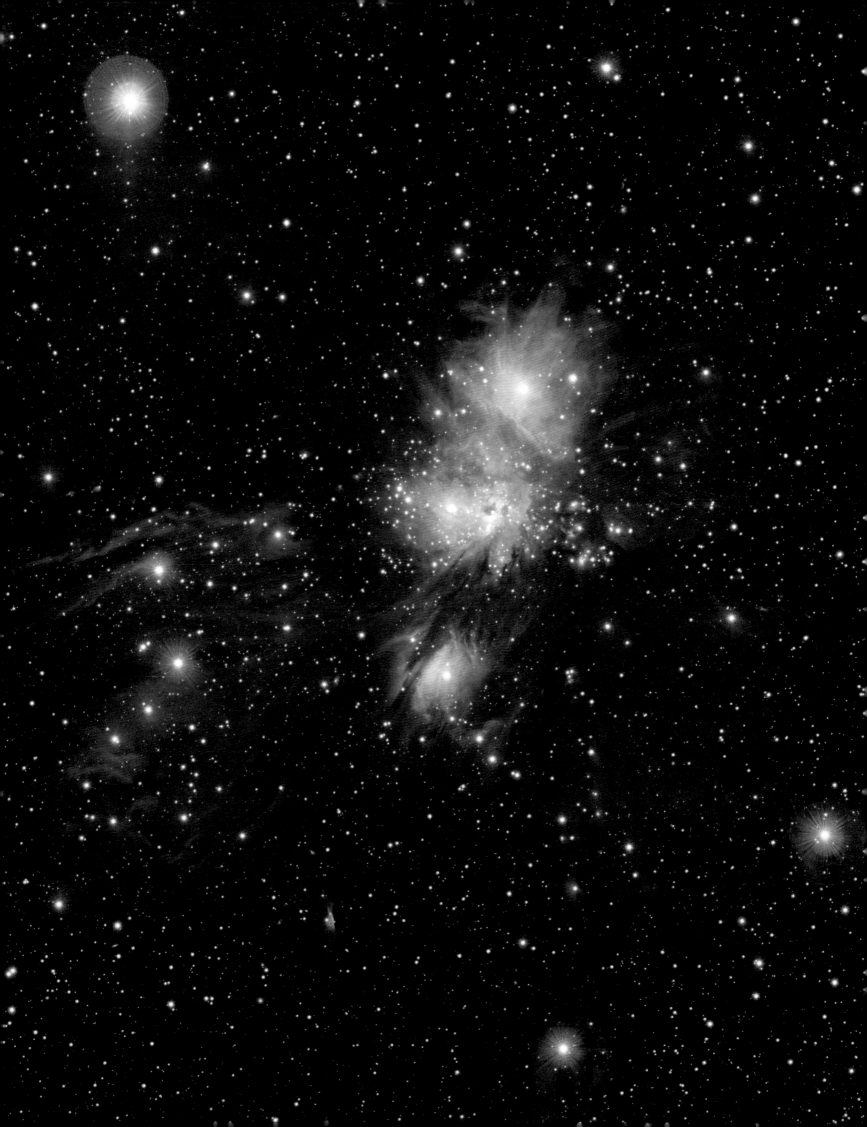

The Monoceros R2 Association

A rich tapestry of predominantly reflection and sparse emission nebulosity exists in the western part of a vast star-forming region known as the Monoceros R2 association, itself part of the Monoceros molecular cloud. Although it appears close in the sky to the more familiar Orion Nebula it is actually almost twice as far from Earth, at a distance of about 2700 light-years. It has been extensively studied, beginning with Sears and Hubble in the 1920s. In 1966, Sidney Van den Bergh (VdB) first identified this major clustering of nine reflection nebulae illuminated by an association of hot B-type stars. He named it R2 to indicate that it was the second association of reflection nebulae in the constellation of Monoceros (The Unicorn). Mon R1 includes NGC 2644, the Cone Nebula, far to the north. Van den Bergh was interested in the link between reflection and emission nebulae and the stars that illuminate them.

Most of the stars pictured here belong to the scattered Monoceros OB association and are type B stars. They are strewn along an east–west line stretching across two degrees of the southern summer sky, about eight degrees to the east of the Orion Nebula. The large reflection nebula lower left is called VdB 68 and the two smaller reflection nebulae NGC 2170 (center) and VdB 69 (center left).

Monoceros R2 seen in Visible Light

An active stellar nursery lies hidden inside a massive dark cloud rich in molecules and dust in the constellation of Monoceros. In visible light a grouping of massive hot stars creates a beautiful collection of reflection nebulae where the bluish starlight is scattered from parts of the dark and misty outer layers of the molecular cloud. However, most of the newborn massive stars remain hidden as the thick interstellar dust strongly absorbs their ultraviolet and visible light. NGC 2170 (center) is the brightest reflection nebula in this region. In visible light, the nebulae appear as bright, light blue islands in a dark ocean, while in the infrared, frenetic factories are revealed in their interiors where hundreds of massive stars are coming into existence.

Monoceros R2 seen in Infrared Light

This infrared image from ESO's VISTA survey telescope covers about the same part of the sky as the visible-light image, and reveals an extraordinary landscape of glowing tendrils of gas, dark clouds, and young stars within Monoceros R2, embedded within a huge, dark cloud. The region is almost completely obscured by interstellar dust when viewed in visible light, but becomes more transparent in the infrared. The image shows in astonishing detail the folds, loops, and filaments sculpted from the dusty interstellar matter by intense particle winds and the radiation emitted by hot young stars.

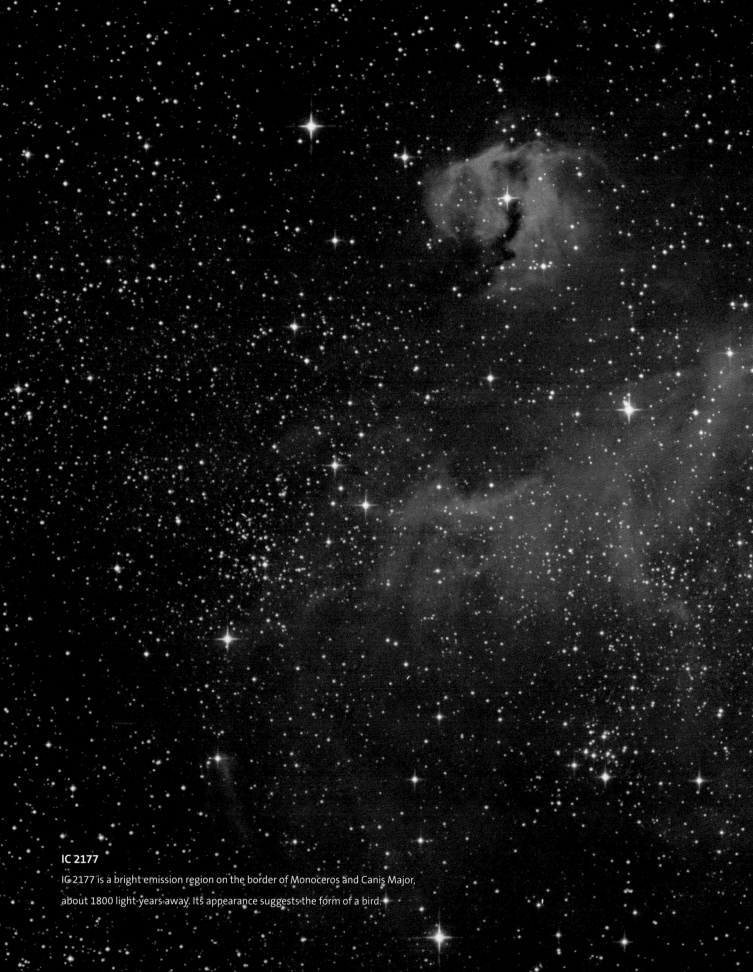

IC 2177

IC 2177 is a bright emission region on the border of Monoceros and Canis Major, about 1800 light-years away. Its appearance suggests the form of a bird.

IC 2177 and NGC 2327

IC 2177 is a bright emission region on the border of the constellations of Monoceros (The Unicorn) and Canis Major (The Great Dog), about 1800 light-years away. It's appearance suggests the form of a bird, its head emphasized by the sinuous dust lane running through it. The brightest part of the nebula, seen as the bird's head, is NGC 2327, visible to the eye through a telescope. The whole finely structured nebula consists of mostly emission with scattered blue reflection and dark dust clouds, especially obvious in NGC 2327, along with the star that excites the nebulosity. The exciting stars of the larger nebula belong to the Canis Major OB1 association. IC 2177 is about one million years old and has two embedded, but not obvious, open clusters NGC 2335 and NGC 2343. The two clusters are thought to represent a double cluster of common origin, similar to, but less impressive than the famous Double Cluster in Perseus in the northern sky.

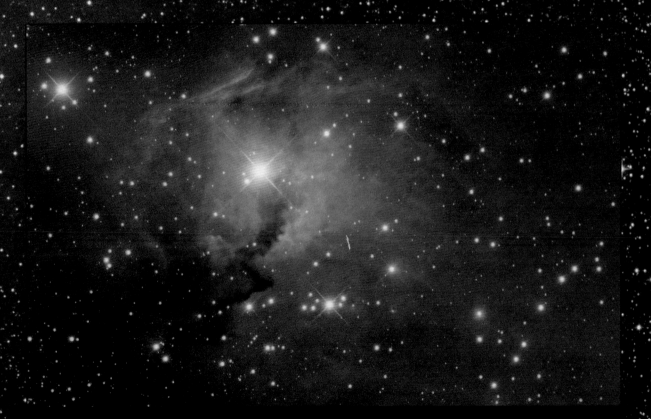

Close-up on NGC 2327

The brightest part of IC 2177, seen as the "head" of the bird, is a compact region of young stars, emission clouds, dust, and reflection nebulosity. The blue nebulosity is known as VdB 93. The object is visible through a modest telescope.

NGC 2359

NGC 2359 is a fine example of a wind-blown bubble whose delicate, luminous walls are expanded by energy from the massive and unstable Wolf–Rayet star HD 56925 near its center. This type of star is quite rare in the Milky Way, with only about 300 known stars of this type, which represent a late evolutionary phase of O-type blue giants that are of 25 solar masses or greater. When they become unstable they eject powerful stellar winds, with velocities up to 7 million kilometers per hour. This instability involves enormous mass-loss and is thus short-lived, which is why Wolf–Rayet stars are rare. These stars get their name from the French astronomers Georges A. Rayet (1839–1906) and Charles J. Wolf (1827–1918), who first reported their existence in 1867.

The violent stellar winds from Wolf–Rayet stars heavily influence the surrounding interstellar medium. The colorful nebula NGC 2359 (sometimes nicknamed Thor's Helmet) consists of two distinct components. The outer part is a U-shaped diffuse red HII region of illuminated gases ejected at an earlier time by the O-type progenitor of HD 56925, or possibly remnants of the molecular cloud from which it was born. The inner component is the central structured bubble, blown more recently by the winds of the Wolf–Rayet star itself as they interact with the relatively stationary interstellar medium.

NGC 2359

This helmet-shaped cosmic cloud with wing-like appendages is a challenging object for astrophotographers, combining highly detailed structures in the wind-blown bubble with faint, almost featureless reflection nebulosity. The nebula is located about 15,000 light-years away in the constellation of Canis Major.

CG 4

Cometary globules are isolated, relatively small, and faint clouds of gas and dust within the Milky Way, and many of them are found in the constellation of Puppis (The Poop, or Stern). These tiny molecular clouds are very faint and were first identified in 1976 on deep plates taken with the UK Schmidt Telescope in Australia. Their low surface brightness and large angular size make them particularly challenging subjects for color imaging. This example, CG 4, is about 1300 light-years distant, so the head is some 1.5 light-years in diameter, and the tail, which fades away off the picture, appears to be about 8 light-years long. The dusty cloud contains enough material to make several Sun-sized stars, so it is related to comets in name only.

The head of the nebula is itself opaque, but its outer surface glows because it is illuminated by light from very hot stars nearby, off the top of the image. The energy from the hot stars is gradually destroying the dusty head of the globule, shaping it, and sweeping away tiny dust particles as a faint, bluish reflection nebula. This particular globule also shows a faint red glow, probably from hydrogen released from the dust and excited by the same hot stars, and it seems to be about to devour an edge-on spiral galaxy, which is actually hundreds of millions of light-years away, far beyond CG 4.

CG 4

This image of CG 4 was created from three photographic exposures made with the Anglo-Australian Telescope.
The images on the glass plates were specially treated to bring out the faint detail and make a true-color image.

NGC 2442

This unusual barred spiral galaxy is about 50 million light-years away in the far southern constellation of Volans (The Flying Fish). It was discovered by John Herschel, who wrote, *"I think it has some sort of hooked appendage."* Not surprisingly, the galaxy is now sometimes nicknamed the Meathook Galaxy. Herschel's "hooked appendage" is a very bright curved ridge of star formation running along the northern arm of the galaxy, which is off the top of the picture here. The southern arm is much less obvious; the nucleus is displaced and the whole galaxy looks distorted.

Although not seen here, (but evident on deep, wide-angle images) NGC 2442 appears to have no fewer than seven, less massive companions within a radius of half a degree, all at a similar distance. The closest is about a quarter degree to the east, and it too is clearly distorted. It seems very likely that the two have had a close encounter in the recent past. This situation has been modeled, and the prediction is that NGC 2442 will have recovered its normal appearance in perhaps half a billion years, but a few billion years after that there will be another interaction and a final merger, with its closest companion galaxy.

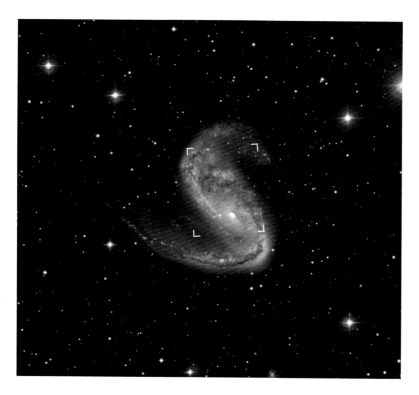

NGC 2442 Wide-Field View

The visible disk and distorted spiral arms of NGC 2442 span about 150,000 light-years. This view was provided by the MPG/ESO 2.2-metre Telescope. NGC 2442's "hooked appendage" is clearly seen.

NGC 2442 Close-Up

This Hubble mosaic shows the marvelous star-forming regions of NGC 2442 in all their glory, and reveals a tiny but very luminous nucleus, shrouded in a dusty torus. To the lower right of the nucleus is the hazy image of a distant edge-on spiral galaxy, seen through the foreground galaxy.

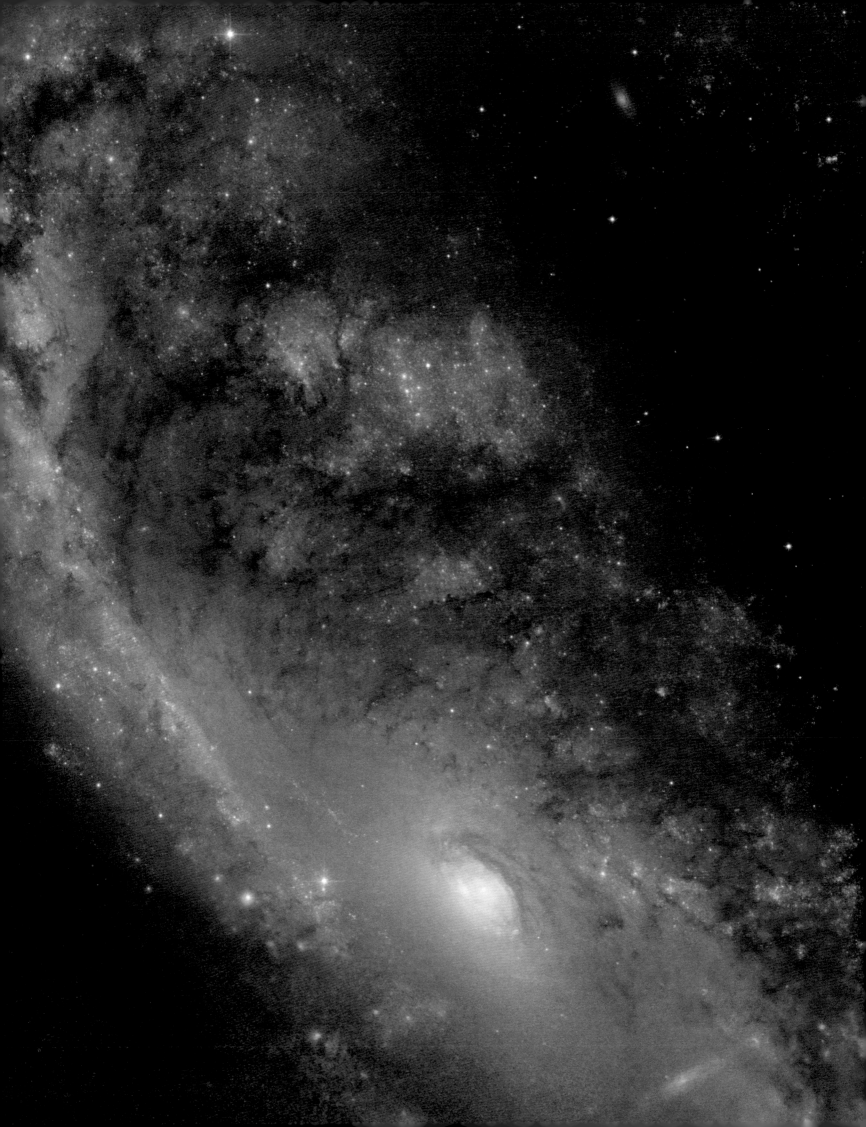

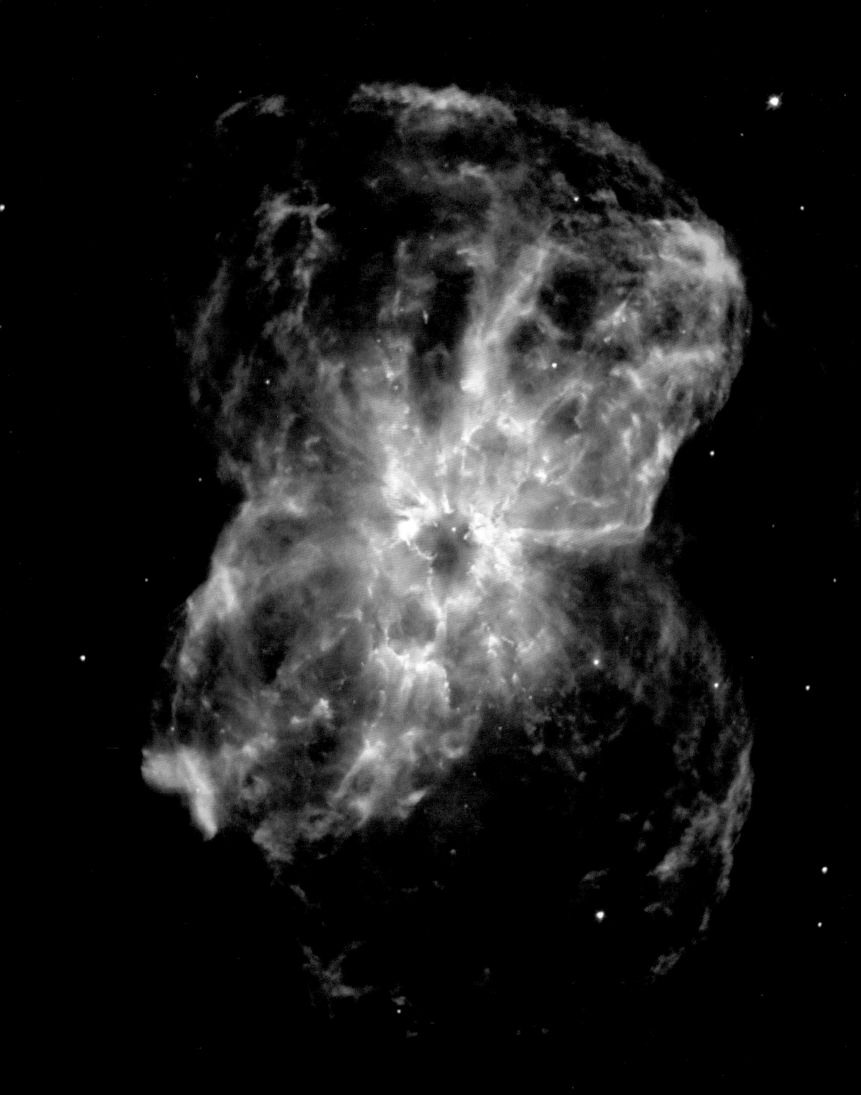

NGC 2440

The visible light that we capture from a planetary nebula is almost always the light from ionized elements, usually the lighter elements that occur in the ejected outer envelope of the precursor star. This fluorescent matter is better described as a plasma (an extremely hot, ionized gas) and is very tenuous, resulting in a rich emission-line spectrum, usually dominated by hydrogen, oxygen, and nitrogen. Because some planetary nebulae are bright, this characteristic spectrum was recognized early in the history of spectroscopy, and distinguishes planetary nebulae from planets, which have the continuum spectrum of reflected sunlight, like a rainbow.

In a planetary nebula, it is the central star that provides the energy to light up the gas. The central star of NGC 2440 is HD 62166, one of the hottest known white dwarf stars, with a surface temperature of 200,000 degrees Celsius and a luminosity 1000 times that of the Sun. The star can be seen in the central cavity of the nebula. Most of its radiation is in the far ultraviolet part of the spectrum, which is why it appears faint here.

The bow-tie-shaped nebula it has shed was molded as it left the surface of the dying star, probably in chaotic stages, but influenced by the rotation of the original star and the interstellar medium around it. Seen from a different direction, NGC 2440 may appear as a torus or a thick ring of light, as in the Helix Nebula (p. 168). Planetary nebulae are common, and the permutations are endless.

NGC 2440

This image of the demise of a Sun-like star was made from data taken by the Hubble Space Telescope. It consists of exposures made in broadband blue and green light, with contributions from narrowband exposures made in the light of helium, oxygen, hydrogen, and nitrogen.

NGC 2467

Only a few million years old, this scattering of young stars in the southern constellation of Puppis is a typical nursery of star formation in the Milky Way. However, its position in our galaxy is unusual. Firstly, it is located very close to the plane of our galaxy. No surprise in that, since that is where star formation is most active. But the distance of NGC 2467, around 13,000 light-years, is quite unexpected. This is twice the distance of the Carina Nebula (p. 84), itself quite remote.

Usually our view through the plane of the Milky Way is blocked by intervening dust, but we can see this far in the direction of Puppis because we are looking along the outer edge of one of the Milky Way's spiral arms, possibly the Orion arm or perhaps the Perseus arm, where it curves away from us. This tangential view, known as the Puppis Window, is unusually free from dust, except for the molecular cloud that hosts NGC 2467. That we are uncertain just which arm is involved reveals how little we know of our own galaxy's detailed structure.

The brightest stars seen here are responsible for creating a cavity lined with glowing gas and pierced by dusty fingers, and it is possible that the Orion Nebula (p. 44) may one day look like this at a later stage in its evolution.

Close-up on NGC 2467

The picture shows a small part of NGC 2467 and was made with data from the Hubble Space Telescope. It is a representative color image. Looking like a roiling cauldron of some exotic cosmic brew, huge clouds of gas and dust are sprinkled with bright blue, hot young stars. Strangely shaped dust clouds, resembling spilled liquids, are silhouetted against a colorful background of glowing hydrogen gas.

NGC 2467

With an age of a few million years at most, NGC 2467 is a very active stellar nursery, where new stars are born continuously from large clouds of dust and gas. The image contains the loose open clusters Haffner 18 (center) and Haffner 19 (middle right, inside the smaller pink region), as well as vast areas of ionized gas. The image was made with the MPG/ESO 2.2-metre Telescope with both broad- and narrowband filters, which accounts for the unusual colors.

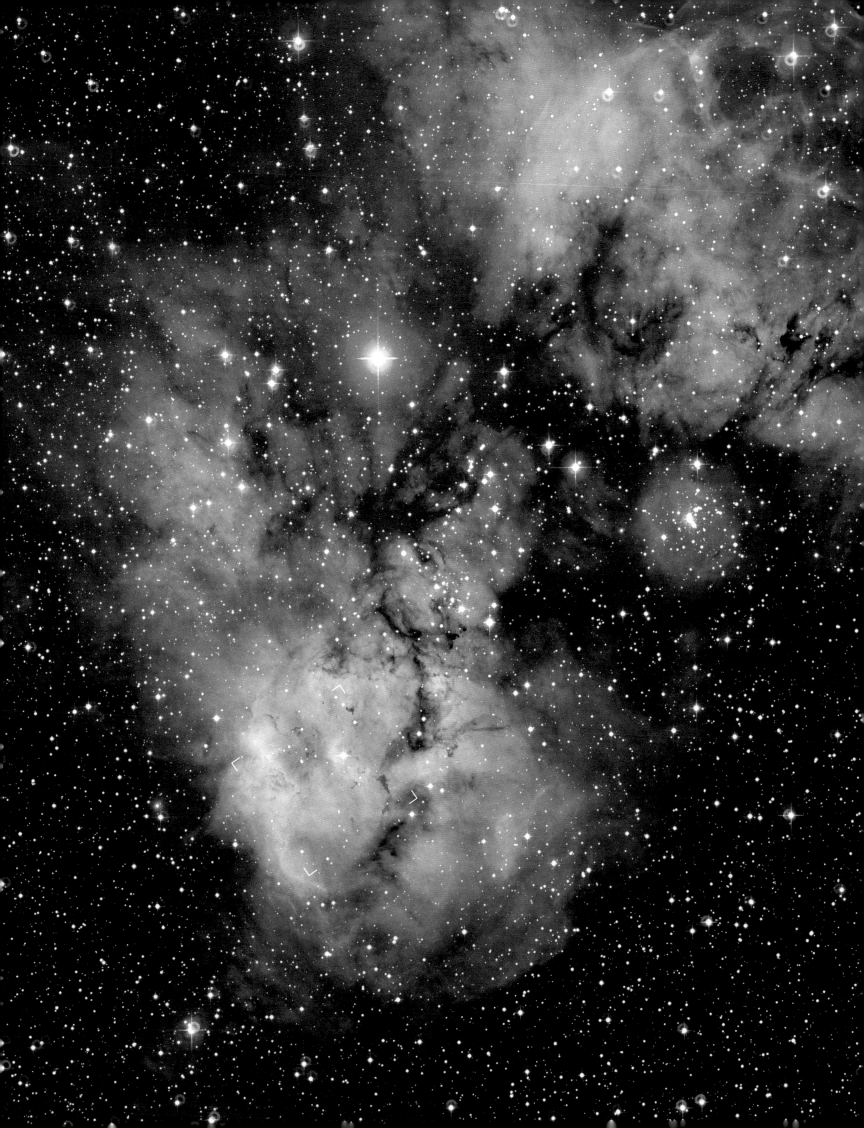

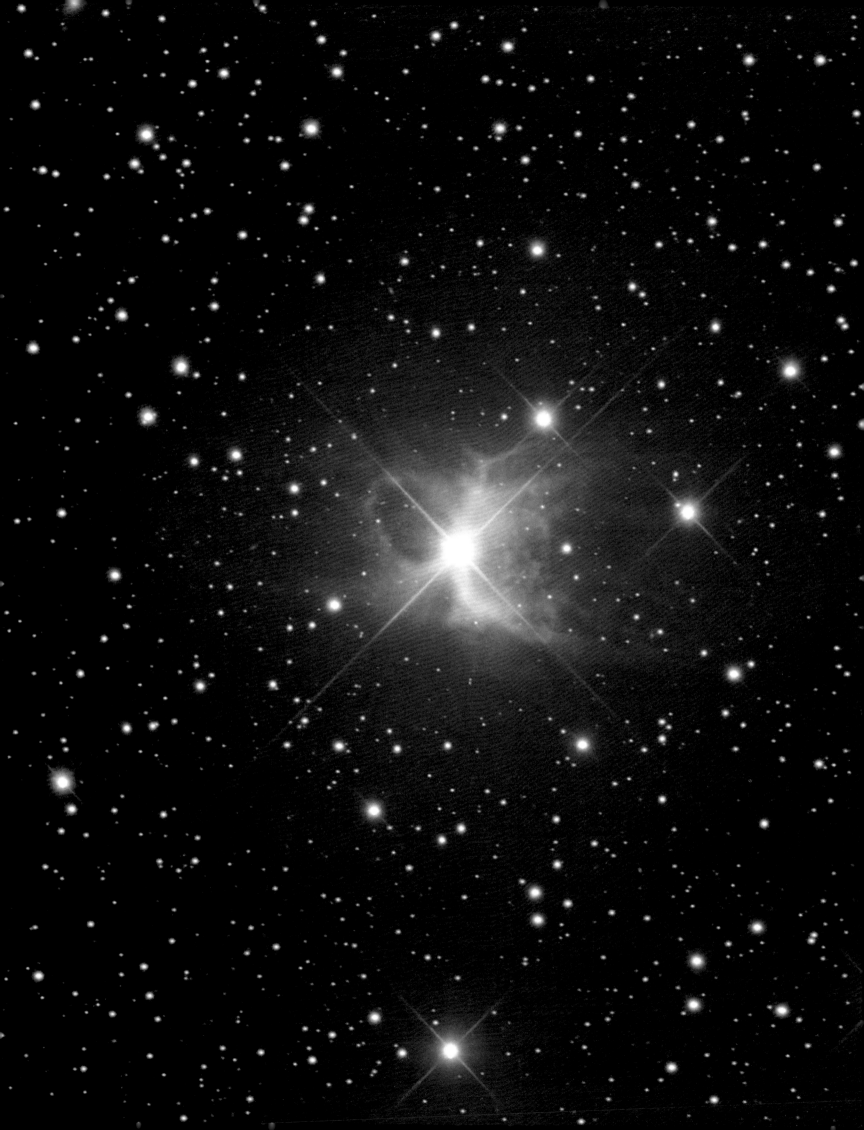

The Toby Jug Nebula

IC 2220 is an unusual structured reflection nebula formed as a result of substantial mass loss from the red giant star HD 65750. This is one of the few reflection nebulae associated with red giant stars — another is Antares in the constellation of Scorpius (The Scorpion). Such stars are losing significant amounts of their mass as their surfaces expand and cool. This allows elements such as carbon and simple, heat-resistant compounds such as titanium dioxide and calcium oxide (lime) to condense as fine dust in the outer atmosphere of the star. In this case, infrared spectra point to silicon dioxide (silica) being the most likely compound reflecting the star's yellow light.

The bipolar structure of the nebula is probably the result of the outflow patterns on the surface of the star, which has a temperature of about 3200 degrees Celsius, roughly the same temperature as the filament in a domestic tungsten filament lamp. As can be seen in the image, the dust itself is quite tenuous. It has a mass of about one percent that of the Sun and much of it was produced in an earlier phase of intense mass loss during the giant phase of this evolving star. British astronomers Paul Murdin, David Allen and David Malin coined the name Toby Jug Nebula for the object because of its shape, which is similar to an old English drinking vessel of a type called a Toby Jug with which they were familiar as youths.

The Toby Jug Nebula

This image shows IC 2220, or the Toby Jug Nebula, an unusual reflection nebula.

This is one of the few reflection nebulae associated with red giant stars.

Vela Supernova Remnant

About 120 centuries ago, a massive star exploded in the southern constellation of Vela (The Sails). It was only 800 light-years away and would have been a spectacular — and probably terrifying — sight to southern hemisphere sky-watchers. When we look towards Vela today we see faint, tangled filaments, the western (lower) side of which hints at a larger, spherical shape. Unobscured, the sphere would be 8 degrees across, or 100 light-years wide at the distance of the supernova, so the ancient explosion continues to affect a huge volume of space.

The picture is very complicated in Vela because there is a younger supernova remnant hidden in the foreground and another, more distant, in the adjoining constellation of Puppis (The Stern). What we see of the Vela supernova at visible wavelengths is the thin and wrinkled shell of the supernova shock wave, interacting with the tenuous interstellar medium and otherwise invisible gas clouds, causing them to glow. We only see the shell when it is edge-on, so we can look through most of the supernova remnant without seeing it at all. Some of the interstellar medium is already glowing, as is the large, but faint, Gum Nebula that occupies the left-hand side of the image.

Finally, towards the center of the Vela supernova remnant, is the Vela pulsar, the diminutive remains of a giant star that exploded. It is a neutron star, an object with a mass greater than that of the Sun, a diameter of about 20 kilometers, and it is spinning 11 times a second. This tiny object until recently was among the faintest stars ever studied at optical wavelengths, a far cry from its brief glory as one of the brightest stars ever seen.

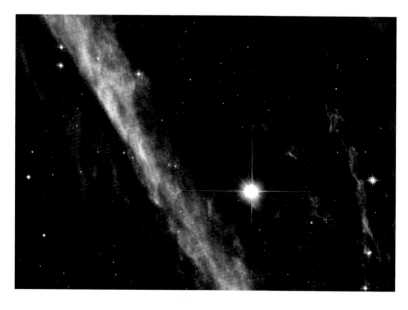

Hubble View of the Pencil Nebula

This Hubble image shows the eastern edge of the undulating shock-front of the Vela supernova remnant, much of which is obscured. This view is less than a light-year across and shows the Pencil Nebula, or NGC 2736, a large, wispy filamentary structure that is a tiny part of the Vela supernova remnant.

Wide-field View of the Vela Supernova Remnant

This image is a wide-field view of the Vela supernova remnant and is a mosaic composed of 30 individual images with a total 60 hours of exposure time. The wide field picture includes several other, unrelated nebulae surrounding the numerous very hot stars in the direction of Vela.

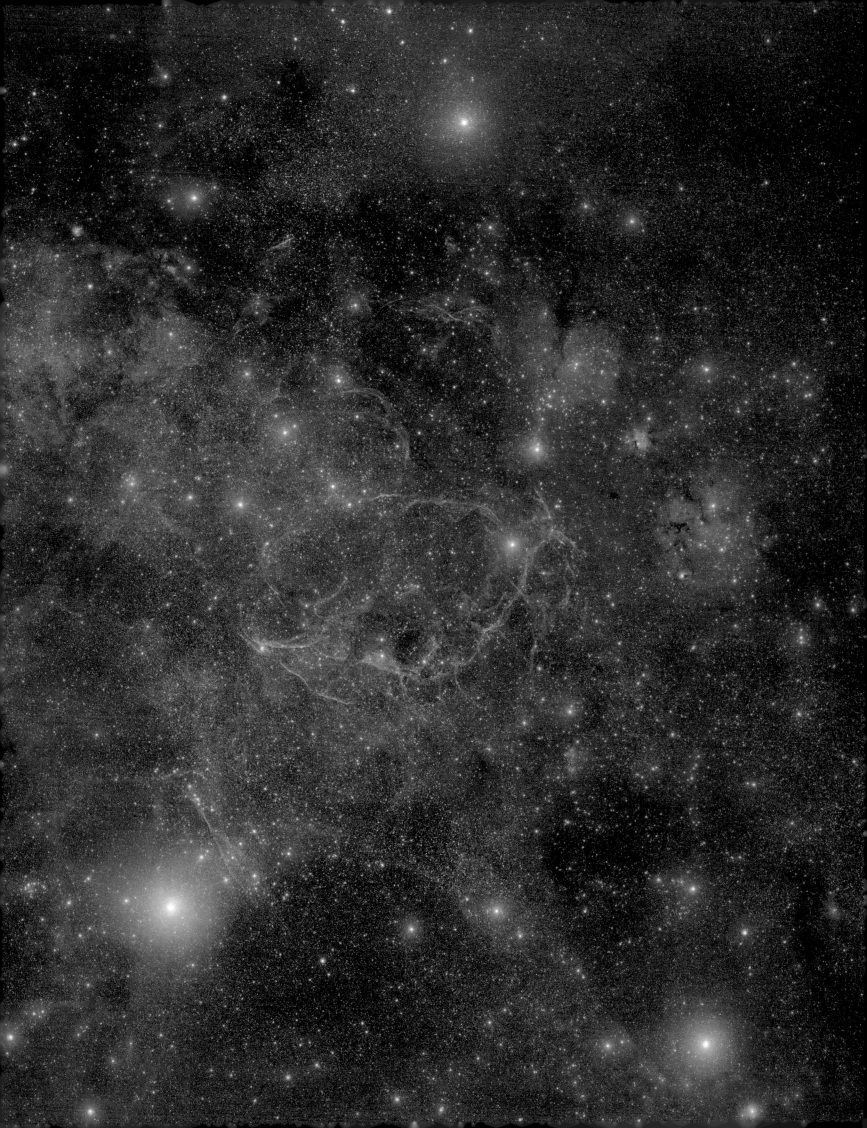

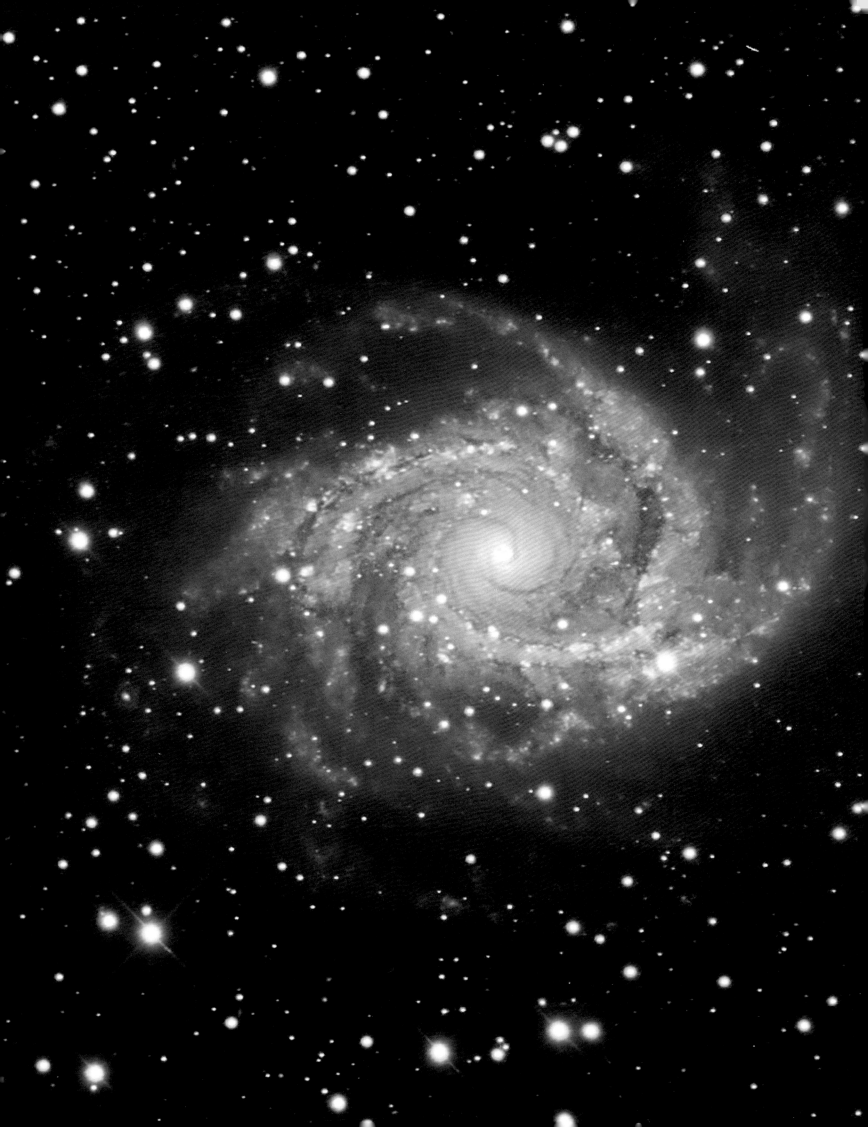

NGC 2997

About 40 million light-years away in the direction of the constellation of Antlia (The Air Pump), NGC 2997 is a grand-design spiral inclined some 45 degrees from our line of sight. It is one of the finest galaxies in the southern sky, and if it could be seen face-on it would appear as a circular disk, rather like Messier 83. The galaxy has two prominent spiral arms that appear to originate in the dust lanes that emerge from the haze of ancient yellow stars in the central parts of the galaxy. The outer arms are peppered with bright red clouds of ionized hydrogen, which are similar to regions of star formation in the Milky Way. The hot blue stars that generate most of the light in the arms of the galaxy are created in these gas clouds.

Grand-design Spiral Galaxy NGC 2997

NGC 2997 in the constellation of Antlia. This spiral galaxy has beautiful arms with prominent dust lanes. The image was acquired remotely using a 15-inch telescope in Australia and is the result of many exposures, totaling 14 hours.

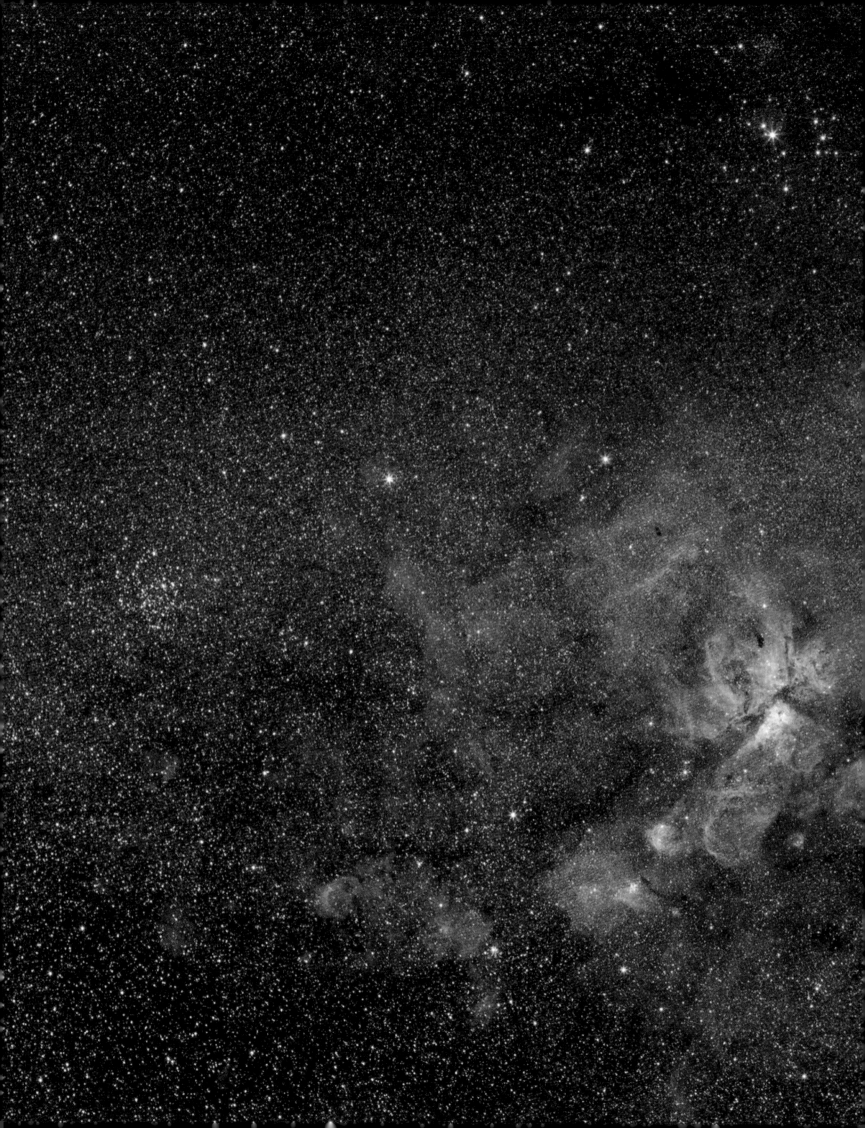

The Southern Fall

10.00 to 16.00 Hours Right Ascension

The Southern Fall

The southern fall is the season of Centaurus, bordered to its south by the iconic Southern Cross the dark hole of the Coalsack and the nearest stars. Its north border forms part of vast constellation of Hydra, which in turn joins the southern part of Virgo and Antlia, rich in galaxies. As fall deepens into winter, Antares begins to dominate the late evening sky, and our own Milky Way makes its presence known. A small telescope captured this panoramic view of the southern autumn sky. The Carina–Sagittarius arm of the Milky Way is home to many legendary objects such as the Carina Nebula, but also an assortment of other bright star-forming regions and young star clusters.

Panoramic View of the Central Part of the Carina Nebula

This spectacular panoramic view shows the central part of the Carina Nebula, which includes the exotic star Eta Carinae, the well-known Keyhole Nebula, and a multitude of dust globules and young star clusters. The composite picture was created from image data recorded by professional and amateur telescopes located in Australia and Chile.

Carina Nebula

The Carina Nebula (NGC 3372) is one of the largest and brightest nebulae in the sky, and we see it from a distance of 7500 light-years. It extends for some 260 light-years across the southern Milky Way and is clearly visible to the unaided eye, but is less famous than the much smaller and closer Orion Nebula. In part this is because NGC 3372 is in the far southern sky, while the Orion Nebula is on the celestial equator, framed by a memorable collection of stars and visible from all parts of the globe.

The nebula in the constellation of Carina (The Keel) was discovered by the Abbé Nicolas de Lacaille in 1751 from the Cape of Good Hope. With more powerful telescopes it is seen to be quite unlike the Orion Nebula and rich in an astonishing variety of smaller structures such as the Keyhole Nebula, the Homunculus Nebula, and numerous bright rimmed and dark globules, dust pillars, and open star clusters.

The Keyhole Nebula is a smaller, darker cloud with an outer rim of brightly glowing filaments some seven light-years in diameter. The shape of the Keyhole is sculpted by an outburst from the enigmatic, erratically variable, hypergiant star, Eta Carinae. Its unusual form is silhouetted against the brighter parent nebula, creating its namesake configuration. The Keyhole was named by the English astronomer Sir John Herschel in the 19th century, when Eta was one of the brightest stars in the sky and the keyhole shape was fully illuminated. Now Eta Carinae hovers on the verge of naked-eye visibility, and the Keyhole is much less well delineated.

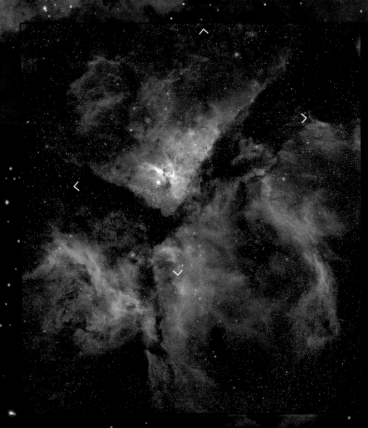

The Carina Nebula in a Different Light

This image provides a different way of looking at the Carina Nebula. Like the larger picture on this page, it was made in visible light, using a ground-based telescope, but in this case the light was captured through narrowband filters. These emphasize discrete wavelengths that carry the spectral signatures of the glowing gases and mostly reject the white light of the stars, which seem almost absent here. Three different filters trace the blue-green emission from oxygen (shown in blue), the red emission from hydrogen (shown in green), and the red emission from sulfur (shown in red). This color scheme reveals the complex chemistry and physics of the nebula and is also representative of the temperature in the ionized gas: blue is relatively hot and red is cooler.

The vast Carina Nebula contains over a dozen stars with masses between 50 to 100 times that of the Sun, and these are the main source of illumination of the nebula itself. However, by far the most exotic star here is Eta Carinae. It is shrouded in a tiny nebula — the expanding, dumbbell-shaped Homunculus — that was blasted off the star in the 1830s and 40s, which is why it appeared so bright to Herschel. The nebula has cooled into dust and become almost opaque to visible light, but it is one of the strongest Galactic infrared sources in the sky, despite its distance. Without this dusty envelope we would see Eta Carinae shining with the light of five million Suns and emitting as much energy in six seconds as does the Sun in a year!

Such an output implies a very massive young star, perhaps 150 times the mass of the Sun and a few million years old, but recent observations of its variable brightness suggest that it is a binary system, with a period of about 5.5 years. Eta Carinae is still an oddity and of abiding interest to astronomers, partly because it is expected to end as a great supernova in the near future. This may even have already happened, and if it has, we will know within the next 7500 years, when the light reaches us. Although a supernova event in Carina would produce a daytime star, it would not affect our planet. The story would be different if Eta Carinae had been born in the Orion Nebula.

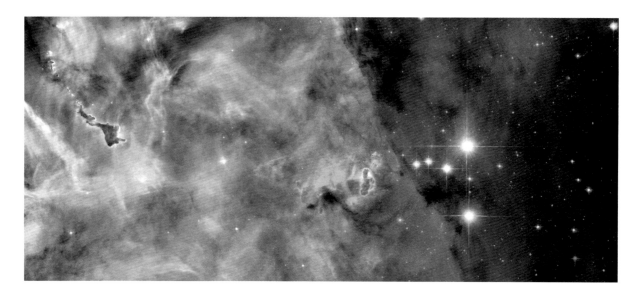

Region of WR 25 and Trumpler 16

Trumpler 16 is one of several similar star clusters associated with the Carina Nebula. All of these star clusters are extremely young and contain some very hot stars, a few of which appear on the right side of this image. The bright yellow star is in the foreground and has no part to play in the action here, but the others emit powerful stellar winds that erode nearby dusty globules. One of these, seen at the left of the picture, seems to raise a defiant finger in the face of this energetic onslaught, but resistance is futile.

Star Birth in the Extreme

The region abounds in dense clouds of dust — molecular clouds — that survive relatively briefly, exposed to the intense bombardment of ultraviolet radiation from the bright stars around them. It is within such clouds that new stars form, and there is the subtle evidence of it here, in the delicate jets of material shot out of the dark clouds. These are the signatures of stars settling down to a steady state, in the final stages of accreting material from the molecular cloud. Soon, the dust will be dispersed by the steady erosion of the surrounding stars, revealing the youngest of them, in all their glory.

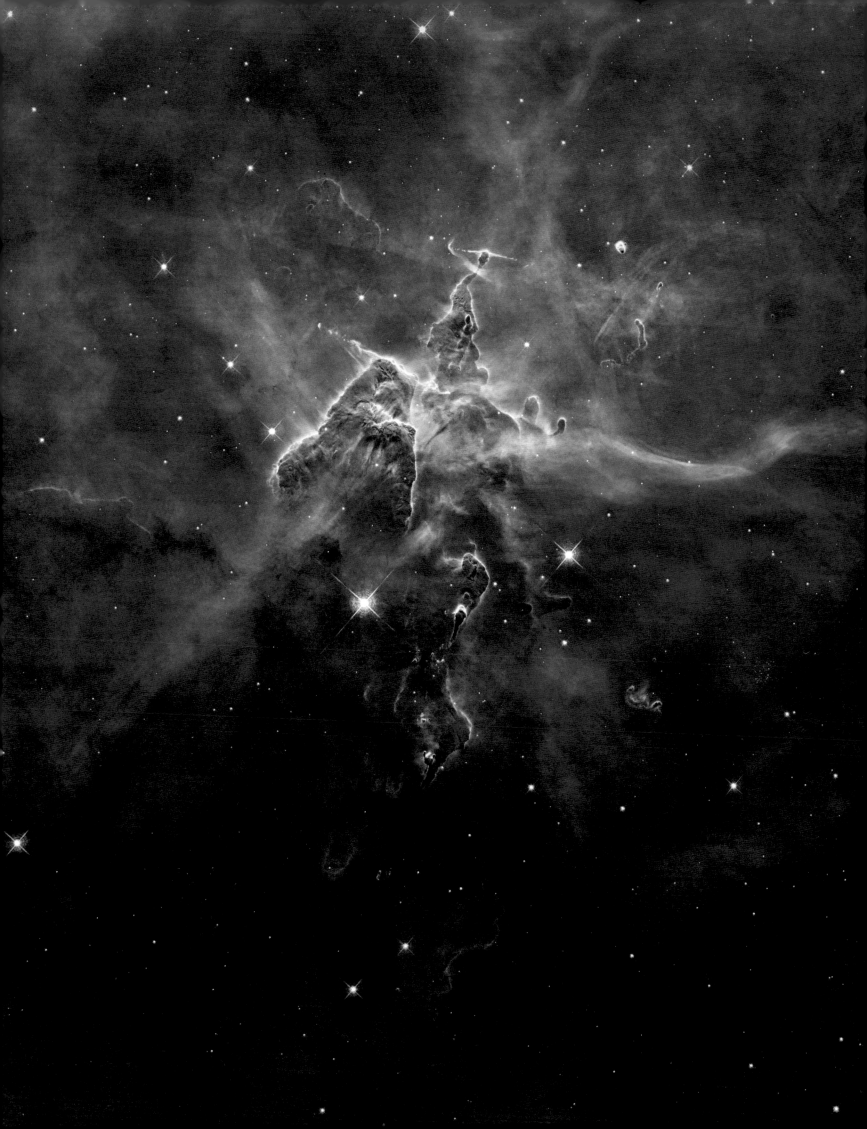

NGC 3293

This beautiful open cluster is in the constellation of Carina, a little northwest of the great Carina Nebula (see p. 84), and has many characteristics in common with the Jewel Box Cluster (NGC 4755, see p. 104), including a single red giant star, which is in striking contrast to the multitude of brilliant blue stars. The cluster was discovered by the Abbé de Lacaille during his visit to South Africa in 1751–2. It is 8500 light-years away, and the component stars are all very young. The cluster is rather more compact than the Jewel Box Cluster, and there are traces of blue reflection nebulosity associated with the brighter stars and the red emission nebula surrounding part of the cluster, which are both indications of youth.

Open clusters such as NGC 3293 are excellent laboratories for studying the late stages of star formation and their early evolution. The young stars have not moved far from their birthplace, so it is certain that they are all at the same distance. This allows a detailed comparison to be made of the individual stars, which reveals that they are not all the same age, but seem have been born in the last four to ten million years. A total of about one hundred stars have been identified as belonging to the cluster, most of them much fainter than the sky-blue (i.e., very hot) B stars. There are no O-type stars in this cluster (or in NGC 4755). These stars are even hotter than B stars and more massive, and are only found in the youngest clusters, such as that in Messier 16 (p. 148).

NGC 3293
NGC 3293 is an open cluster that seems connected with NGC 3324 in the Carina Nebula (see p. 84). Remnants of nebulous material are visible in the image.

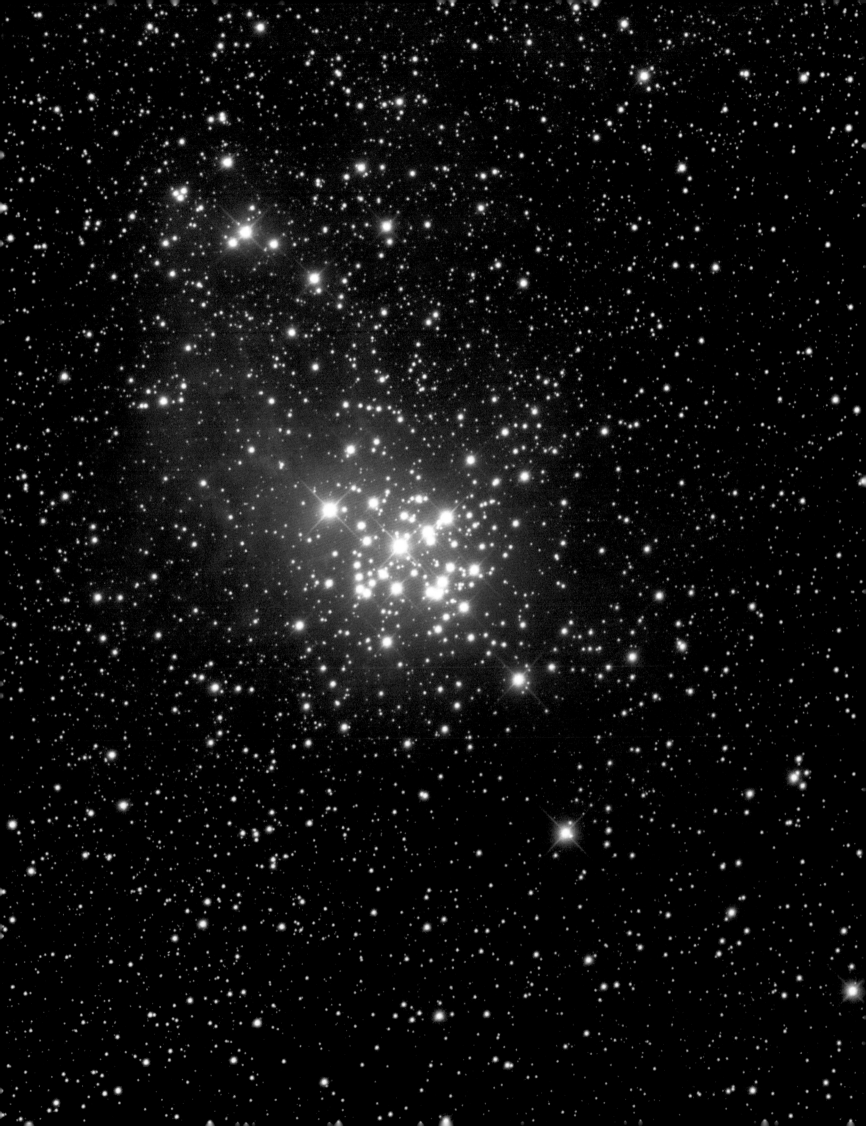

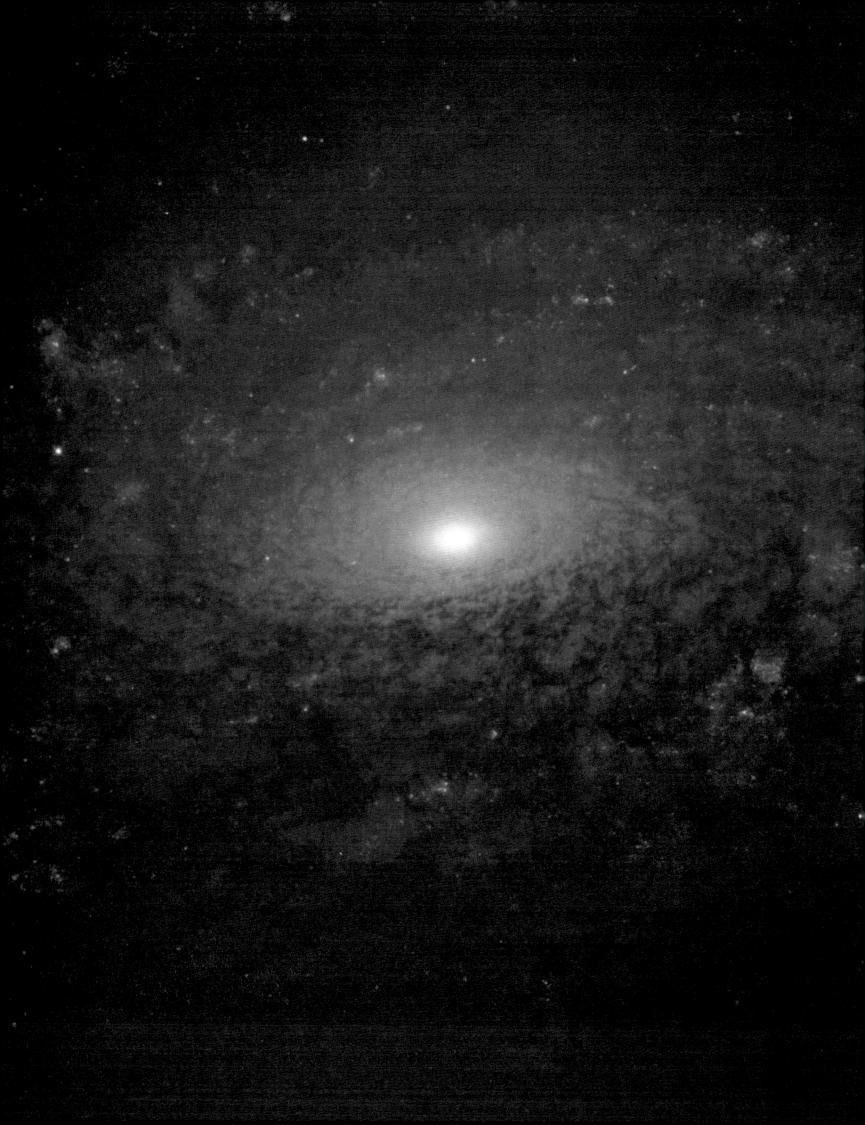

NGC 3521

NGC 3521 is a galaxy highly inclined to the line of sight and is about 25 million light-years distant, on the celestial equator in Leo. This orientation on the sky shows it to be extremely dusty, with few obvious star-forming regions, and it emphasizes the very bright nucleus. NGC 3521 is superficially similar to Messier 63 and belongs to the class of compact bright galaxies recognized as lacking a well-defined spiral arm structure. Such galaxies have an appearance that is as remote from the "grand design" paradigm as it is possible to be and still be a spiral galaxy. They are known as flocculent galaxies because they have patchy spiral arms that are fragmented and loosely organized. "Fluffy" would be the obvious word to describe their appearance on photographs, but that is not normally part of the scientific lexicon.

Many spiral galaxies have flocculent spiral arms to some extent, and other well-known flocculent spirals in the southern hemisphere are NGC 6744 (p. 160) and NGC 7793, (p. 172) with Messier 33 in the northern sky. The Milky Way is also in this category. NGC 3521 also has at least one other anomaly, a rotation curve that falls with increasing distance from the nucleus, suggesting that any dark matter is concentrated towards the center of the luminous disk. Deep photographs show it to have an extensive, faint, and asymmetrical halo, strongly suggestive of a recent merger.

NGC 3521 Close-up

This close-up view of NGC 3521 highlights this galaxy's characteristic, patchy, irregular spiral arms laced with dust and clusters of young, blue stars. NGC 3521 is easily visible in small telescopes, but often overlooked by amateur imagers in favor of the better-known Leo spiral galaxies Messier 65 and Messier 66.

NGC 3576 and NGC 3603

NGC 3603 (left) and NGC 3576 (right) are two of the most luminous star-forming regions in our galaxy, but their juxtaposition is really an illusion. The objects are physically unrelated; NGC 3603 is 20,000 light-years away, about twice as distant as NGC 3576. Although they appear side by side, NGC 3603 is in the Carina arm of our galaxy while NGC 3576 resides in the much closer Sagittarius arm. In true-color images, NGC 3603 (below) has a distinctly redder hue than the closer NGC 3576, due to the selective absorption of blue light by the intervening dust.

Despite their different appearances there are some similarities, as both are undergoing a high rate of star formation. NGC 3603, a giant star-forming region, is an extraordinary object. It is likely the most massive visible emission region in our galaxy, extending at least 1000 light-years across and containing the overall mass of 10,000 suns. NGC 3576 contains several embedded clusters and scattered small dark nebulae known as Bok Globules, seen in silhouette against the emission nebula. The bright emission component extends some 100 light-years across.

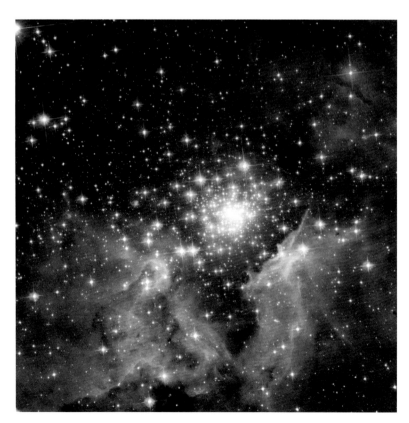

Close-up on NGC 3603

The compact open cluster NGC 3603 is seen here with the Hubble Space Telescope in close to its natural colors. It is one of the most impressive massive young star clusters in the Milky Way. Bathed in gas and dust, the cluster formed in a huge rush of star formation thought to have occurred around a million years ago. The hot blue stars at the core are responsible for carving out a huge cavity in the gas around it.

NGC 3576 and NGC 3603 Overview

This image shows a large field that contains both of the star-forming regions NGC 3603 (left) and NGC 3576 (right). It was taken through narrowband filters that let through only the monochromatic light from particular atomic transitions. This reduces the amount of light from the stars and gives a crisp view of the nebulosity.

NGC 3621

NGC 3621 is a member of the Leo spur of galaxies and is an isolated spiral, relatively neglected compared to other famous denizens of Hydra (The Water Snake) such as Messier 83.

This galaxy has a flat pancake shape, indicating that it hasn't recently come face to face with another galaxy, as such a galactic collision would have disturbed the thin disk of stars, creating a small bulge in its center. Most astronomers think that galaxies grow by merging with other galaxies, in a process called hierarchical galaxy formation. Over time, this should create large bulges in the centers of spirals. Recent research, however, has suggested that bulgeless, or purely disk-like spiral galaxies such as NGC 3621 are fairly common.

The galaxy has loose spiral arms almost 100,000 light-years across. This is seen to be even bigger on deep images. The galaxy also has an unusually small, bright nucleus that does not seem to have any significant bulge of older stars that are common in spiral galaxies. The nucleus was recently shown by the Chandra X-ray Observatory to contain X-ray sources consistent with the presence of a black hole. This galaxy provides one of the best examples of a spiral galaxy that has both an active central black hole and nuclear star clusters, and it shows that central black holes can occur in disk galaxies even in the absence of a significant bulge.

In the late 1990s, NGC 3621 was studied extensively using the Hubble Space Telescope as part of an enormous project to determine the extragalactic distance scale. NGC 3621 contributed 69 Cepheid variable stars to the project, establishing its distance as 20 million light-years.

NGC 3621

The bright galaxy NGC 3621, as seen here, appears to be a fine example of a classical spiral. But it is in fact rather unusual: it does not have a central bulge and is therefore described as a pure disk galaxy.

IC 2944

IC 2944 is a large, very faint star-forming cloud of glowing hydrogen emission in the southern constellation of Centaurus. It sits in a rich part of the southern Milky Way between Crux and Eta Carinae. The nebula is mostly featureless, with an unusually smooth texture in normal broadband visible-light images, but when imaged through narrowband filters and composited into an image using appropriate colors, it can have an almost transcendent, delicate beauty. The smooth texture is punctuated by stark, dark clouds of dust, their crisp outlines sharpened by the radiation from a small cluster of stars, dominated by lambda Centauri. The dusty gas globules are known as Thackeray's Globules after the astronomer who first described them in 1950. They are the same kind of objects as Bok Globules, first described by Bart Bok in 1947. Bok Globules are small dark clouds of gas and dust that are seen against the bright background of emission regions and typically have a mass of about 10 to 50 solar masses.

Close-up on Thackeray's Globules

A more detailed Hubble view of the center of IC 2944 shows Thackeray's Globules as strangely glowing dark clouds floating serenely in a sea of nebulosity. The astronomer A. D. Thackeray first spied the globules in IC 2944 in 1950. Globules like these have been known since the Dutch–American astronomer Bart Bok first drew attention to such objects in 1947. The largest of the globules in this image is, in reality, two separate clouds that appear to gently overlap along our line of sight. Each is about 1.4 light-years across and contains enough mass to make a dozen stars like the Sun.

IC 2944 in Centaurus

IC 2944 is a star-forming region of gas and dust that is illuminated and heated by a loose cluster of stars much hotter and more massive that the Sun. This narrowband image clearly shows the ridges and cavities carved out by the intense radiation from these very luminous stars.

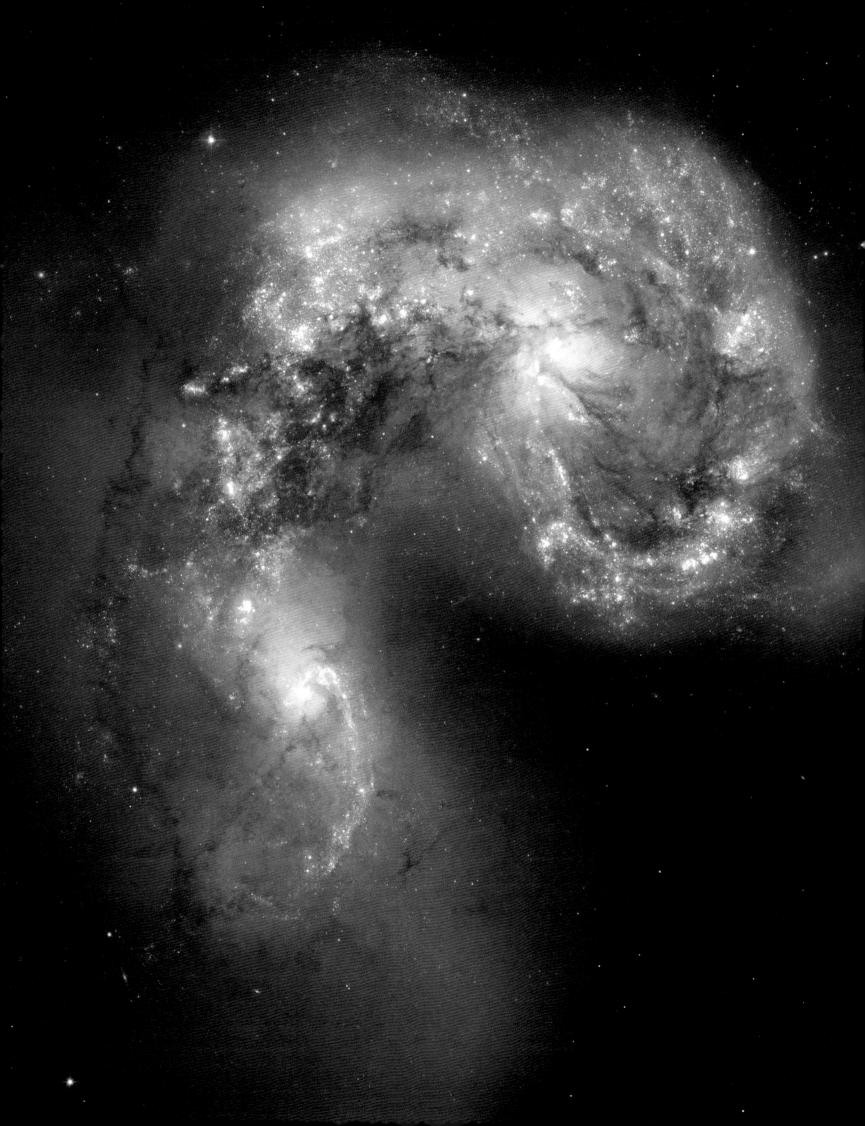

The Antennae Galaxies

The average distance between galaxies is typically 20 times their diameter, and galaxies are attractive, gravitationally speaking, so collisions and mergers occur often, and more often where massive galaxies are involved. These events happen over hundreds of millions of years and vast distances. However, while galaxies frequently collide, the stars within them mostly do not, but they can be dramatically displaced, sometimes with velocities that send them into the intergalactic void.

The Antennae Galaxies (NGC 4038 and NGC 4039) are among the most magnificent examples of a pair of interacting galaxies. The galaxy to the right in the picture was a gas- and dust-rich spiral that has encountered another spiral with much less gas. The two yellow nuclei are still identifiable, while all around is chaos. Although stars generally do not collide, dusty gas certainly does, and there is an enormous gathering of it in the brown "bridge" between the two seriously distorted participants. The whole scene seethes with star formation on a scale unknown in normal galaxies. However, the significant feature of the Antennae are the antennae themselves, seen further out in the image below. These are delicate, curved streams of stars, displaced by the enormous gravitational forces at work when galaxies meet. Despite the displacement, stellar evolution continues undisturbed, and in 2007, a rare Type 1 supernova appeared towards the end of the southern arm (wide-field image below). These supernovae are "standard candles" from which galaxy distances can be estimated.

The interaction between the two galaxies began about 300 million years ago and will likely be resolved a billion years after they first met. Galactic interactions and mergers have long been recognized as playing a central role in galactic evolution, and most of the massive galaxies in the Universe, including the Milky Way, are the assorted wreckage of countless mergers.

Wide View of the Antennae Galaxies

The Antennae galaxies take their name from the long antenna-like arms extending far out from the nuclei of the two galaxies, like some giant insect. These tidal tails were formed during the initial encounter of the galaxies some 300 million years ago. They hint at what may happen when the Milky Way collides with the neighboring Andromeda Galaxy in several billion years.

Close-up on the Antennae Galaxies

The Universe is an all-action arena for some of the largest, most slowly evolving dramas known to humankind. This Hubble picture shows a sharp view of the center of the Antennae Galaxies. Apparently a violent clash between a pair of once isolated galaxies, this dramatic event has turned into a fertile union. As the two galaxies interact, billions of stars are born, mostly in groups and clusters of stars. The brightest and most compact of these are called super star clusters.

The Sombrero Galaxy

The Sombrero Galaxy (Messier 104) is a very luminous, unusual, and visually striking galaxy with a mass equivalent to 800 billion Suns. Its most distinctive feature is the dust lane that divides the galaxy in two and reveals it as a highly inclined spiral system, seen a few degrees above the plane of the dust lane and from a distance of about 30 million light-years. This dark feature gives it its popular name, the Sombrero, an allusion to a type of broad-brimmed Mexican hat, 50,000 light-years across.

Infrared images, which selectively detect the modest heat radiation from the dust, show it to be concentrated in a disk on the outskirts of the galaxy, rather than throughout the disk, as in most spirals. This probably reflects the influence of the central supermassive black hole. Messier 104 is one of a growing list of galaxies known to possess a black hole at its heart, and it is thought that most massive galaxies have one, strongly influencing the structure and evolution of spiral galaxies. The black hole in Messier 104 has a mass of about a billion times that of the Sun.

M104 has a rich population of globular clusters, with many of the brightest easily visible in the image. Some estimates say it may contain some 2000 globular clusters, ten times as many as orbit the Milky Way.

The Sombrero Galaxy
The Sombrero Galaxy is notable for its dominant nuclear bulge, composed primarily of mature stars, and its nearly edge-on disk made up of stars, gas, and intricately structured dust. The complexity of this dust is most apparent directly in front of the bright nucleus, but is also very evident as dark lanes throughout the disk. A significant fraction of the galaxy disk is even visible on the far side of the source, despite its massive bulge.

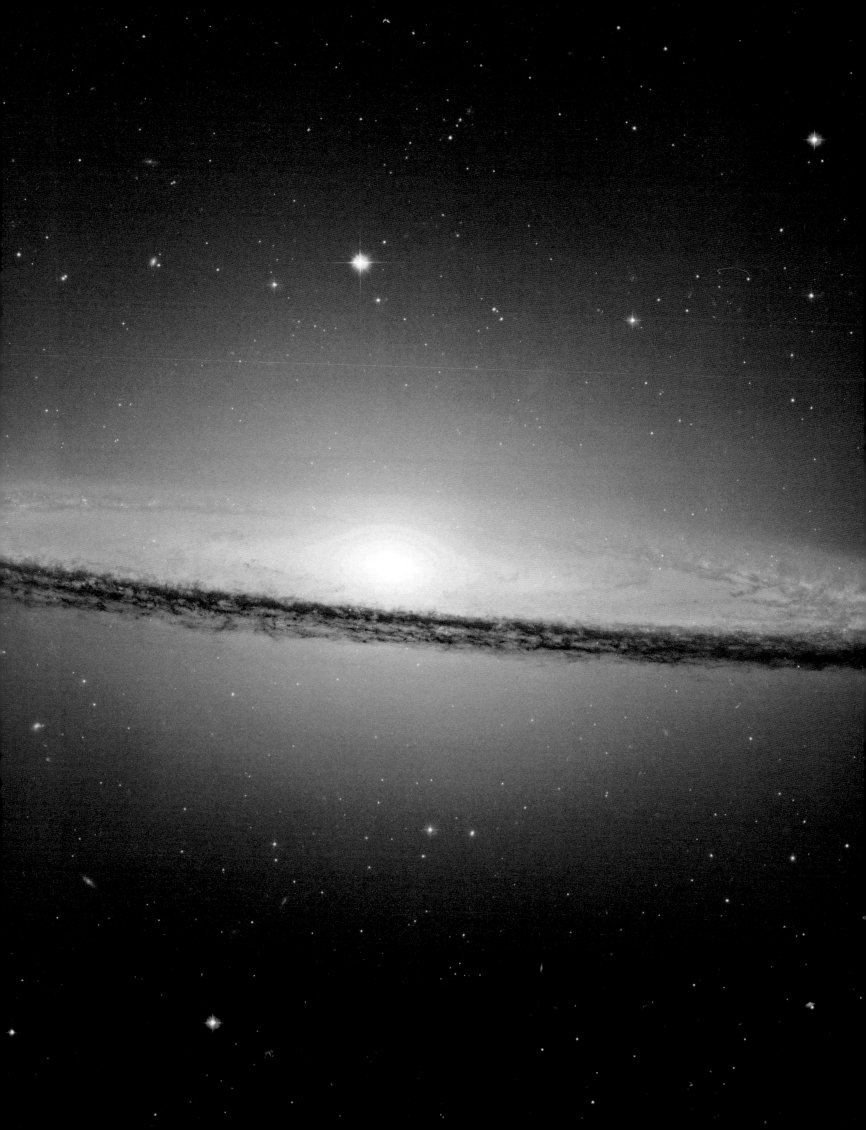

The Coalsack

Crux, perhaps better known as the Southern Cross, is the smallest constellation in the sky, yet one of the most distinctive, at least to those who live south of the Tropic of Cancer. From those latitudes, in the early evening between April and July it stands proud on the southern horizon. From the Tropic of Capricorn, 23 degrees south of the equator, it is visible at some time of night throughout the year. This distinctive asterism appears on the national flags of many southern hemisphere nations, including Australia, Brazil, New Zealand, Papua New Guinea, and Samoa. The long axis of the Southern Cross points towards the south celestial pole, so the cross itself acts as a very convenient circumpolar clock, compass, and calendar.

Alongside the Southern Cross is a very distinctive dark shape known as the Coalsack, a foreground dust cloud that obscures a patch of the Milky Way. This, and the sixth magnitude star embedded in it, is used by southern hemisphere astronomers as an indicator of a truly dark sky.

The first European to comment on this remarkable object was probably the Spanish navigator and explorer Vincente Yanez Pinzon when he sailed to the South American coast in 1499. The Coalsack was nicknamed the Black Magellanic Cloud in the 16th century, apparently rivaling the prominence of the Large and Small Magellanic Clouds, the two dwarf irregular galaxies that also ornament the skies of the southern semisphere. The Incas tell that the god Ataguchu, in a fit of temper, kicked the Milky Way and a fragment flew off, forming the Small Magellanic Cloud where it landed on the sky and leaving the black mark of the Coalsack behind. The Coalsack also has a prominent place in Australian Aboriginal stories, sometimes seen as the head of an emu, whose neck and body is represent by the prominent dark shapes in the Milky Way's bulge.

The Coalsack
The Coalsack is located approximately 600 light-years away from Earth and is one of the most prominent dark nebulae visible to the unaided eye. Dust grains in the cloud absorb almost all of the light of the background Milky Way and what little light does penetrate the less dense edge of the cloud is heavily reddened by the absorption and scattering of blue light.

The Jewel Box

Star clusters are among the most visually alluring and astrophysically fascinating objects in the sky. The Jewel Box Cluster (NGC 4755) is certainly one of the southern hemisphere's showpieces. It is easily visible to the unaided eye as an unresolved "star" close to beta Crucis, the most easterly star of the Southern Cross. NGC 4755 is popularly known as the Jewel Box, based on John Herschel's comment in the 1830s that it looked like a superb piece of costume jewelry. Herschel was commenting on the colors of the stars that he could see, but in reality there are only two colors visible here, the sky blue of the hottest stars and the orange-yellow of the coolest. This range of colors is typical of a very young cluster, and NGC 4755 is less than 10 million years old. Herschel's eye was caught by the dozen or so brightest stars, which, with one exception, are all B-type stars, with surface temperatures of 20,000 to 30,000 degrees C.

The conspicuous bright star that is not a blue hot giant is kappa Crucis, an orange-yellow "red giant" with an effective temperature of 3800 degrees C. Kappa Crucis is the most massive and most evolved of the stars, having used up most of its hydrogen. As it enters its short helium-burning phase, it will expand dramatically and cool, before vanishing as a supernova. The rest of the hottest stars will also explode, in order of their mass, until only the faint, low mass stars remain, in about 500 million years.

Despite their different temperatures and colors, these stars are all related. Open clusters typically contain anything from a few to thousands of stars that are loosely bound together by gravity. Because the stars all formed together from the same cloud of gas and dust their ages and chemical make-up are similar, which makes them ideal laboratories for studying how stars evolve.

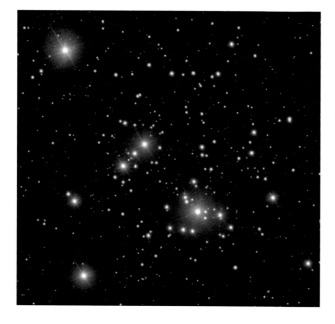

The Jewel Box Seen with the Very Large Telescope
The brightness of the Jewel Box Cluster is demonstrated by the short exposure time necessary when imaging this cluster with ESO's 8.2-meter Very Large Telescope — a little over five seconds!

The Jewel Box
The Jewel Box Cluster of stars is beautiful in binoculars and splendid in a modest telescope. It is about 6400 light-years away and is no more than 10 million years old.

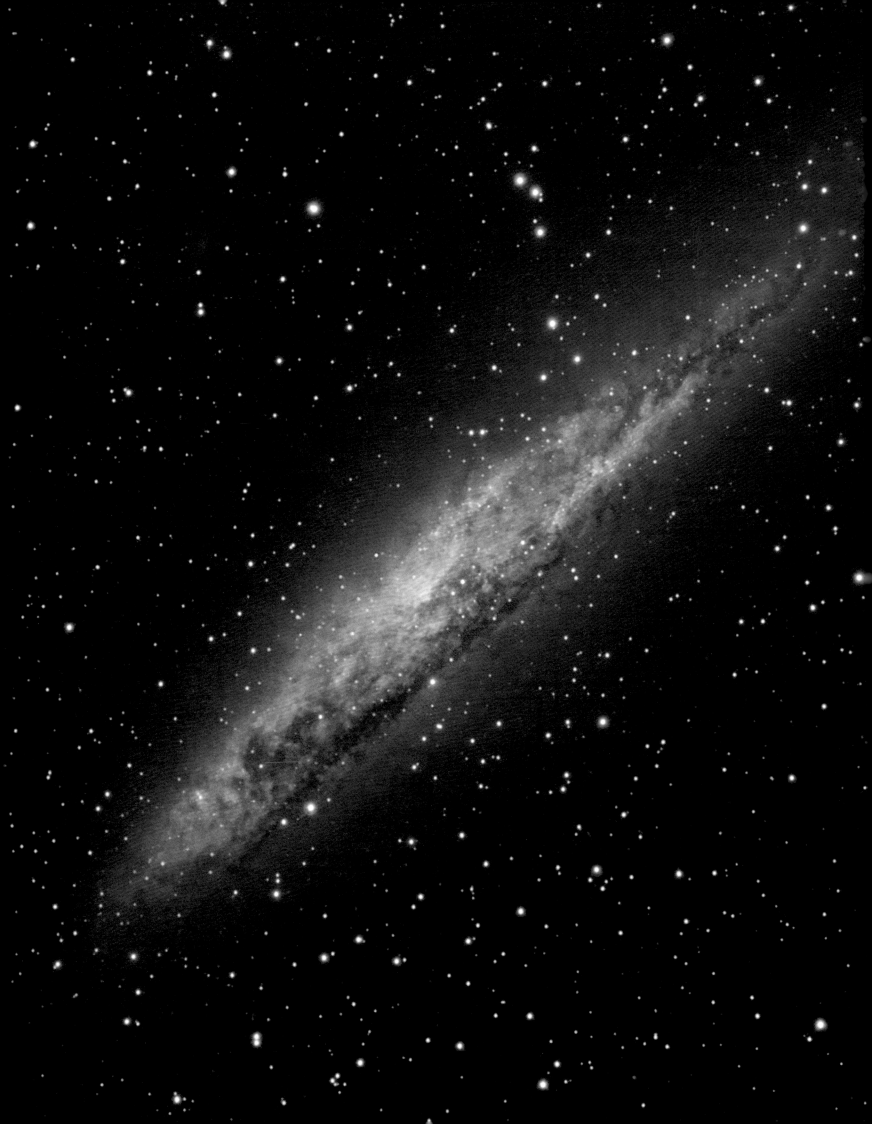

NGC 4945

NGC 4945 is a prominent, nearby, edge-on galaxy whose optical appearance is dominated by dust, which is unusually thick and patchy. It obscures all evidence of spiral arms and hides the nucleus. In addition, there is a substantial amount of dust along the line of sight, adding significantly to the muddy hue and contributing to the relative faintness of NGC 4945 in the telescope. The galaxy is about 13 million light-years distant and is part of the Centaurus group, which also contains other famous galaxies such as Centaurus A (NGC 5128, p. 108) and Messier 83, in the adjoining constellation of Hydrus (p. 114). Like NGC 5128, NGC 4945 was a James Dunlop (1826) discovery. In a wider context, NGC 4945 is one of three nearby but unrelated starburst galaxies, which include NGC 253 and Messier 82 in the northern sky. Starburst galaxies are characterized by high infrared luminosities, a sign of the immense energy released from their young massive stars, which is trapped by its dust and then radiated as heat.

Like the Milky Way, NGC 4945 hides a supermassive black hole behind the thick, ring-shaped structure of dust visible in the picture. But, unlike the black hole at the center of our Milky Way, that inside NGC 4945 is an active galactic nucleus that weighs in at a million solar masses and is vigorously consuming any surrounding matter and so releasing tremendous amounts of energy.

NGC 4945 is also known for the first water maser discovered in a galactic nucleus; it was detected at radio wavelengths within three light-years of the nucleus of NGC 4945. Maser is the acronym for *microwave amplification by stimulated emission of radiation* and signals the presence of molecular species (in this case water molecules) spiraling into the black hole.

NGC 4945

The chaotic, yet captivating, form of this near edge-on galaxy, shaped by powerful forces deep within its nucleus, was captured in this image by professional and amateur telescopes located in Australia and Chile. This remarkable galaxy is visible to southern stargazers through a modest telescope.

Centaurus A

At 13 million light-years, Centaurus A (NGC 5128) is the nearest large elliptical galaxy, but it is a far from typical example in almost every way. This giant radio galaxy is the second strongest extragalactic radio source, and the origin of two huge radio lobes covering 12 degrees of the southern sky. It is also a powerful source of X-rays and infrared radiation. In addition, a jet streams out from the supermassive black hole at its heart at half the speed of light, and a broad band of dust seems to divide the galaxy in two. The apparently smooth profile of the outer elliptical part on closer inspection reveals a series of delicate shells and loop-like structures (not seen here). The list goes on — this is no ordinary galaxy.

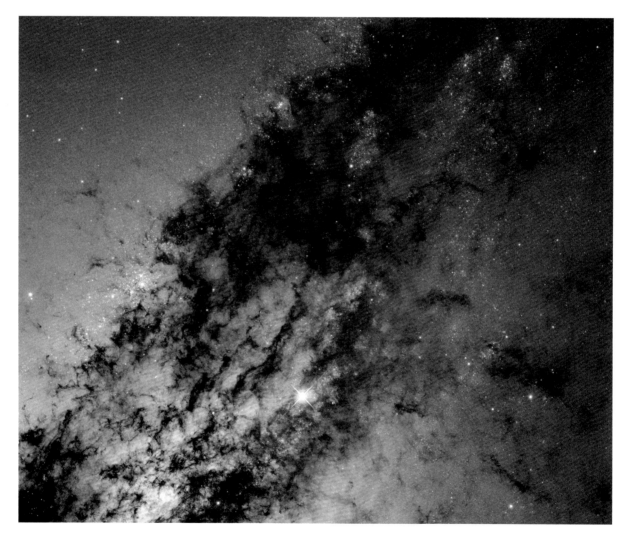

A Detailed Glimpse of the Red Heart of Centaurus A

This visible-light image shows a small part of the edge-on girdling dust disk of NGC 5128. This heavily structured dark lane has long been considered the dusty remains of a smaller spiral galaxy that merged with the large elliptical galaxy and deposited its gas and dust. The shock of the collision continues to compress the dusty interstellar gas, precipitating a flurry of star formation, evident in the pink star-forming regions. These dark filaments of dust mixed with cold hydrogen gas are silhouetted against the innermost stars of the galaxy, and the intrinsically bright, but greatly dimmed nucleus is the dull red glow at the left (eastern) side of the image.

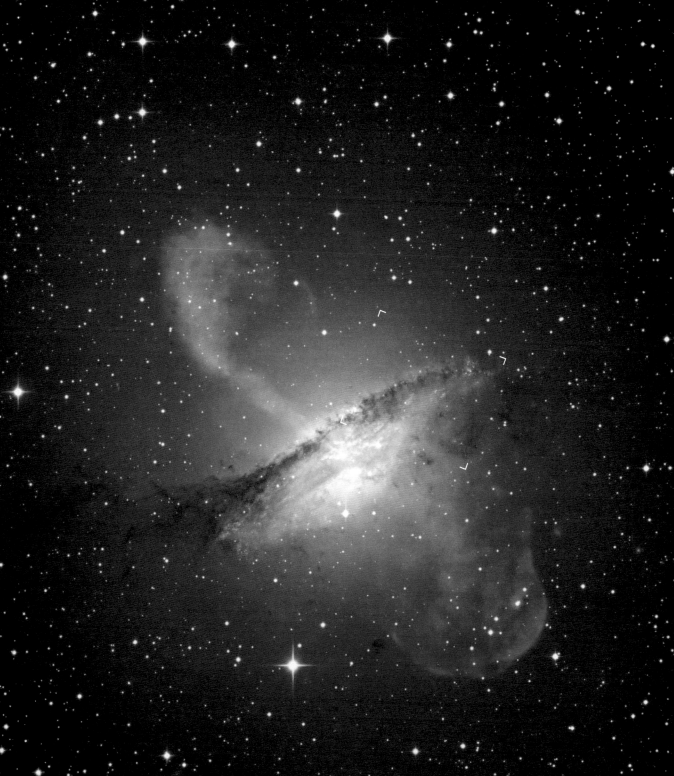

Centaurus A seen in X-ray, Optical, and Sub-millimeter Wavelengths

This image of Centaurus A combines three observations. An optical image (taken with the MPG/ESO 2.2-metre Telescope) shows the diffuse white haze of stars that is the underlying elliptical galaxy, crossed by a dust lane. The dust lane is the in-falling relic of a dusty galaxy that NGC 5128 is still absorbing. The yellow plumes and orange hues aligned with the dust lane depict the galaxy at sub-millimeter wavelengths (imaged with APEX), revealing both the cold dust inside the galaxy and synchrotron emission associated with the radio jet and the inner radio lobes. This is a signature of material moving at nearly the speed of light. The X-ray emission (from the Chandra X-ray Observatory), shown in blue, uncovers the linear jet emerging from the central black hole on the northern side of the galaxy (top) and opposite, a diffuse glow where the expanding radio lobe collides with the interstellar material, creating a shockwave. Remarkable!

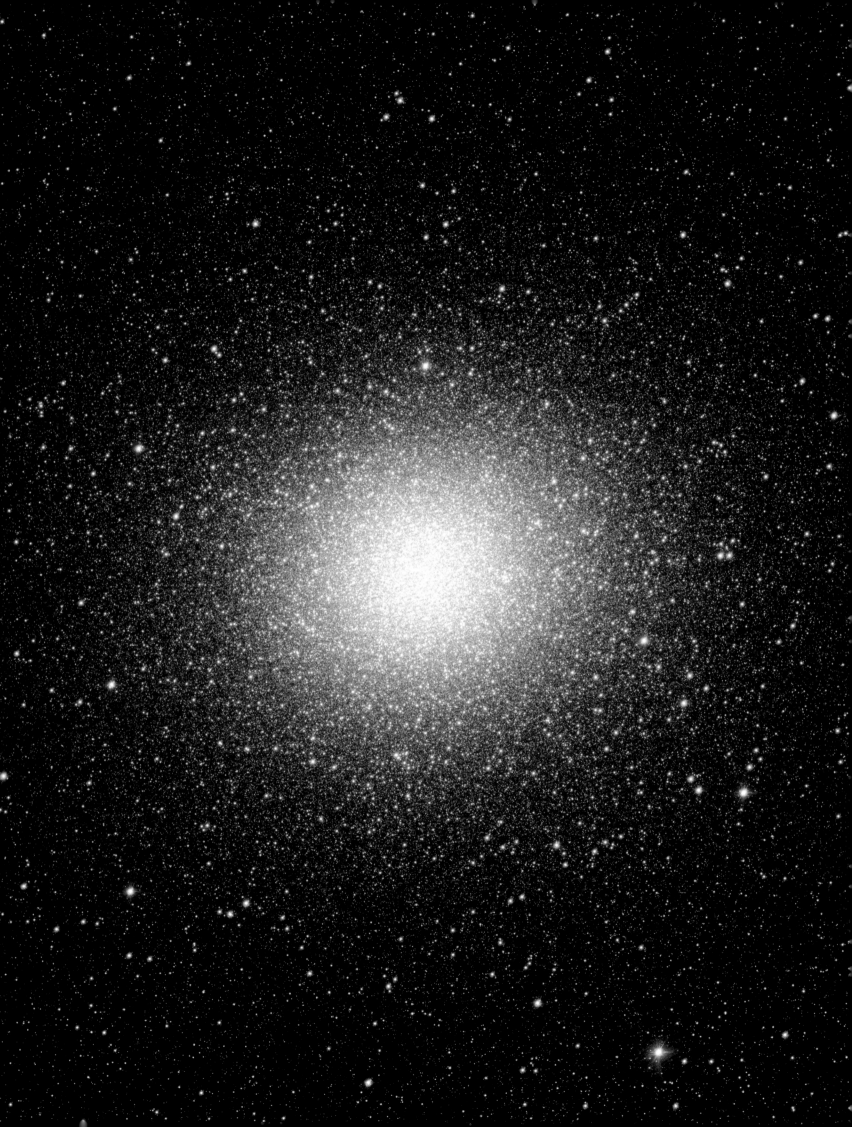

Omega Centauri

Omega Centauri (NGC 5139) is one of two splendid, naked-eye globular clusters in the southern sky. Easily seen as a 3.7 magnitude star, it is obviously not stellar, even to the casual observer, and is frequently mistaken for a naked-eye comet. If Messier had lived in the southern hemisphere, Omega Centauri would surely have been number one in his catalog! Good binoculars will hint at its granularity, and a 3-inch telescope will resolve the cluster into a vast multitude of faint stars. On deep photographs the outlying stars are dispersed over a degree on the sky, twice the diameter of the full Moon. Omega Centauri is the most massive and brightest of all the known Milky Way globular clusters, and we see it from a distance of 17,000 light-years. The cluster is over 200 light-years across and is thought to contain some 10 million stars.

Omega Centauri has been observed throughout recorded history. The great astronomer Ptolemy and later Johann Bayer cataloged the cluster as a star, while Edmond Halley described it as a nebula in 1677. It was not until the early 1830s that John Herschel recognized Omega Centauri as a huge cluster of faint stars. *"Altogether this object is truly astonishing,"* he wrote.

Objects like Omega Centauri are among the oldest star clusters and are usually found in the halos that surround galaxies of all kinds. The cluster is thought to be around 12 billion years old, but it does contain stars younger than this, suggesting an eventful history. It may even be the stripped nucleus of small galaxy that has been largely destroyed in an encounter with the Milky Way. Recent research into this intriguing celestial giant even suggests that there is a medium-sized black hole sitting at its center. Whatever its origins, it remains an intriguing object for professional and amateur astronomers alike.

Omega Centauri
Omega Centauri is easily visible with the unaided eye from a clear, dark observing site. Even through a modest amateur telescope, the cluster is revealed as an incredible, densely packed sphere of stars. The photograph was made using green, red, and infrared light, and shows most of the cluster — about a degree in the sky. This image is based on data collected with the VLT Survey Telescope (VST), located at ESO's Paranal Observatory, high up in the arid mountains of the southern Atacama Desert in Chile.

NGC 5189

At the end of its life, any star with a mass less than eight times that of the Sun will blow its outer layers away, giving rise to a planetary nebula. Some of these stellar puffballs are almost round, resembling huge, luminous soap bubbles in space or, in a telescope, a giant planet, hence the name. Others, such as NGC 5189, are more intricate.

This nebula was first noted by James Dunlop in Parramatta, Australia, in 1826, and again by John Herschel with a much superior telescope a decade later. Herschel was sufficiently intrigued by what he saw to describe it as *"a very strange object,"* and published a drawing that clearly shows its distinctive S-shape. NGC 5189 is located some 1800 light-years away in the constellation of Musca (The Fly).

NGC 5189 is also sometimes nicknamed the Spiral Planetary Nebula, after the only sign of symetry in its apparently chaotic structure, which is forming as the expanding remains of the dying star HD 117622 collide with previously ejected gas and dust. Although it appears disordered, careful examination of the spectra of individual knots and condensations reveals an underlying symmetry, which is a hallmark of a planetary nebula. Although it superficially resembles a spiral galaxy, especially to the eye, this peculiar object is regarded by observers as one of the finest planetary nebulae in the sky.

The image was assembled from light emitted in the distinctive wavelengths of the ionized elements hydrogen, oxygen, and sulfur, revealing hot streamers of gas, glowing dust, and cometary knots pointing away from the hot star that is the sole source of everything we see here.

NGC 5189

NGC 5189 is a planetary nebula with an oriental twist. Similar in appearance to a Chinese dragon, these cosmic fireworks are the swansong of a dying star. This planetary nebula exhibits a curious S-shaped profile, with a central bar that is most likely the projection of an inner ring of gas discharged by the star, seen edge on. The details of the physical processes producing such a complex symmetry from a simple, spherical star are still the object of astronomical controversy. One possibility is that the star has a very close (but unseen) companion. Over time the orbits drift due to precession, and this could result in the complex curves visible on the opposite sides of the star in this image.

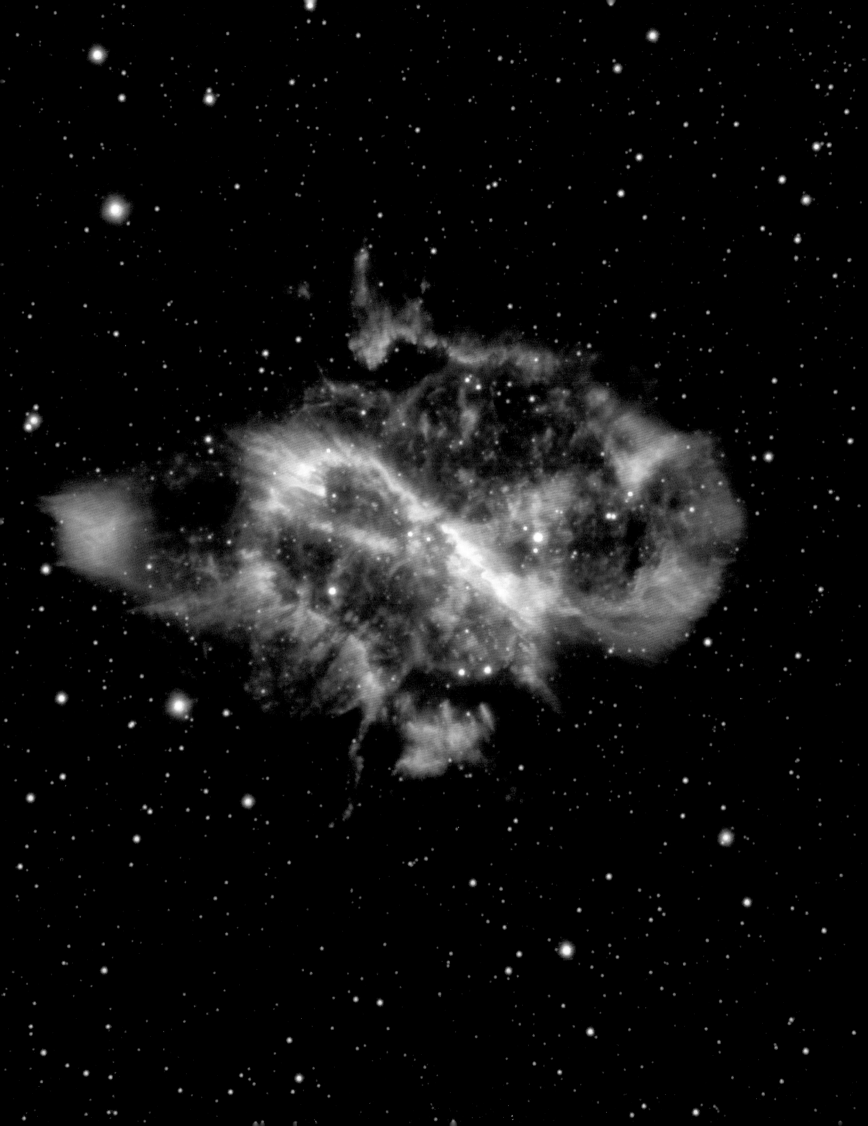

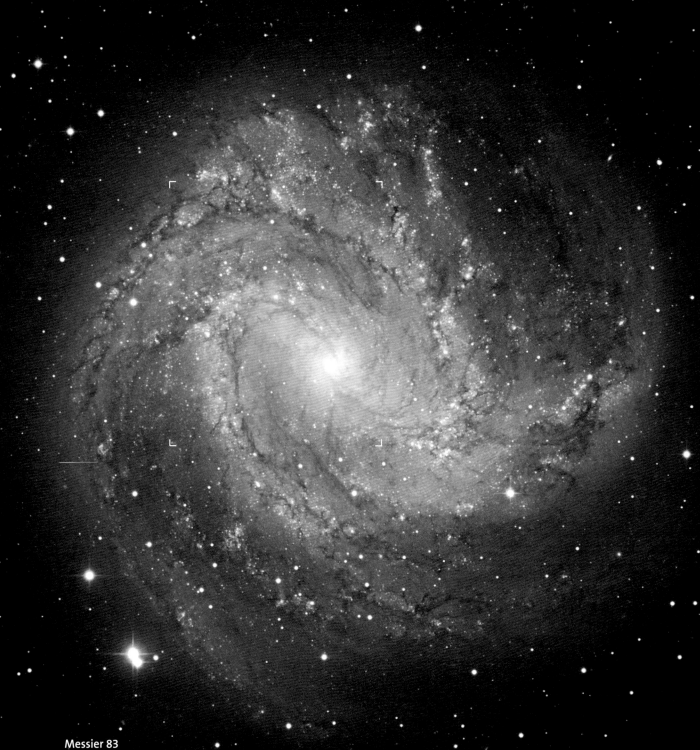

Messier 83

This image is about 12 arcminutes across and shows the spiral arms of Messier 83 adorned by countless bright ruby-red patches. These are huge clouds of glowing hydrogen gas. Ultraviolet radiation from newly born, massive stars is ionizing the gas in these clouds, causing the great regions of hydrogen to glow red. These red star-forming regions and the pale blue stars they produce make a dramatic contrast with the ethereal glow of older yellow stars near the galaxy's central hub. The image also shows the delicate tracery of dark and winding dust streams weaving through the arms of the galaxy.

Messier 83

Messier 83 (NGC 5236) is a nearby face-on barred spiral galaxy with a classic "grand-design" form, and has long been a favorite with southern observers. Messier 83 has been a prolific producer of supernovae, with six observed in the past century, second only to NGC 6946 in the northern sky, which has produced nine supernovae. The high supernova rate reflects the exceptionally high rate of star formation, supporting its classification as a starburst galaxy, similar to Messier 82 and NGC 253. Very deep images reveal an unusual gigantic loop or arc spanning the northern part of the galaxy, possibly the remains of a dwarf galaxy that has been shredded by its interaction with Messier 83.

The central 1000 light-years of the galaxy show an unusually high level of complexity, containing both a double nucleus and a double starburst ring surrounding the nucleus. The nature of the double nucleus is uncertain, but some evidence suggests that the off-centered nucleus may be a remnant core of a small galaxy that merged with Messier 83 in its distant past. Messier 83 is about 20 million light-years away in the constellation of Hydra. It is almost 30 degrees south of the celestial equator and is the southernmost object in Messier's catalog, which was made from Paris, at a latitude of 49 degrees north. The galaxy was discovered by de Lacaille from Cape Town in 1752, who described it as *"a small nebula, shapeless."* But then, he only had a 12 mm telescope.

Messier 83 Detail with Hubble
The astonishingly prolific rate of star formation in M83 is revealed by the huge red emission nebulae sprinkled along the outer edge of the curved dust lane. There is nothing comparable to this in the Milky Way. As the newly formed stars begin their lives they blow away the dusty gas, and the high resolution of the Hubble image shows them exposed as individual blue stars. Unusually, the dust lane continues into the compact, bright nucleus, seeming to slice it in two. This may be triggering star formation there, where the brightest star clusters form a distinctive bright arc.

NGC 5426 and NGC 5427

This beautiful pair of galaxies is number 271 in Arp and Madore's *Catalogue of Southern Peculiar Galaxies and Associations* (1987). Evidence of the interaction is very subtle, but the signs are there, especially in the faint bridge of stars that appears to join NGC 5427 (seen almost face-on) to its more inclined companion, NGC 5426. The favorable inclination of NGC 5427 also shows a few abnormal kinks and distortions in its spiral arms.

Both spirals appear nearly identical in size, structure, and shape, but as they gradually merge they will lose their identities as spiral galaxies and, for a while, perhaps look like the chaos that rules the Antennae Galaxies (NGC 4038 and NGC 4039, p. 98). While witnessing the collision of two immense bodies of stars has to be one of the most physically impressive events occurring in the Universe, it all takes a very long time. The process, though dramatic, might require a billion years to arrive at a merged galaxy that does not show some sign of trauma. In the meantime, the interaction will have triggered energetic bouts of star formation as the dust and gas in the spiral arms of the galaxies is compressed and stretched by fluctuations in their combined gravity. Such scenes are a foretaste of the Milky Way's coming encounter with Messier 31 in Andromeda (The Chained Maiden), sometime in the next five billion years.

Located 90 million light-years away towards the constellation of Virgo (The Virgin), the Arp 271 pair is about 130,000 light-years across. It was originally discovered in 1785 by William Herschel.

NGC 5426 and NGC 5427

NGC 5426 and NGC 5427 are two spiral galaxies of similar sizes engaged in a dramatic dance. This dance will last for tens or even hundreds of millions of years, creating new stars as a result of the mutual gravitational attraction between the galaxies — a pull seen in the bridge of stars already connecting the two. The images were made in green, red, and infrared bands with a total exposure time of over an hour, and the resulting photograph is not true color.

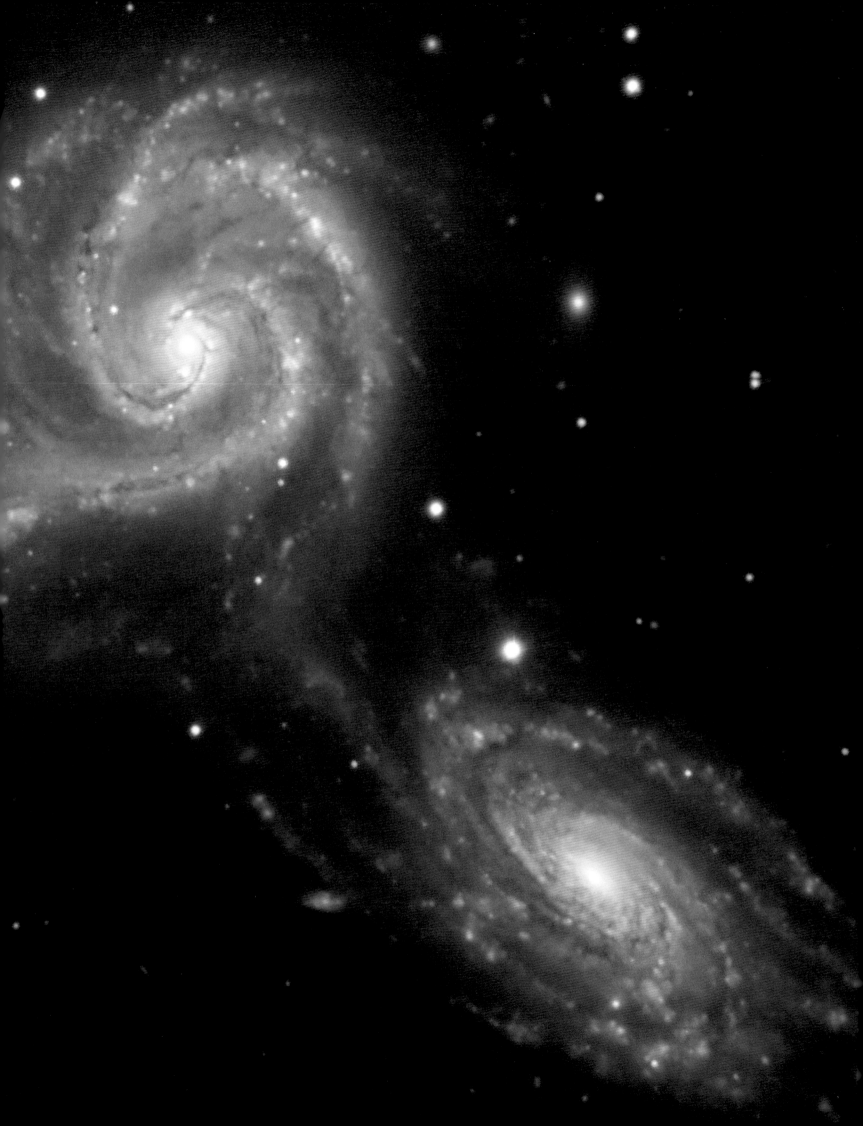

The Southern Winter

16.00 to 22.00 Hours Right Ascension

The Southern Winter

The long nights of the southern winter are filled by the Milky Way, arching from horizon to horizon. The combined brightness of its myriad stars is interrupted by dark spaces that we now know to be dust between and among the stars. As the hidden center of our galaxy passes overhead, we can understand why the form of our own galaxy, the Milky Way, remained mysterious for so long. The mystery is solved, but the majesty remains. This panoramic scene reveals our galaxy's central galactic bulge which can be seen in the southern winter sky just a few degrees west of the large Sagittarius Star Cloud.

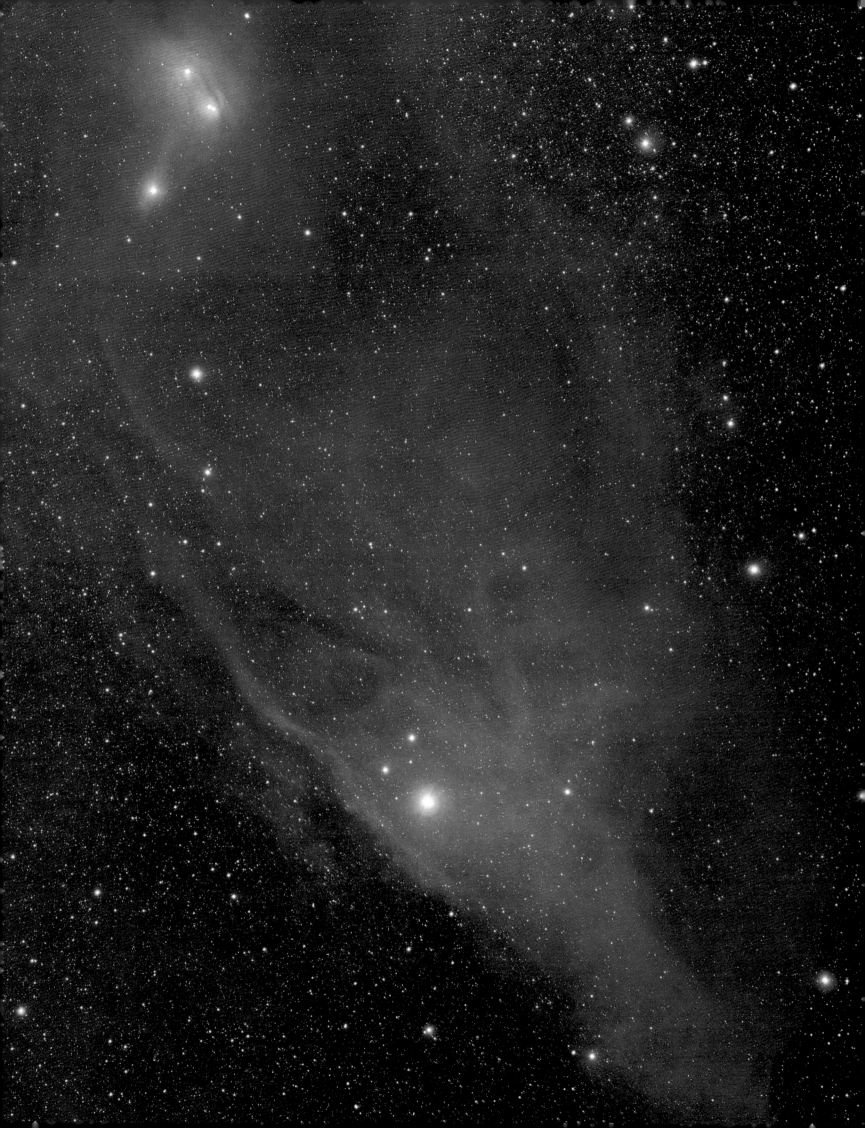

IC 4592 and IC 4601

Reflected blue light from massive stars forms the shape of a horse's head in the southern constellation of Scorpius, sometimes nicknamed the Blue Horsehead (IC 4592). It is seen here looking northwest, towards the lower right corner. The nebulosity is mostly faint, and covers about two square degrees of sky, about twice the area seen here, and a much greater area than the better-known Horsehead Nebula in Orion (p. 56). The smaller complex of blue and faint yellow reflection clouds in the upper left corner, in the horse's neck, is known as IC 4601. Adjoining it near the left edge of the image is the faint red outline of the dark cloud Barnard 41, and this extends towards the center of the picture, joining with Barnard 40.

The source of much of the scattered blue starlight in the more massive cloud comes from the bright star Nu Scorpii, which makes up the eye of the horse. This is a large structure with delicate, muted colors, probably because we see it through the dust that gathers close to the plane of the Milky Way. This dust selectively absorbs blue light, just as the dust that surrounds the bright stars selectively scatters it. Elsewhere, the faint reddish hues mark the diffuse outskirts of molecular clouds and is probably emission excited by the ultraviolet light from hot stars within the Milky Way.

The Blue Horsehead

This complex of mostly dusty reflection nebulosity in Scorpius is illuminated by a small number of young bright stars. The image covers a field approximately 2.5 by 1.5 degrees and was taken with an amateur telescope from the southwestern United States.

The Rho Ophiuchi Nebula

Splashes of vibrant of color and light adorn the spectacular region surrounding the bright triple star Rho Ophiuchi, close to the border of Scorpius. Probably no other part of the sky provides such an impressive range of hues juxtaposed with entwining dark rivers of Milky Way dust. The scene is highlighted by the bright star Antares (lower left, Latin for "rival of Mars"), a cool, red supergiant 40,000 times more luminous than the Sun and 600 light-years distant. Seemingly close to it (lower middle), but 4000 light-years further away is one of the nearest globular clusters, Messier 11 (NGC 6121, p. 156). The colorful reflection nebula at the top of the picture surrounds the group of stars that is Rho Ophiuchi. The nebula is the blue light reflected by dust, the visible counterpart of a much larger but unseen molecular cloud permeating the region, known as the Ophiuchus Molecular Cloud. Infrared observations penetrate the dust and show it to be heated by young stars, in the dust and unseen in this photograph.

The Rho Ophiuchi Nebula

The dusty region between Ophiuchus and Scorpius contains some of the most colorful and spectacular nebulae ever photographed. The upper part of the picture is filled with the bluish glow of light from hot stars reflected by a huge, cool cloud of dust and gas where such stars are born. This dust is also seen as a dark nebula, a molecular cloud, hiding the light of background stars, especially on middle left of the picture. Dominating the lower half of this cosmic landscape is the over-exposed image of the red supergiant star Antares, a star that is steadily shedding material from its distended surface as it nears the end of its life. These tiny, smoke-like solid particles reflect light from Antares and hide it in a nebula of its own making. Partly surrounding Sigma Scorpii at the right of the picture is a red emission nebula, completing perhaps one of the most comprehensive collections of nebular types that it is possible to capture in one photograph.

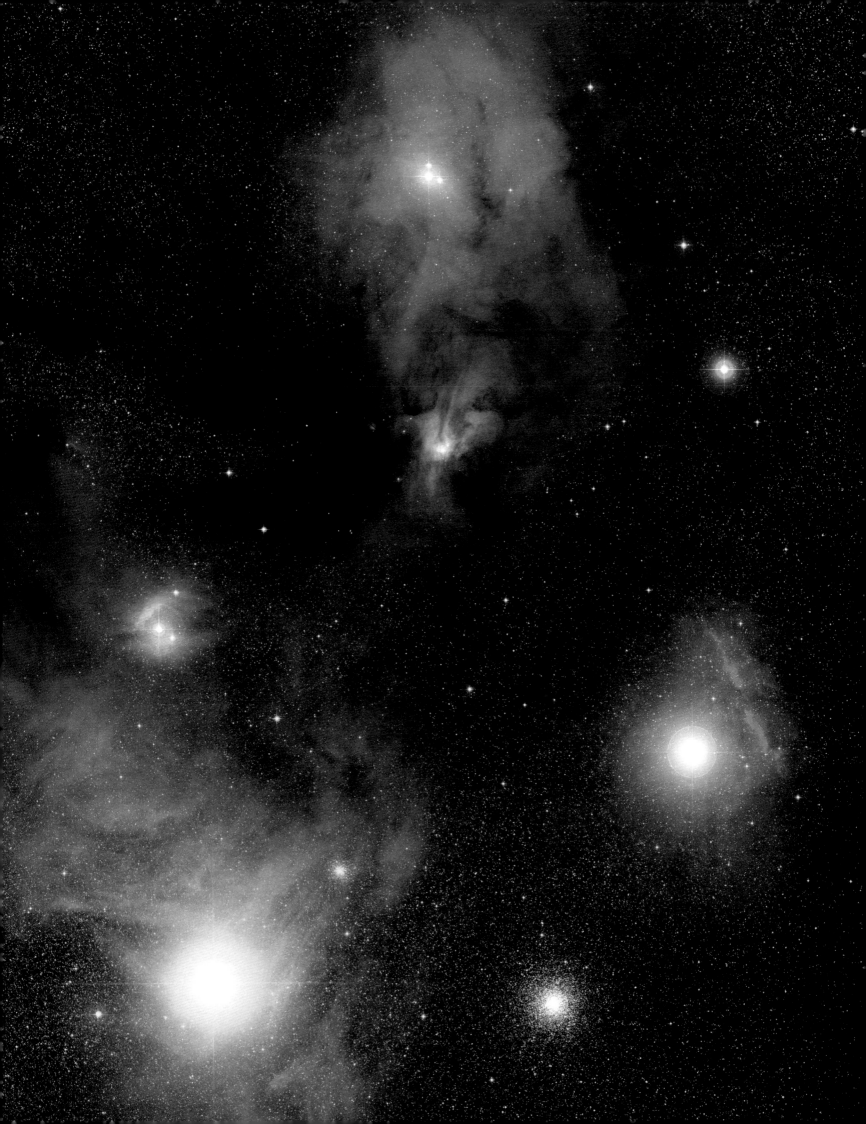

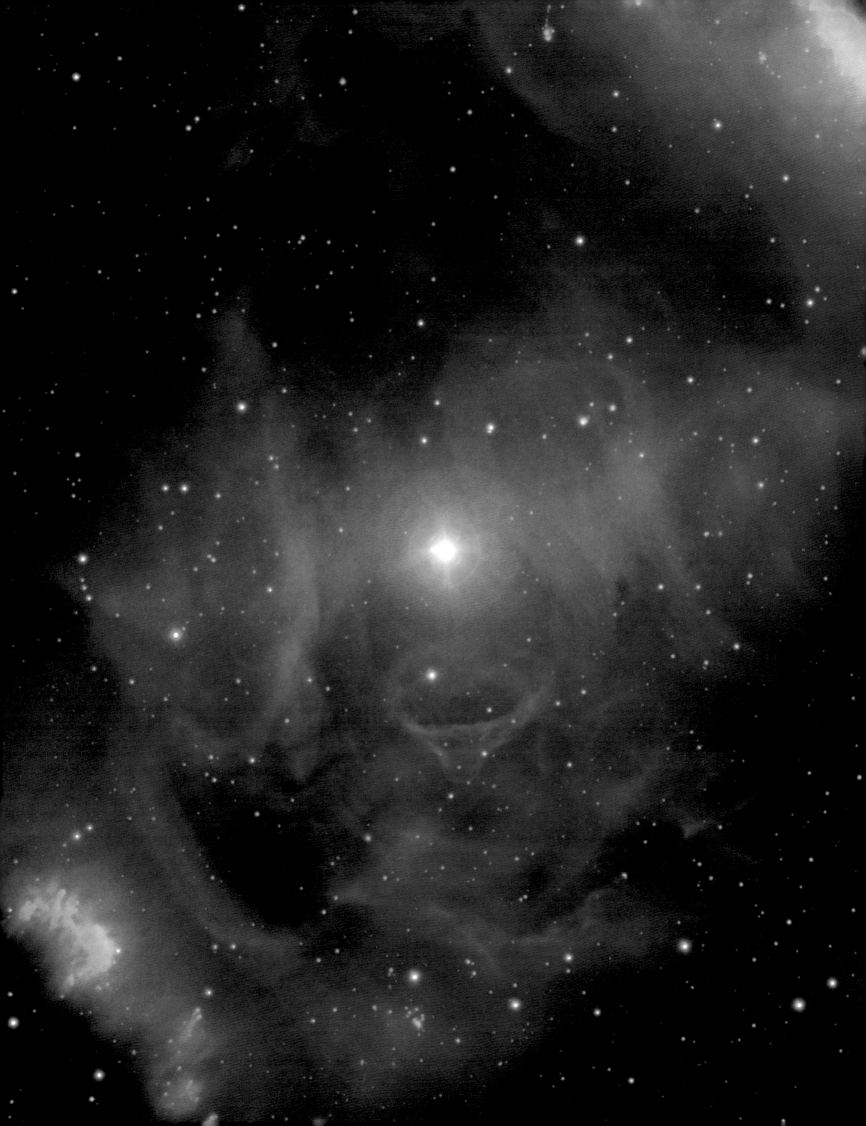

NGC 6164–6165

The designation NGC 6164–6165 implies two objects, but the bipolar nebula surrounding the peculiar star HD 148937 is a single entity, a bright star surrounded by two lobes of material the star itself has ejected. The inner parts of these appear in the corners of the photograph. Although the nebula was initially believed to be a planetary nebula, to which it has a superficial resemblance, its central star is young and very massive, quite unlike the old, lightweight stars at the center of planetary nebulae. The central star of NGC 6164–6165 shares many characteristics with Wolf–Rayet stars, which are evolved O-type stars that have left the main sequence. But in this case the central star is not a Wolf–Rayet star but something rather similar, a young, O-type supergiant of 40 solar masses, ejecting a substantial part of its surface as the two symmetrical bright nebulae. Deeper, wide-angle images show much larger faint nebula centered on the star, indicating that this outburst is not the first. Knowing the unstable temperament of these types of stars, and the vigor with which they seek to lose mass, it is unlikely to be the last.

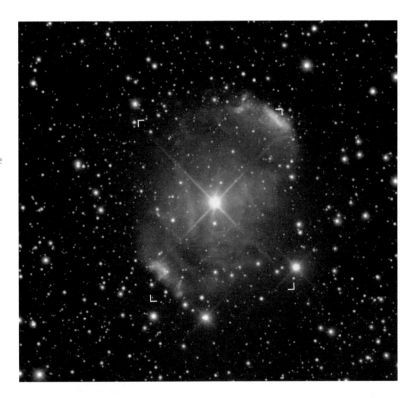

Wide Field View of NGC 6164–6165

This wide-angle image shows that NGC 6164–6165 lies within a larger cavity presumably cleared by the radiation of its powerful central star. The central star is 40 times more massive than the Sun and is about three to four million years old — past the middle of its life span. Stars this massive may only live a few million years, so it is quickly depleting its fuel and will likely end its life in a violent supernova explosion.

NGC 6164–6165

Some astronomers suggest that NGC 6164–6165 has been ejected from its star as it spins on its axis, in much the same way a rotating lawn sprinkler shoots out water as it spins. It is also possible that the magnetic fields surrounding the star may play a role in creating the complex shapes clearly seen in the image. However, evidence of the stellar wind interacting with dust, can be seen in the corners of this Gemini Telescope picture, which suggests that the outer nebula consists of material remaining from an earlier stage in the star's life.

NGC 6188 and NGC 6193

NGC 6193 is a remarkable young star cluster at the center of the Ara OB1 stellar association, which spans a full square degree of the southern sky. The cluster NGC 6193 is composed of at least two superimposed star clusters, the nearest being about 4500 light-years away and less than three million years old. The stars are embedded in a region cloaked by thick gas clouds and obscuring lanes of dust, and some features are reminiscent of the better-known Horsehead Nebula in Orion.

The hottest stars of the cluster, and the brightest stars in the image, are two closely spaced, O-type giants, HD 150135 and HD 150136. They illuminate the emission nebula NGC 6188. The cluster NGC 6193 and its emission counterpart NGC 6188 are seen in projection along a dark rim, which is the edge of a molecular cloud marking an immense, expanding bubble of neutral hydrogen gas spanning some 300 light-years. Ultraviolet radiation from the O-type giants of NGC 6193 is presently eroding the eastern edge of the parent molecular cloud and may be triggering and sustaining further star formation hidden within it.

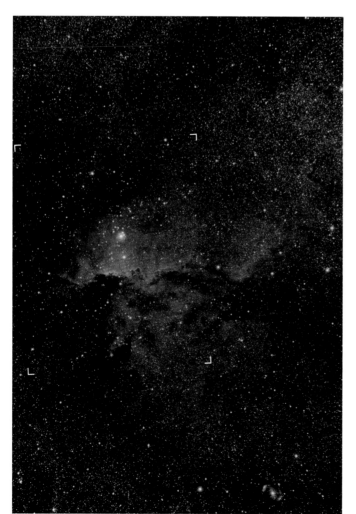

The Region around NGC 6188 and NGC 6193

This wide-field view includes the objects in the main picture and shows the vast network of nebulosity and dust encompassing the region that extends to the north (bottom) of the picture and disappears into dark clouds at both extremities. Also seen at the northwest edge of the image (lower right) is NGC 6164–6165 (p. 124). Deeper images show it interacting with the same emission clouds, suggesting it is located at a similar distance.

NGC 6188 and NGC 6193

NGC 6188 is a molecular cloud that is in the process of being destroyed by intense ultraviolet radiation from hot, massive stars in the nearby stellar cluster NGC 6193, seen in the center of the photo. NGC 6188 is a strip of bright nebulosity running north–south (right to left in the photo) in the constellation Ara (The Altar), deep in the southern sky.

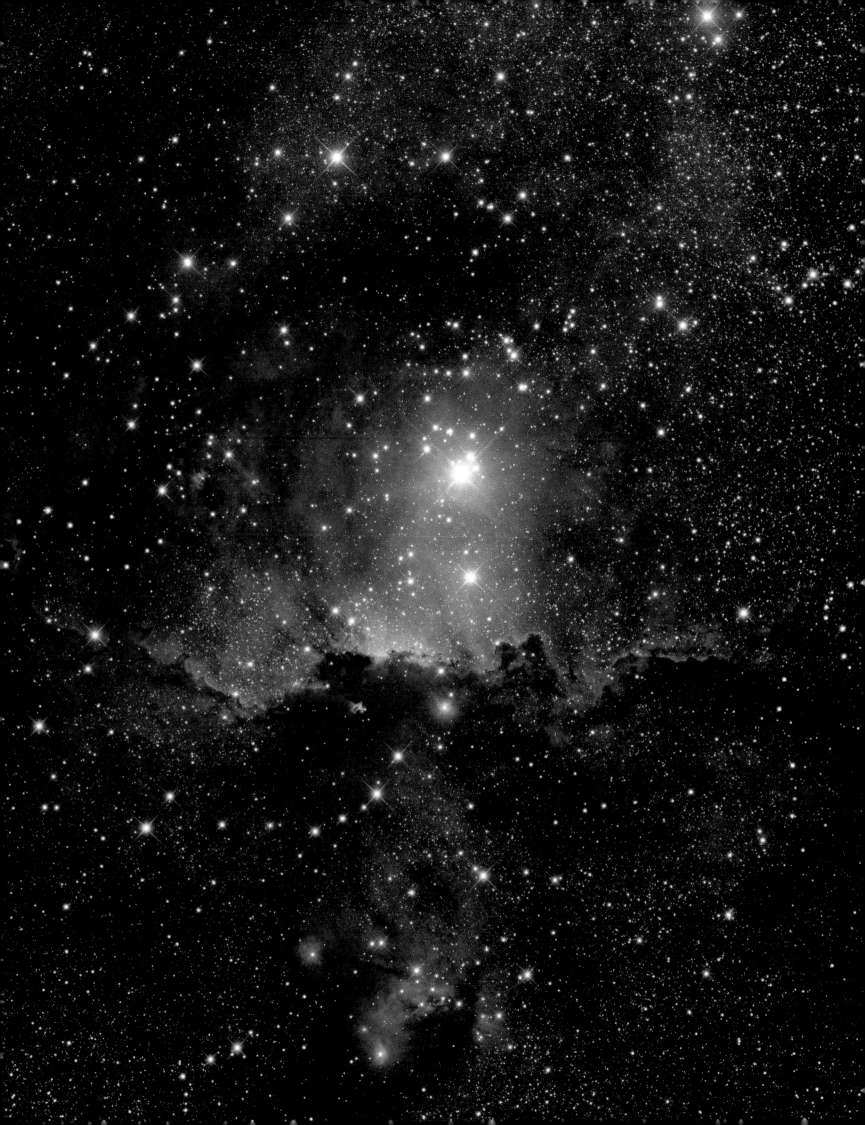

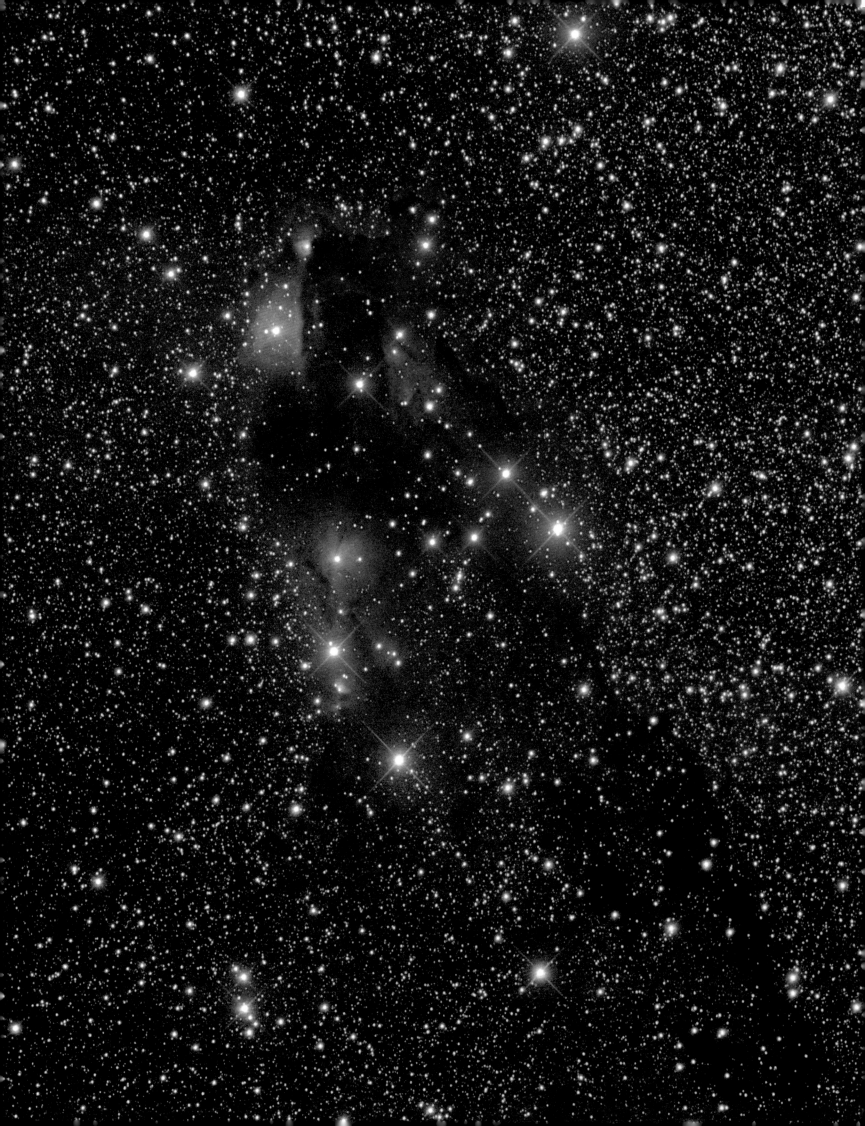

The Dark Tower

Bright-rimmed globules and their more evolved and smaller cousins, cometary globules, are fascinating dynamic structures formed by the interplay of cold molecular clouds and hot ionizing stars. In the northern hemisphere, many of these dark clouds were cataloged by E. E. Barnard in the 1920s, and later by Beverly Lynds. In the southern hemisphere a similar but more comprehensive catalog had to await the commissioning of the UK Schmidt Telescope in the 1970s, and the first author of the southern *Catalogue of 1101 Dark Clouds* (1986) was Malcolm Hartley, of comet fame. The object seen here is HMST 343.0+02.8 in that catalog, in the star-forming region Gum 55, nicknamed the Dark Tower.

Typically, the head of the globule faces a hot O- and B-type star or stars. Intense radiation from the stars warms the cold surface of the molecular cloud, releasing the hydrogen gas that has condensed on the dusty grains. This is instantly ionized by the intense ultraviolet light from the stars, forming a red plasma — an HII emission nebula. The radiation pressure also blows away the dust, creating a comet-like shape, as seen in this picture. The ionizing stars involved in shaping the Dark Tower are members of the famous open cluster NGC 6231, the Scorpius OB association, off the top of this picture and outside the scene.

The Dark Tower
Silhouetted against a crowded star field toward the constellation of Scorpius, this dark cloud is sometimes nicknamed the Dark Tower, a name that is only appropriate when the image is oriented with east at the top, as it is here.

NGC 6302

The Bug Nebula, NGC 6302, is one of the brightest and most extreme planetary nebulae known. A planetary nebula is a small emission nebula excited by an extremely hot, but moribund, star. Like most planetary nebulae, the Bug Nebula is symmetrical, in this case with two distinct lobes. It was first studied by the famous astronomer E. E. Barnard in 1907, but its true beauty was not revealed until the Hubble Space Telescope observed it in 2000 and 2009.

What we are seeing here is the disassembly of a moderate-mass star. After a long life it has transformed most of its hydrogen into helium in the nuclear reactor core of the star. This leads to instability, and the star throws off its outer layers, predominantly made of the elements mentioned above. At the center of the denuded star, the nuclear reactor is exposed and, with a temperature of over 220,000 degrees C, it is violently hot, with most of the radiation being emitted in the extreme ultraviolet part of the spectrum. This causes the expanding outer layers of the star to glow in their characteristic colors.

The image reveals a complex history of ejections from the star, which first evolved into a huge red giant, with a diameter of about 1000 times that of our Sun. It then lost its extended outer layers. Some of this gas was cast off from its equator at a relatively slow speed, perhaps as low as 32,000 kilometers per hour, creating the doughnut-shaped ring. Other material was ejected in a direction perpendicular to the ring at higher speeds, producing the elongated "wings" of the butterfly-shaped structure. Later, as the central star heated up, a much faster stellar wind, a stream of charged particles traveling at more than 3.2 million kilometers per hour, ploughed through the existing wing-shaped structure, further modifying its shape.

The image also shows numerous finger-like projections pointing back to the star, which may mark denser blobs in the outflow that have resisted the pressure from the stellar wind.

One day, this will be the fate of the Sun. Its outer layers will be shed, and its retinue of planets will be evaporated in a flurry of butterfly wings.

Hubble Image of the Bug Nebula

The NASA/ESA Hubble Space Telescope obtained this image of the planetary nebula, cataloged as NGC 6302, but more often called the Bug Nebula. NGC 6302 lies within the Milky Way, roughly 3800 light-years away in the constellation of Scorpius. The glowing gas is the star's outer layers, expelled over a period of about 2200 years. The central star itself cannot be seen, because it is hidden within a doughnut-shaped ring of dust, which appears as a dark band pinching the nebula in the center. The thick dust belt constricts the star's outflow, creating the classic "bipolar" or hourglass shape displayed by some planetary nebulae. This image was made by combining six separate images recording light emitted by the elements sulfur, nitrogen, oxygen (two wavelengths), helium and hydrogen, all of them fluorescing in the intense ultraviolet radiation from the invisible central star.

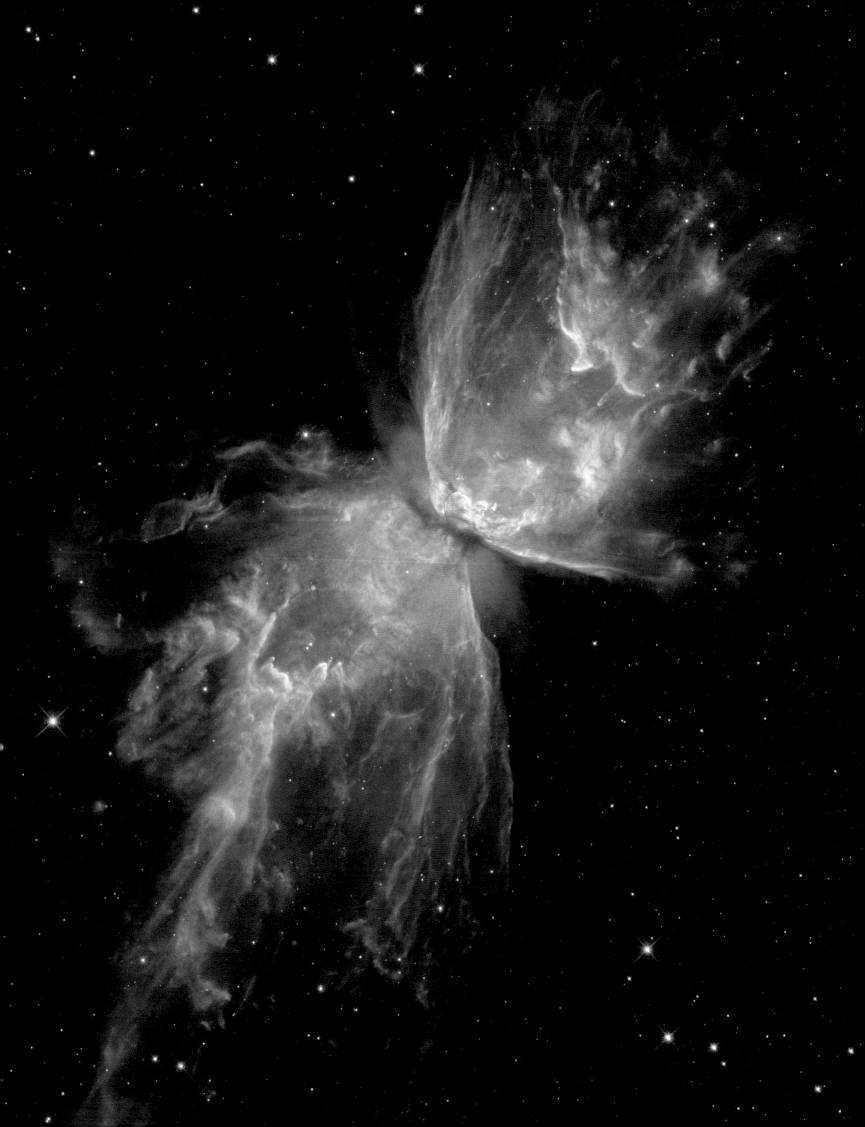

The Cat's Paw Nebula

Located in the constellation of Scorpius, the Cat's Paw Nebula resembles a faint, luminous pawprint on the sky. Deep images reveal that the nebula is about a degree across, or about twice the apparent diameter of the Moon. However, it is about 5500 light-years away, so it is truly huge — almost 100 light-years across. The sculpted gases of NGC 6334 are illuminated by the light of numerous powerful stars, some exceeding 10 solar masses. Such stars are hot, and even at the distance of this nebula might be expected to be clearly visible. That they are not confirms what we know about this part of the sky — that we are looking at it through the dusty plane of the Milky Way.

The nebula was discovered by John Herschel in 1837, and the brief and uninformative description in his Cape Observations catalog is a testament to its faintness. The ruddy hue of this complex is the result of the absorption of blue light by the ubiquitous dust clouds along our line of sight in the plane of the Milky Way.

A Celestial Cat

Few objects in the sky have been as well named as the Cat's Paw Nebula, several separated patches of a glowing gas cloud that together resemble the gigantic pawprint of a celestial cat. It is one of the most active nurseries of massive stars in our galaxy and has been extensively studied by astronomers. The red, intricate bubble in the lower right of the image is particularly striking and is most likely either a star expelling large amounts of matter at high speed as it nears the end of its life or the remnant of a star that already has exploded.

Infrared View of the Cat's Paw Nebula

The Cat's Paw Nebula, NGC 6334, is the birthplace of hundreds of massive stars. In a magnificent view taken with ESO's Visible and Infrared Survey Telescope for Astronomy (VISTA), the glowing gas and dust clouds obscuring the view are penetrated by infrared light, and some of the Cat's Paw's hidden young stars are revealed. Infrared light also reveals countless stars from the Milky Way, overlaid with spectacular tendrils of dark dust, seen here fully for the first time. The dust is sufficiently thick in places to block even the near-infrared radiation to which VISTA's camera is sensitive. In many of the dusty areas, such as those close to the center of the picture, features that appear orange are apparent — evidence of otherwise hidden active young stars and their accompanying jets. Elsewhere, the hot dust in the star-forming regions is shown in blue.

Towards the Center of the Milky Way

The Milky Way is a large spiral galaxy, a flattened disk containing billions of stars mixed with dust and gas. Knowledge of what lies at the center of our Milky Way may very well hold the secret to the forces that shape billions of other spiral galaxies throughout the Universe. However, the view towards the center of our galaxy (middle, marked) and its lurking supermassive black hole is obscured at visible wavelengths and difficult to interpret.

Most of the light in this spectacular scene, 34 by 20 degrees across, comes from the myriad of old, cool stars that are gathered in the bulge around the center of our galaxy. Many of the dark patches are actually a series of overlapping silhouettes — starlight blocked by patchy clouds and streamers of dust. We see this complex vista from our vantage point on Earth, almost 30,000 light-years from the Milky Way's central black hole, safe in our distant galactic suburbs. Our line of sight passes through the dust that gravity constrains to the flat disk of the Milky Way, and, as is the way with silhouettes, it is difficult to determine the distance of the obscuration, although there are clues.

To the right in the picture is the bright orange star Antares at a distance of about 600 light-years. Antares and stars like it are the main source of the dust we see in spiral galaxies, but around Antares the dust glows with the reflected light of the star itself (p. 122). Close to Antares is a blue reflection nebula at a distance of about 460 light-years, and this appears to be joined to the Milky Way by a slender stream of dust. This dust is nearby!

Fortunately, astronomers can peer through this opaque material by using instruments capable of observations at radio, infrared, and X-ray wavelengths. The Milky Way's central bulge can be seen overhead in the southern winter sky just a few degrees west of the large Sagittarius star cloud, the brightest patch of stars that dominates this wide angle mosaic. The dusty lane of the Milky Way runs obliquely through the image, dotted with remarkable bright, reddish nebulae, such as the Lagoon and the Trifid nebulae (upper left, p. 142 and 140), as well as NGC 6357 and NGC 6334 (bottom, middle, p. 136 and 132). All these star-forming regions straddle the equator of the Milky Way.

Wide View of the Central Milky Way
The unique and remarkable image spanning this page shows the region of the sky from the constellation of Sagittarius (The Archer, left) to Scorpius (The Scorpion, right). The very colorful Rho Ophiuchi and Antares region features prominently to the right, as well as much darker areas, such as the Pipe and Snake Nebulae. The image was taken under the clear skies of ESO's Paranal Observatory with an amateur telescope and is composed of a total of 1200 exposures through blue, green, and red filters.

NGC 6357 and Pismis 24

This emission nebula is at a distance of about 8000 light-years and is almost on the equator of the Milky Way, near the well-known Cat's Paw Nebula, NGC 6334 (see p. 132). The line of bright stars that ornament the foreground of this field runs north–south and has no part to play in exciting the atoms in the tenuous gas forming the nebula. Indeed it is remarkable that so few bright stars that are truly embedded in the faint nebula are visible here. In part, this is because they are shrouded by the nebula itself, but also because the whole field is seen through thick layers of dust that selectively absorb blue light — except, of course, for the conspicuous trail of stars in front of the nebula.

The brightest part of the nebula is associated with a compact cluster of stars known as Pismis 24, the brightest of which is probably a multiple star with several highly luminous and energetic components, some of them approaching the 100-solar-mass limit of stability. Although they appear insignificant in these pictures, it is only because they are heavily obscured by the dust of the Milky Way itself.

Part of NGC 6357 is ionized by the youngest massive stars in Pismis 24. The intense ultraviolet radiation from the blazing blue stars heats the gas surrounding the cluster and creates a bubble in the nebula. Pismis 24 was the last in a short catalog of southern hemisphere star clusters identified by the Turkish–Mexican astronomer Paris Pismis (1911–1999).

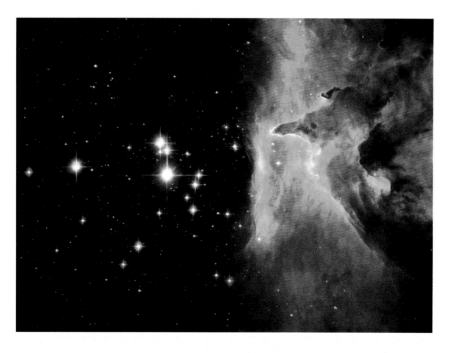

Pismis 24 in the Center of NGC 6357
The brightest part of NGC 6357 is associated with a compact cluster of stars known as Pismis 24, which ionizes parts of the nebula. The intense ultraviolet radiation from the ultraluminous stars heats the gas surrounding the cluster and etches it away, creating the structures seen here and the bubble-like features seen on the wide-field image.

The Emission Nebula NGC 6357
The emission nebula NGC 6357 is close to the galatic plane, at a distance of almost 8000 light-years from Earth.

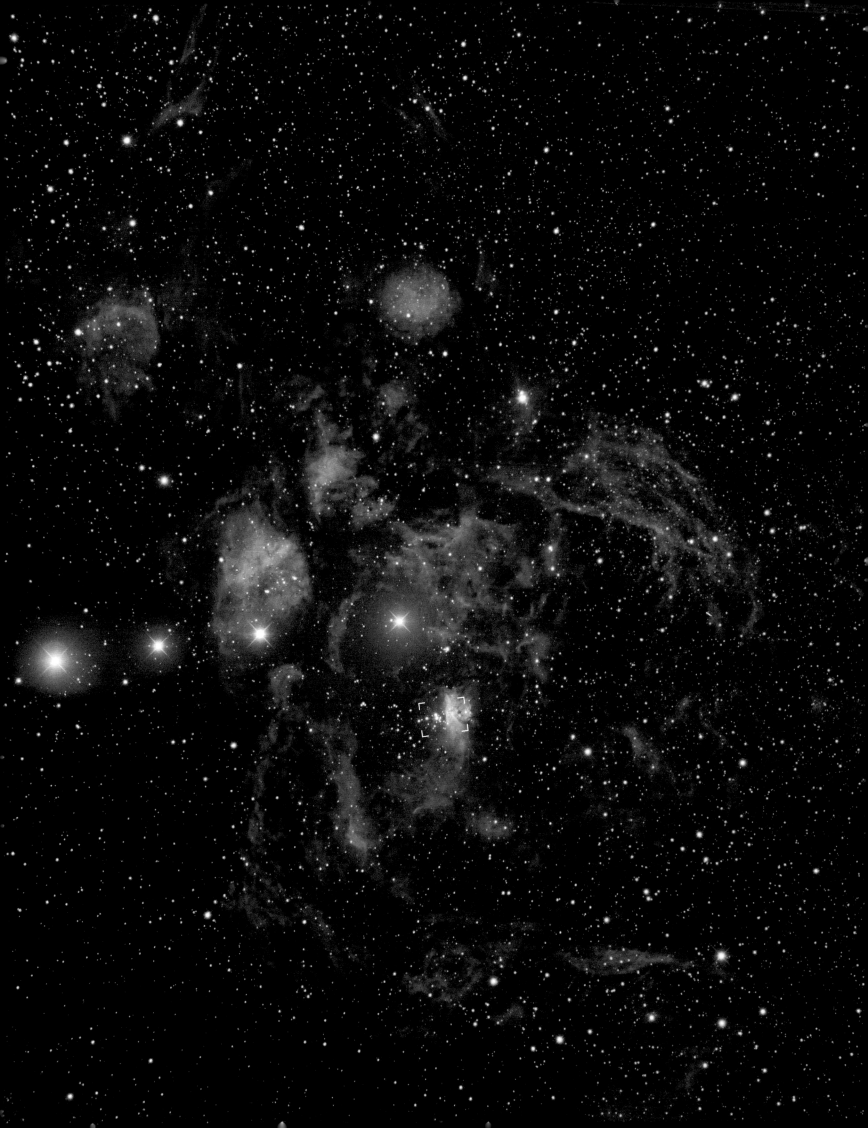

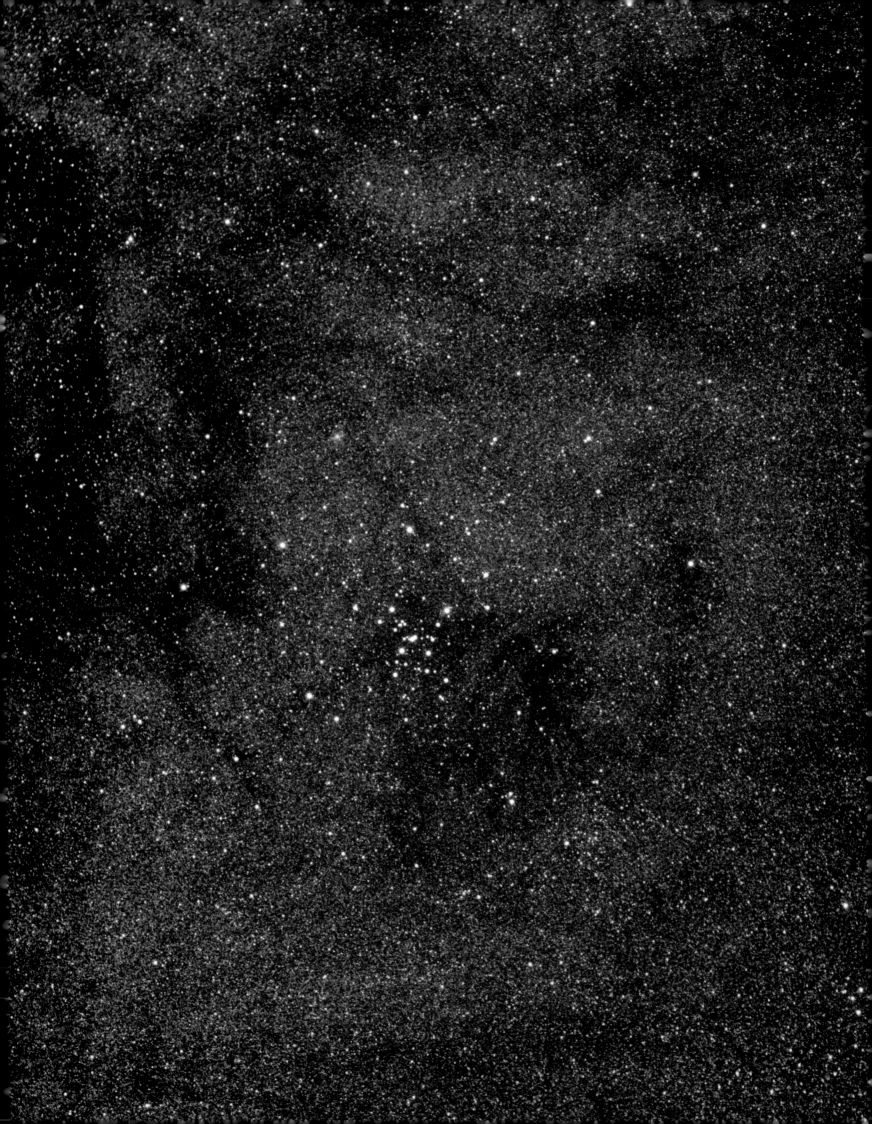

Messier 7

John Herschel described the appearance of Messier 7 in a telescope as *"coarsely scattered clusters of stars,"* which sums it up perfectly. To the unaided eye Messier 7 appears as an easy-to-see diffuse luminous patch in a bright part of the southern Milky Way, close to the Scorpius-Sagittarius border. This patch has been recognized as a diffuse "star" since ancient times and is occasionally known as Ptolemy's Cluster.

Messier 7 is about 220 million years old and is thus considered to be a mature, even middle-aged, cluster. As it ages, the handful of bright stars that attract the eye will vanish as supernovae, and the remaining faint stars, which are much more numerous, will hardly be recognizable as a group. Messier 7 is about 1000 light-years distant, over a degree of arc across, and is seen against a background of dense Milky Way star fields. However, the background is not uniform and is noticeably streaked with dust around and beyond the cluster, so it is tempting to speculate that these dark shreds are the dispersed molecular cloud from which the cluster formed. However, the Milky Way will have made one full rotation during the life of the cluster, with a lot of reorganization of the stars and dust as a result, so what we see now could be a chance alignment.

Messier 7

Messier 7 is a bright and populous cluster with its brightest blue members projected on a crowded background of dense star fields. Messier 7 is an important astronomical object, as it is the closest example of a typical middle-aged cluster, about 220 million years old. Its age places it midway between a much younger cluster such as Messier 45, with an age of about 100 million years, and a prototypical old cluster such as the Hyades, with an age of about 700 million years. The cluster contains about 100 stars and extends over 20 light-years of space or about one degree of the sky.

The Trifid Nebula

A well-known gem of the southern winter sky, the Trifid Nebula or Messier 20 provides a rare glimpse into a region of recent star birth and reveals the fascinating interplay of gas and dust and the light from hot stars. Messier 20 is a young star-forming region, about a third of a million years old, and the sphere of red emission is about 20 light-years across. The fainter, blue reflection nebula that completely surrounds it can be traced out for a much greater distance. While the multi-colored nebula is quite large, most of the energy that makes it glow comes from a compact group of stars at the intersection of the three dust lanes. In all there are at least seven members of a small star cluster packed within a half light-year at the center of the nebula. The main ionizing star is about 30 times the mass of our Sun and is the principal component of a triple system of stars, emitting most of the short wavelength ultraviolet light. This is absorbed by the neutral hydrogen around it, creating a Strömgren sphere — the red emission nebula that we see. Beyond that, the remaining visible light, depleted of its ultraviolet component, is scattered by gas and dust, creating a large, faint reflection nebula. In the center of the image, above the red emission, part of the reflection nebula is illuminated solely by an F-type supergiant star, far too cool to excite any emission.

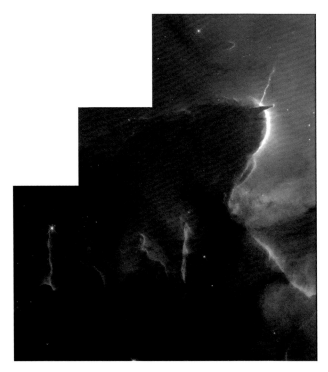

Detail in the Trifid Nebula

Recent X-ray, infrared, and high resolution optical observations have uncovered an amazing array of very young stars and protostars within Messier 20, revealing manifestations of the violent early stages of star birth. Of particular interest is the large bright-rimmed globule TC2 along the southern border of the Trifid Nebula seen in this Hubble image. This area has received much attention because of an enormous Herbig–Haro jet that projects out of the globule. The jet appears to be powered by a protostar only a few hundred thousand years old buried deep within the globule.

The Trifid Nebula

The Trifid Nebula presents a compelling portrait of the early stages in the life of the stars, from gestation to first light. The heat and "winds" of newly ignited, unstable stars stir the Trifid's gas and dust-filled cauldron; in time, the dark tendrils of matter strewn throughout the area will themselves collapse and form new stars. The French astronomer Charles Messier first observed the Trifid Nebula in June 1764, recording the hazy, glowing object as entry number 20 in his renowned catalog. Observations made about 60 years later by John Herschel of the dust lanes that appear to divide the cosmic cloud into three lobes inspired the English astronomer to coin the name "Trifid."

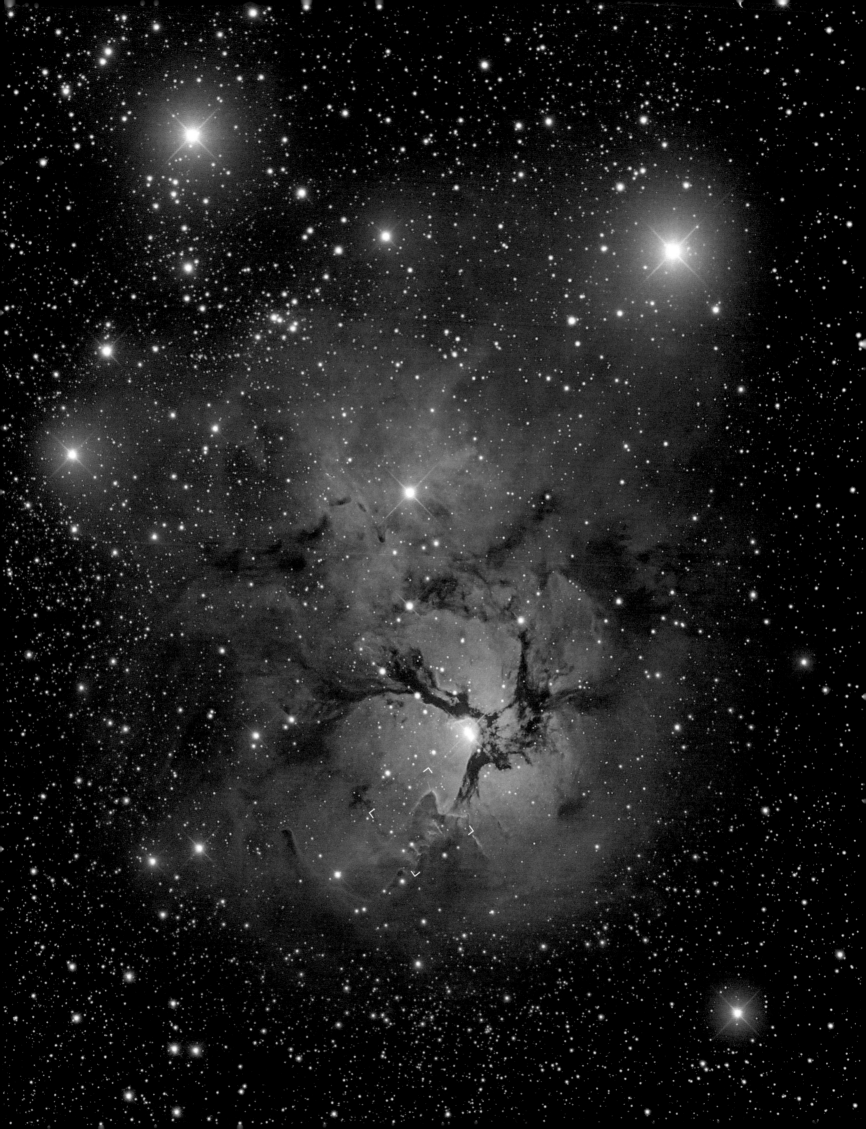

Overview Image of the Lagoon Nebula

The intriguing object depicted here — the Lagoon Nebula — is located 4000 to 5000 light-years away towards the constellation of Sagittarius (The Archer). The nebula is a giant interstellar cloud 100 light-years across, where stars are forming. The scattered dark patches seen all over the nebula are huge clouds of gas and dust that are collapsing under their own gravity and which will soon give birth to clusters of young, glowing stars.

The Lagoon Nebula

The large star-forming region dubbed the Lagoon Nebula, and also known as Messier 8 or NGC 6532, is centered on the young star cluster NGC 6530. The brightest part of the nebula is illuminated by several O-type giant stars within the cluster. The nebula is uniformly bright and is easily seen with the unaided eye very close to the equator of the Milky Way, which separates Sagittarius from Ophiuchus and Serpens in this part of the sky. The distribution of faint Milky Way stars around the nebula is very patchy, indicating a foreground molecular cloud of which the Trifid Nebula is also a part.

Silhouetted against the nebula around NGC 6530 are tiny dark dust globules, first identified in the 1940s by the Dutch–American astronomer Bart Bok, who suggested that they could be the precursors of protostars. Bok globules are small, typically a light-year across, and, if they are not evaporated by surrounding stars, can give rise to double or multiple stars. Between the open cluster NGC 6530 (left in the main image) and the compact and brilliant Hourglass Nebula (right in the main image) is a dark lane of dust that divides them like a deep and mysterious lagoon, giving the whole Lagoon Nebula its popular name. The Hourglass Nebula is small but very luminous, and it is excited primarily by two massive O-type supergiants designated Herschel 36 and 9 Sagittarii.

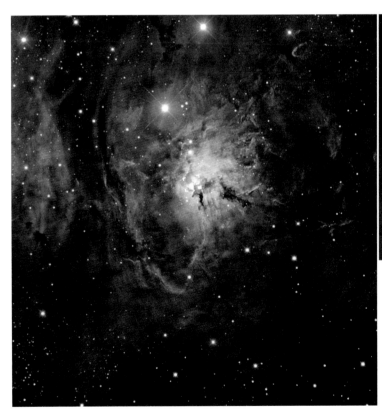

Intermediate View

The name of the Lagoon Nebula derives from the wide lagoon-shaped dark lane located in the middle of the nebula that divides it into two, very luminous sections. This lane is seen to the left in this view.

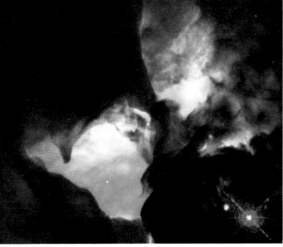

Detailed View from Hubble

Looking even closer at the heart of Messier 8, into the area called the Hourglass Nebula, we see a pair of interstellar "twisters" — eerie funnels and twisted-rope structures that stretch out for half a light-year. The hot star, Herschel 36 (lower right), is the primary source of the ionizing radiation for the Hourglass Nebula. The ionizing radiation induces photo-evaporation of the surfaces of the clouds and drives the violent stellar winds that tear into the cool clouds.

NGC 6559

The rich and colorful tapestry of diverse nebulosity known as NGC 6559 is a part of the same molecular cloud in the Sagittarius arm of the Milky Way that nourishes its neighbors, the Lagoon Nebula (Messier 8) and the Trifid Nebula, Messier 20. The region is awash with a rich sprinkling of old, faint, and yellowish stars that appear to be unevenly scattered. But appearances can be deceptive, and the uneven distribution is entirely due to patches of dust that lie along the line of sight.

Here and there, the dust is thick enough to completely obscure visible light, but infrared radiation can escape so the dark clouds cool to a few degrees above absolute zero. Within this celestial cooler, protected from the disruptive ultraviolet light of open space, molecules condense onto the tiny dust grains. Gradually, the molecular clouds collapse, eventually forming stars that soon clear away the dust from around them, emerging from their dusty cocoons to light up the neighborhood.

Within the nebula complex are several bright blue reflection clouds glowing by way of starlight reflected from innumerable microscopic dust particles still surrounding the brighter stars. The two brightest reflection nebulae are cataloged as NGC 6559 (bottom) and IC 1274 (top). The meandering channel of dark dust appearing etched into the background of bright emission is known as Barnard 303. All this springs from chilly darkness and the relentless force of gravity.

Close-up on NGC 6559

The dust lane meandering through NGC 6559 is called Barnard 303, from the catalog of dark clouds created by the American astronomer E. E. Barnard. The gas glows from the hard ultraviolet radiation of the newborn hot stars. This radiation also pushes away most of the gas and dust near them and only the densest portions remain — the dust lanes and columns and mountains of dusty gas.

Cosmic Colors and Shapes in NGC 6559

Few regions in the sky exhibit the variety of color and detail shown by the region around NGC 6559. Dark and wispy absorption clouds float against a background of diffuse glowing hydrogen gas.

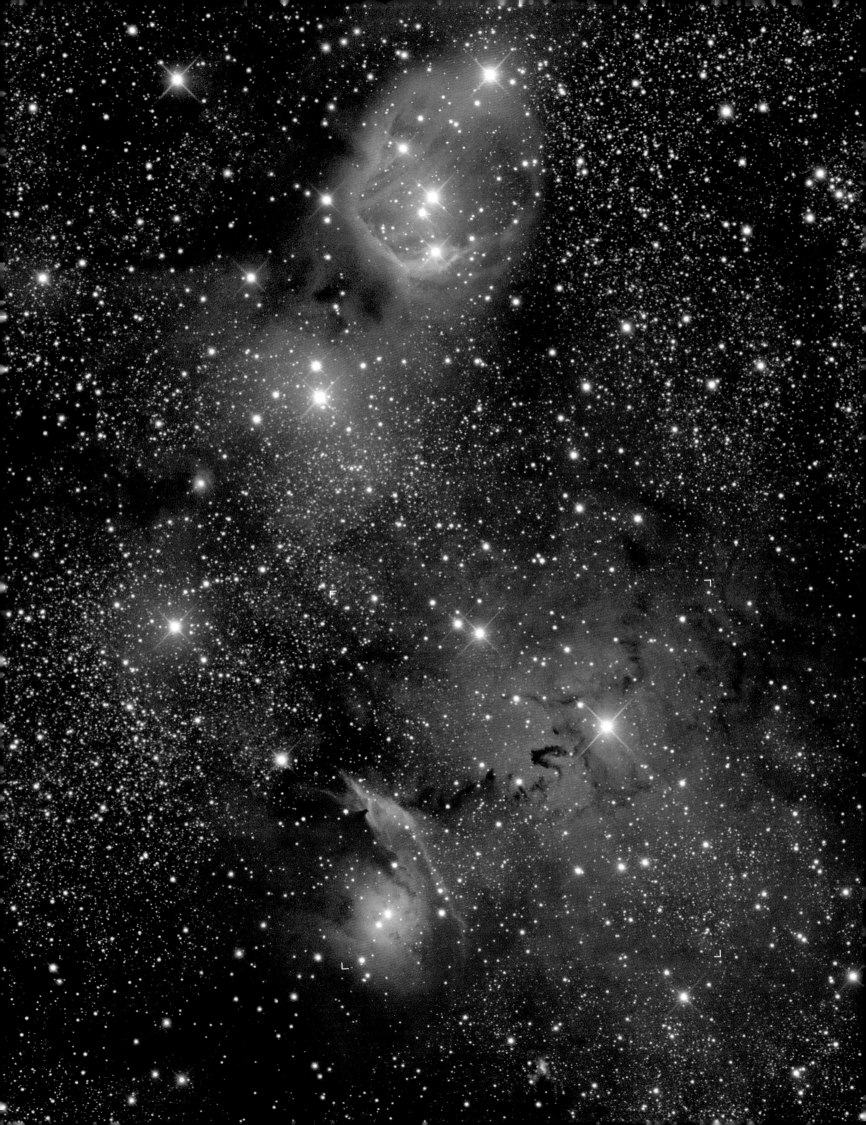

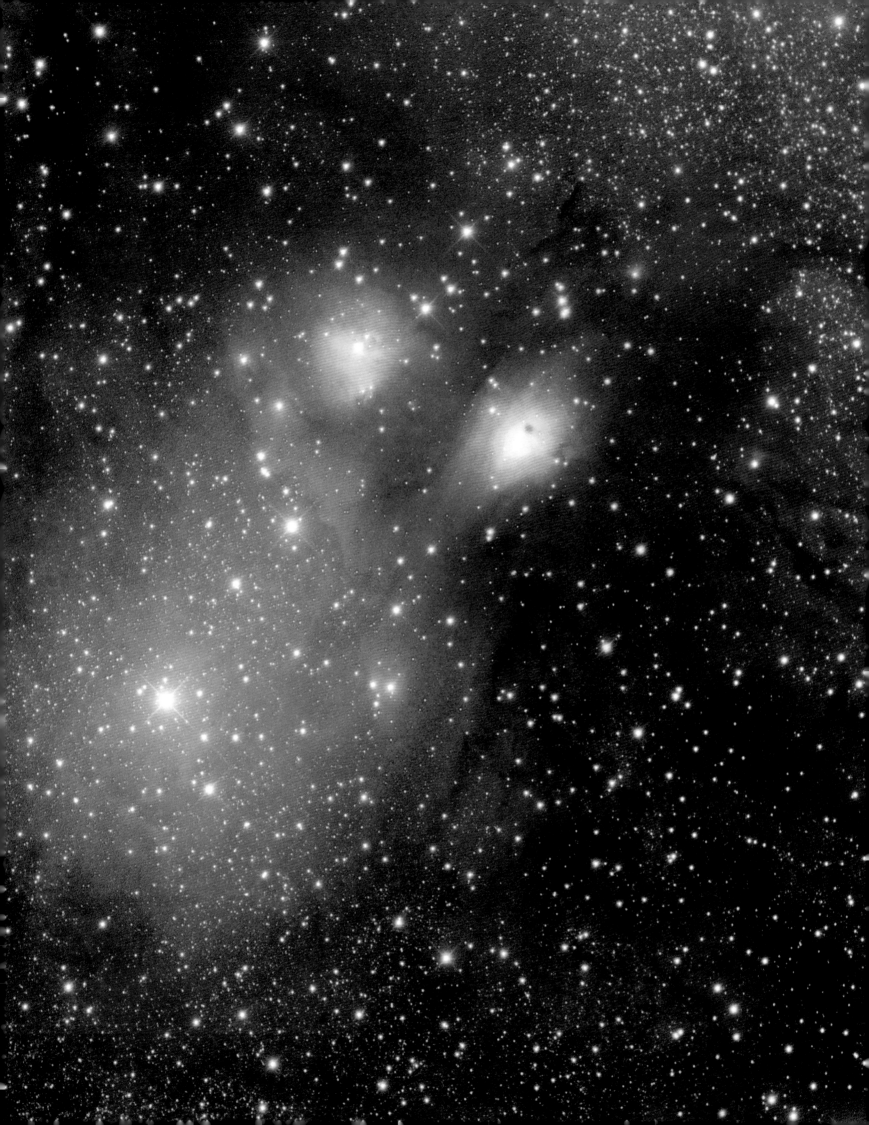

NGC 6589 and NGC 6590

This unusual scene is observed in the direction of the center of the Milky Way, in Sagittarius. Dust is everywhere and often partially obscures the view at visible wavelengths, making for difficult navigation. The two bright blue clouds are NGC 6589 and NGC 6590, both of which are reflection nebulae. The scattered starlight comes from two embedded young blue stars. These bright stars are part of the loose cluster IC 4715, although this cluster is so diffuse and loosely bound that its very existence is debatable. However we can be sure that the diffuse magenta cloud is an emission nebula, IC 1283–1284, which is excited by the brightest star of the putative cluster. The star is hot enough to disperse the ubiquitous dust, so that we see the starry background through the red emission of fluorescent hydrogen, again the result of the hot star. This region of our Milky Way is filled with dust clouds and young stars that together produce this richly varied view of a small part of the Milky Way where the exact nomenclature is tangled and complex, like this scene itself.

NGC 6589 and NGC 6590

The emission nebula IC 1283–1284 is seen to the left of this image, and nearby we find the two reflection nebulae, NGC 6589 and NGC 6590. The region is not far from the direction of the center of the Milky Way, and the flurry of nebulae, dust, and the rich tapestry of stars here makes it hard to distinguish between objects and to catalog them correctly.

Messier 16

Messier 16 is usually described as a cluster (NGC 6611) associated with nebulosity. In recent years it is the nebulosity (the Eagle Nebula, also called IC 4703) that has captured public attention, triggered by the Hubble Space Telescope's startling and iconic Pillars of Creation image. However, the stars are also of great interest, since they form one of the youngest known star clusters and, together with the unrelated stars of the Jewel Box (p. 104) and NGC 3293 (p. 88), define a sequence of clusters of increasing age, revealing much about the evolution of young stars in general. The dark pillars in the center are themselves part of this process.

Similar to the dramatic sandstone buttes that withstand the forces eroding the surrounding landscape, the tenuous dusty gas pillars of the Eagle Nebula resist the relentless erosive power of the ultraviolet radiation produced by massive neighboring stars. A similar and earlier process of compression and evaporation must have triggered the formation and release of the star cluster we see today.

The Messier 16 cluster is about 6.5 light-years from the dark pillars, which point accusingly at the hottest, most destructive stars, and the whole lightshow is in the constellation of Serpens Cauda (The Serpent's Tail), at a distance of 6500 light-years. The cluster, which contains stars ranging in age over a few million years, includes about a dozen hot O-type stars and many B-type stars that generate an intense radiation field, creating the vast red emission nebula.

Infrared View of the Center of the Eagle Nebula

Comparing an infrared view (above) with a visible-light view (main image, right) of the central parts of the Eagle Nebula, the difference is striking. Thousands of newborn stars that appear in the infrared image are hidden in visible light. The markers show the area imaged by the Hubble Space Telescope (adjoining, right).

Close-up of the Pillars of Creation

This iconic Hubble image shows finger-like features protruding from huge sinuous columns of cold gas and dust at the center of the Eagle Nebula. Inside the gaseous towers, which are light-years long, the interstellar gas is dense enough to collapse under its own gravity, forming young stars that continue to grow as they accumulate more and more mass from their surroundings.

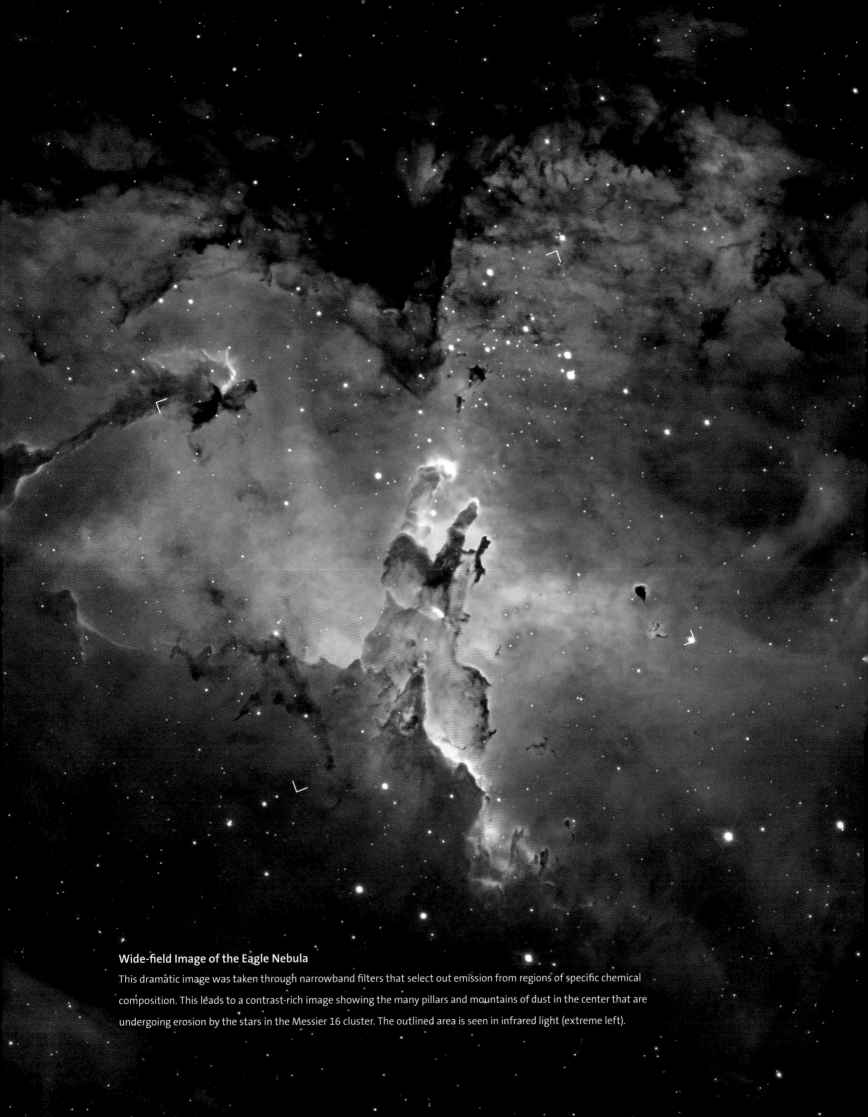

Wide-field Image of the Eagle Nebula
This dramatic image was taken through narrowband filters that select out emission from regions of specific chemical composition. This leads to a contrast-rich image showing the many pillars and mountains of dust in the center that are undergoing erosion by the stars in the Messier 16 cluster. The outlined area is seen in infrared light (extreme left).

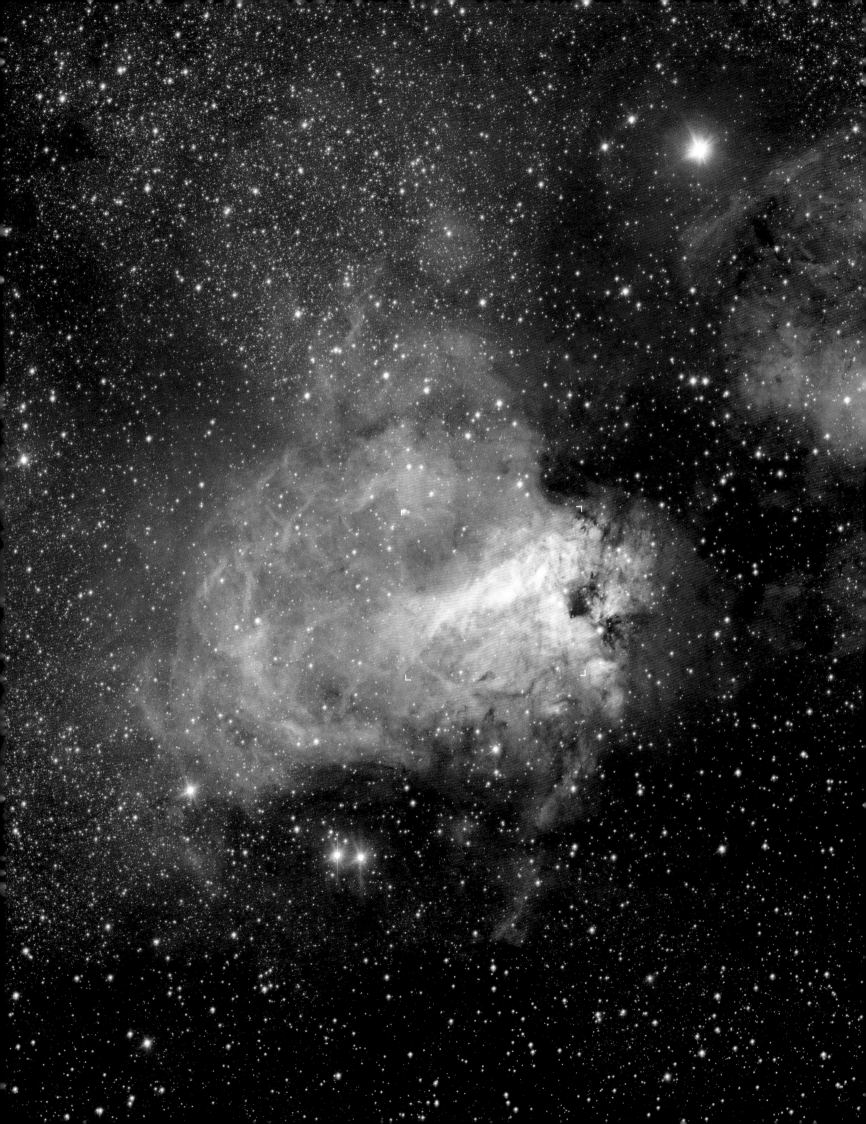

Messier 17

Messier 17 (NGC 6618) is in the inner Milky Way, in the Sagittarius–Carina spiral arm, the most conspicuous part of our galaxy especially when viewed from the southern hemisphere. It is about 6000 light-years distant, not far on the sky and in space from the more famous Eagle Nebula, Messier 16. Both are visible to the unaided eye under perfect conditions. Through a telescope Messier 17 reveals why it is sometimes called the Swan Nebula, or (from the Greek letter) the Omega Nebula. This last name came from a description by John Herschel.

Messier 17 is the illuminated part of one of the largest star-forming regions and molecular cloud complexes in the inner part of our galaxy, and it contains enough material to make 3000 stars like the Sun. The object is remarkable because it is a bright emission nebula, apparently devoid of the hot bright stars necessary to excite the abundant hydrogen. This is because the stars responsible for the emission are still hidden in the dusty molecular cloud and cannot be seen directly. However, some of their light filters through the dust, diluting the vivid red color of fluorescent hydrogen to a paler shade of pink in the brightest parts of the nebula. The energy from the stars also warms the dust, so Messier 17 is a strong infrared source.

Central Part of Messier 17

The intense light and strong winds from the hulking infant stars in Messier 17 have carved remarkable filigree structures in the gas and dust. In recent years, astronomers have discovered that Messier 17 is one of the youngest and most massive star-forming regions in the Milky Way. Active star birth started a few million years ago and continues today. The brightly shining gas shown in this picture is just a blister erupting from the side of a much larger dark cloud of molecular gas. The dust that is so prominent in the picture comes from the remains of massive hot stars that have ended their brief lives and ejected material back into space, and also from the cosmic detritus from which future suns will form.

Messier 17

Messier 17 is an active star-forming region of gas and dust about 15 light-years across, and the nebula has recently spawned a cluster of massive hot stars. This image was made with the VLT Survey Telescope (VST), located at ESO's Paranal Observatory.

NGC 6520 and Barnard 86

It is always easy to forget that the Universe is more or less transparent and that when we look into space we are literally looking in depth. The sand-like scattering of faint yellow stars we see in this rich star field in Sagittarius are among the oldest stars in the Milky Way and to the eye make up the brightest part of our galaxy. In this part of the sky, the line of sight passes close to the center of the Milky Way, about 26,000 light-years away. This scene is close to Baade's Window, selected by the German–American astronomer Walter Baade in the 1940s as a relatively unobscured view towards the hidden nucleus of our Milky Way. Some of the fainter stars will be at that distance. But not all the stars are equally faint, and some will have their light dimmed by intervening dust.

Against the backdrop of old and distant stars there are some that are nearby and young. Almost anything that is blue in this picture is young, but confusingly, a few of the brighter yellow stars are also juveniles, mostly members or outliers of the obvious open cluster NGC 6520 (above the center), whose age is about 150 million years. We can be fairly sure that these stars are about 5000 light-years away, and, if we assume that they were born in the adjoining dust cloud (Barnard 86), are also at the same distance. Although seemingly quiescent, Barnard 86 contains enough material to make about 600 stars the mass of the Sun. The bright yellow star close to it is a chance alignment — this star just 600 light-years away.

NGC 6520 and Barnard 86

This image shows the open star cluster NGC 6520 and nearby dust cloud Barnard 86, in the constellation of Sagittarius, one of the most crowded parts of the Milky Way.

Messier 22

Messier 22, also called NGC 6656, is in Sagittarius and is one of the nearest globular clusters to the Sun. It is about 10,000 light-years away, and it covers about half a degree of arc on the sky, corresponding to a diameter of 100 light-years. It contains at least half a million stars and, remarkably, one planetary nebula. This is not seen in this photograph, which was made from Hubble Space Telescope data, and shows only the central region of the cluster.

For overall brightness the cluster ranks third among the 150 or so known Milky Way globulars, but for northern hemisphere observers it hugs the southern horizon and so tends to be overlooked for more accessible clusters. Observing it from South Africa in the 1830s, John Herschel wrote *"A superb, very much compressed, round cluster …. admirably seen in twilight."* The cluster is actually more luminous than it appears because it lies close to the plane of the Milky Way, and we see it dimmed by foreground dust, which is not uniform across the cluster.

The distribution of globular clusters in the sky is also not uniform and on the widest scale appears to be centered on a point in Sagittarius. This was first appreciated in 1918 by Harlow Shapley, who realized that the globular clusters are in orbit around the hidden center of the Milky Way, and from their distribution he was able to determine the distance and direction of the center.

Globular Cluster Messier 22
Messier 22 is one of the nearest globular clusters to the Sun. It is about 10,000 light-years away and lies in the direction of the center of the Milky Way. This image was taken with the Hubble Space Telescope.

Messier 11

Messier 11 is a rich and compact open cluster of middle-aged stars with a total mass of about 11,000 times that of the Sun, with most of stars found within 30 light-years of the center. It lies about 6000 light-years away in the southern winter constellation of Scutum (The Shield). Messier 11 is also known as the Wild Duck Cluster since, with the aid of a telescope, and a vivid imagination, it resembles a gathering flock of water birds. Discovered in 1681 by Gottfried Kirch, Messier 11 became part of Charles Messier's famous catalog in 1764.

The cluster is about 220 million years old, and many of its more massive and luminous stars have evolved into red giants and vanished as supernovae. Some red stars do remain, as can be seen from the image. The age of the cluster explains why the dust and gas from which it formed have long since been swept away. This period, about 220 million years, is also roughly the time it takes our Milky Way to rotate once about its axis. In that time the cluster will have been influenced by the gravitational forces of massive molecular clouds and possibly other clusters, which will have removed any loosely bound stars and contributed to its compact appearance. It must have been a very spectacular cluster in its youth, a Galactic year ago.

There are few open clusters that have enough stars for both their radial velocity (along the line of sight) and their proper motion (across the line of sight) to be measured with any accuracy. However, Messier 11 is one such, and this can be used to give an accurate distance measurement, in this case 6200 light-years, in good agreement with other, independent methods.

Messier 11

Messier 11, the Wild Duck Cluster, is a compact, middle-aged open cluster at a distance of 6200 light-years.

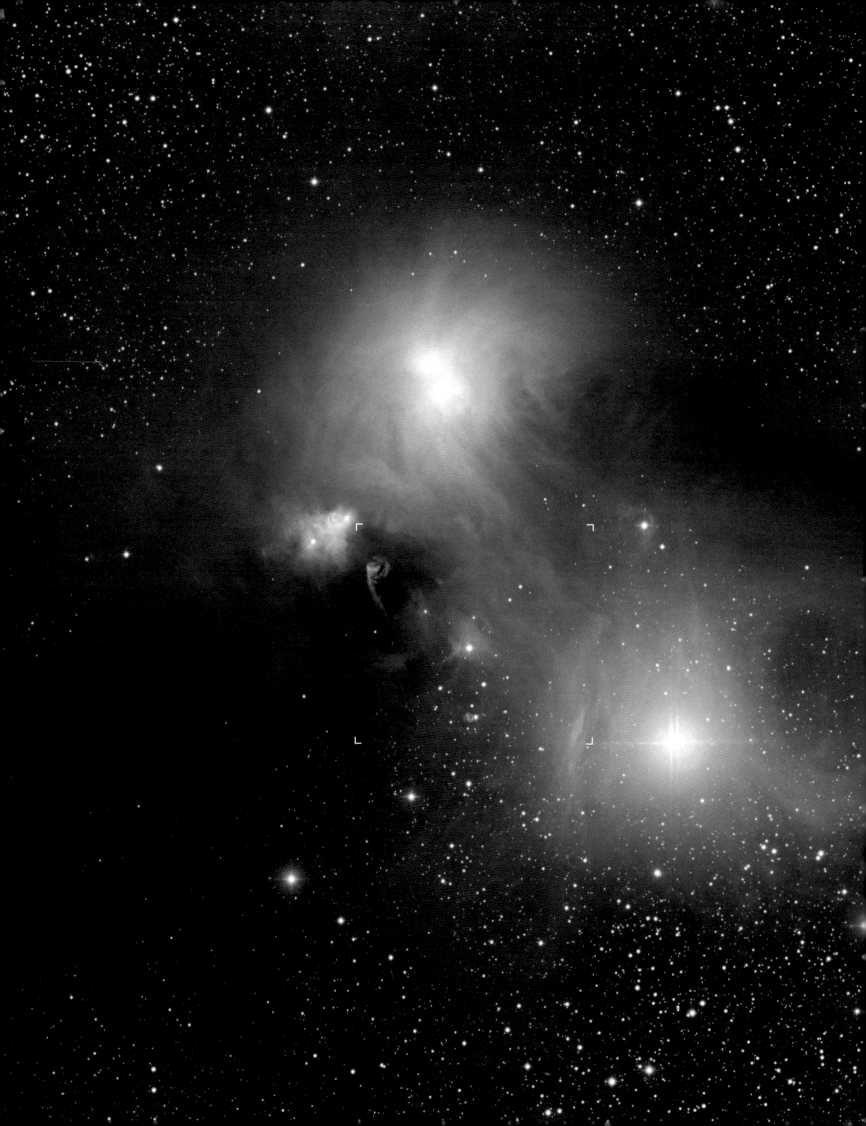

NGC 6726

The young stars of the Corona Australis region reveal their presence in a variety of ways. Most noticeable are the delicate blue clouds (NGC 6726–NGC 6727 and IC 4812) that reflect the light of their embedded progeny. Young stars have formed here recently, and the region is known as a fertile repository of embryonic and juvenile main-sequence stars.

The various stages of stellar evolution are in evidence throughout the field, although much of the activity is obscured by dust. Small red patches of light known as Herbig–Haro objects are visible in the image left. These unusual objects are the energetic outflows of otherwise invisible, embryonic stars. Still cloaked in the dust, these emerging suns are in the process of accreting. As the pressure and temperature inside the infalling dust and gas rises, nuclear fusion begins, turning a hot cloud of gas into a ball of incandescent plasma — a star. During this process powerful periodic outflows occur as the infant star settles into the equilibrium state that we know as the main sequence.

The field is also rich in a host of fascinating variable stars, variable nebulae, and stellar outflows. One particularly intriguing object is R Corona Australis, an irregular variable star buried within a small yellow cloud that powers two of the largest Herbig–Haro objects in the field. The vast dark cloud, known as Bernes 157 (near the left edge), attenuates the starlight of more distant suns and harbors the raw materials for the future stars of the region.

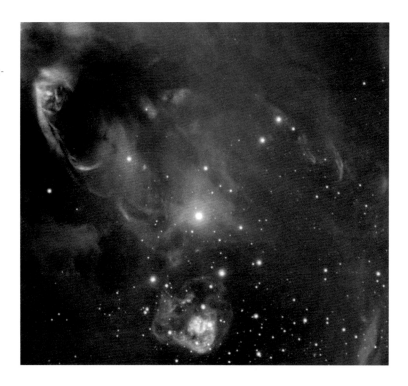

Central Part of NGC 6726

This image of the central part of NGC 6729 gives a close-up view of the dramatic effects that young stars have on their surroundings. Hidden from view, these stars reveal their presence when ejected material collides with ambient gas and dust clouds, sculpting a surreal landscape of glowing arcs, filaments, and shells. This enhanced color picture was created from narrowband images made by ESO's Very Large Telescope.

NGC 6726

This magnificent view of the region around the star R Coronae Australis was created from images taken with the Wide Field Imager at ESO's La Silla Observatory in Chile. R Coronae Australis lies at the heart of a nearby star-forming region and is surrounded by a delicate bluish reflection nebula embedded in a huge dust cloud, shown here in impressive detail. The subtle colors and varied textures of the dust clouds make this image resemble an impressionist painting. The prominent dark cloud known as Bernes 157 crosses the image from the center to the bottom left, where the visible light emitted by the stars that are forming inside the cloud is completely absorbed by the dust.

NGC 6744

NGC 6744 is a majestic barred spiral galaxy seen through the rich star fields of the southern constellation of Pavo (The Peacock). It has great similarities to the Milky Way in form, structure, and in its rate of star formation. We see it inclined at an angle of about 50 degrees to our line of sight, and it is at a distance of approximately 25 million light-years. However, despite its favorable inclination and large angular size (15 x 20 arcminutes) it has a low surface brightness, and long exposures are needed to show its full glory. Seen at radio wavelengths in the 21-cm line of neutral hydrogen, the galaxy is as large as the full Moon.

At its northern tip (lower left) NGC 6744 is interacting with a dwarf companion galaxy (NGC 6744A) in much the same way as the Milky Way interacts with the Large Magellanic Cloud, and on deep, wide angle images many faint dwarf galaxies can be seen around it, rather like the Local Group galaxies that cluster around the Milky Way. However, unlike the Milky Way, NGC 6744 is unusually isolated, with no equivalent of M31 nearby. The spiral arms are flocculent — have a fluffy appearance (at least on visible-light images), rather like the galaxies NGC 7793 (p. 172) and NGC 3521 (p. 90). NGC 6744 also appears to have several spiral arms, as does the Milky Way.

NGC 6744, the Milky Way's Twin
NGC 6744 in the constellation of Pavo resembles the Milky Way in many ways and is similarly surrounded by smaller, fainter dwarf galaxies.

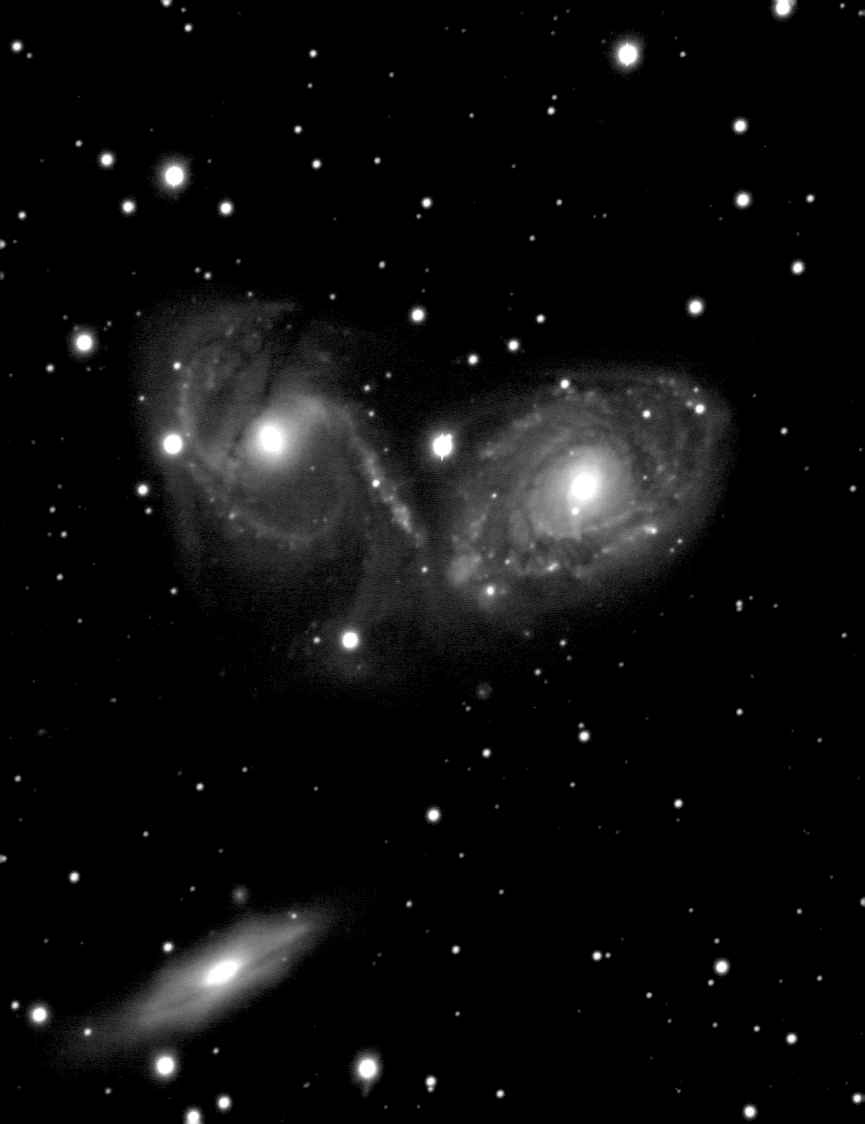

NGC 6769–6770–6771

This triple system of interacting galaxies shows features characteristic of the early phases of a galactic merger. The picture hints at a common envelope of gas and stars stripped from the main spiral galaxies as they approached each other. On deeper images this feature is easy to see, and the galaxies already show signs of interaction on the image shown here. Star formation is enhanced in the anomalously bright arm of NGC 6770, forming a bridge between the two spiral galaxies, and there is a curiously displaced dust lane over part of its nucleus.

The other main spiral galaxy (NGC 6769, upper right) appears relatively undisturbed, but it, too, reveals subtle anomalies on more detailed images. The third member of the group (bottom) is the edge-on S0 galaxy NGC 6771, which seems quite normal, but deep images again uncover a faint, diffuse bridge between it and NGC 6770. Each of these galaxies is being influenced by its neighbor, and since they share a common velocity of recession (between 3700 and 4200 kilometers per second) they are probably an associated triplet, in orbit around each other.

However, within a few galaxy diameters lurk two other significant galaxies (IC 4842 and IC 4845, not seen here), again with similar recession velocities, strongly suggestive of a small group. Interesting interactions occur within small groups, and it is probable that where there are now five galaxies, there may one day just be the one.

NGC 6769–6770–6771

Galaxies in groups and clusters move around among each other in a slow and graceful ballet. But every now and then, two or more of the members may get too close for comfort — the movements become hectic, sometimes indeed dramatic, as when galaxies collide. The image shows an example of a cosmic tango. This is the superb triple system NGC 6769–6770–6771, located in the southern constellation of Pavo (The Peacock) at a distance of about 200 million light-years.

NGC 6822

NGC 6822 is an irregular dwarf galaxy and a nearby member of the Local Group of 40 or so galaxies, which are mostly small and centered on the major members of the group, the Milky Way and Messier 31 in Andromeda. NGC 6822 is also known as Barnard's Galaxy, for the American astronomer E. E. Barnard, who discovered it in 1884. It is located in the direction of Sagittarius, which is something of a surprise, since the Milky Way fills much of that constellation, hiding everything beyond. As a consequence the galaxy is seen through a rich veil of nearby stars.

NGC 6822 is broadly described as of the Magellanic type and is very similar to the Large Magellanic Cloud, with a distinct, diffuse, and featureless bar and irregular distribution of bright groups of hot stars and their associated pink star-forming regions. However, its star formation rate is much lower than that in the Large Magellanic Cloud, probably because it is currently not involved in any strong interactions with massive neighbors.

At a distance of about 1.6 million light-years, the brightest stars in NGC 6822 are easily resolved in a telescope of moderate aperture, and in 1925, in a classic paper, Edwin Hubble found 12 Cepheid variable stars there. Using the newly established Cepheid period–luminosity relation, he determined the distance to NGC 6822. His result lay beyond the then currently accepted value for the distance to the edge of the Universe. Although his measurement was inaccurate by a factor of three, it stimulated an important and vigorous debate that soon led to the realization that the Universe was much bigger than anyone had imagined.

Barnard's Galaxy

One of our nearest galactic neighbors is Barnard's Galaxy, also known as NGC 6822. The galaxy contains a few regions of star formation and curious nebulae, such as the bubble clearly visible in the lower left of this remarkable vista. Astronomers classify NGC 6822 as an irregular dwarf galaxy because of its odd shape and relatively diminutive size by galactic standards. The strange shapes of these cosmic misfits help researchers to understand how galaxies interact, evolve, and occasionally cannibalize each other, leaving behind radiant, star-filled scraps.

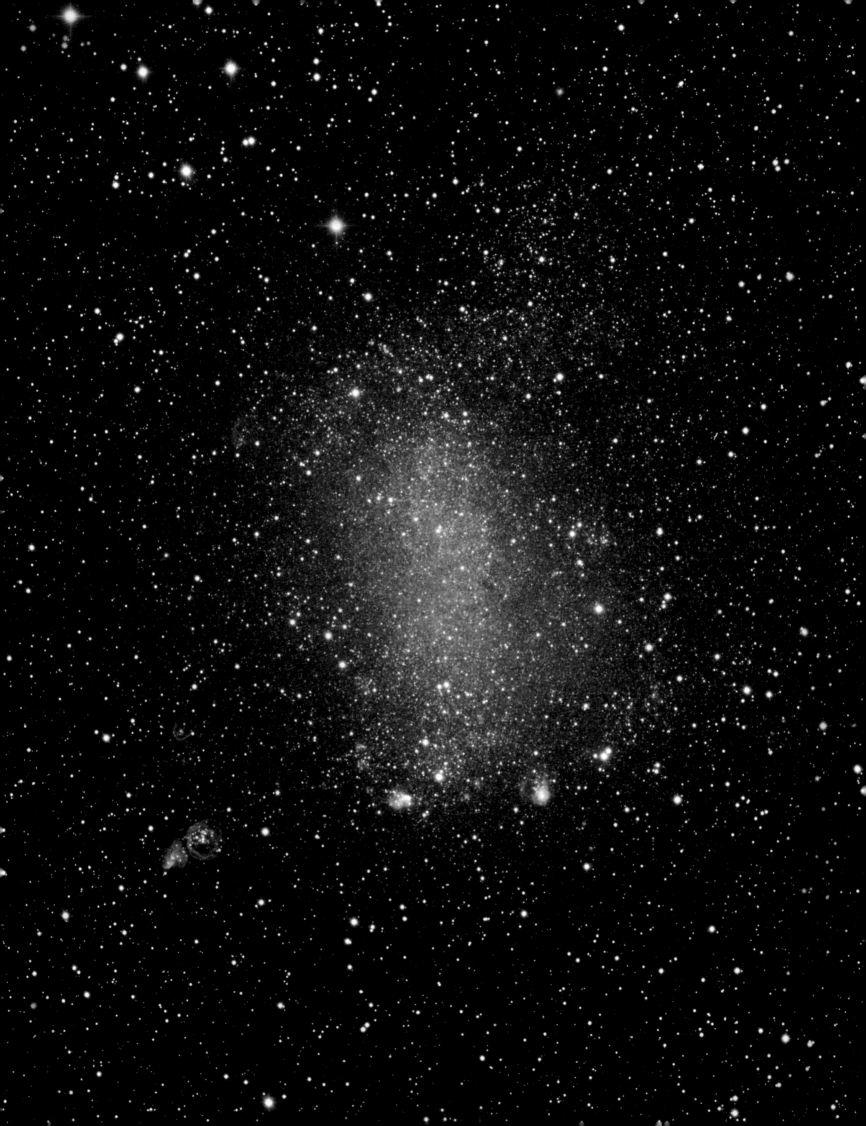

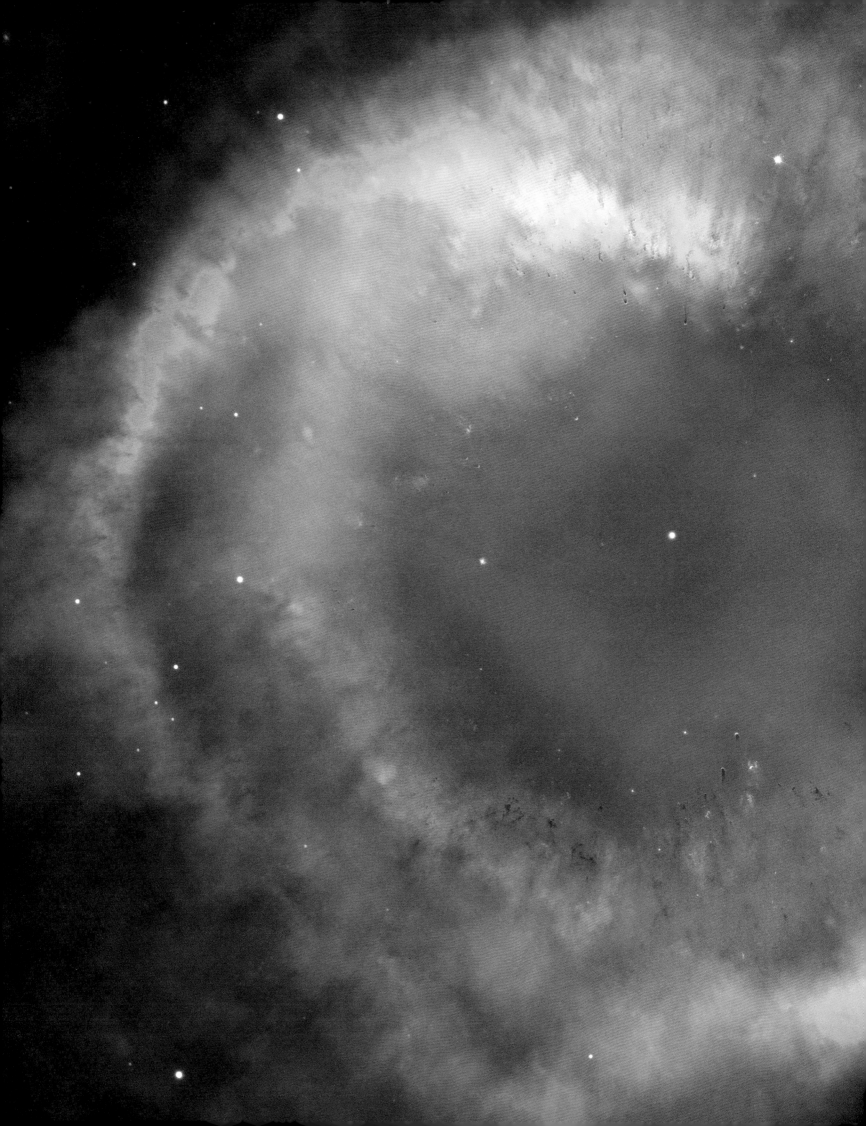

The Southern Spring

22.00 to 04.00 Hours Right Ascension

The Southern Spring

The southern spring is the season of the galaxies, as first Sculptor and then Fornax pass over head, each with a rich scattering of extragalactic objects. The South Galactic Pole lies in Sculptor, and so we find few stars and little dust in this direction; stars and dust are out of fashion in spring, as the Milky Way encircles the horizon. As summer approaches, the Small Magellanic Cloud rises ever higher, with its perpetual companion, 47 Tucanae. The Helix Nebula, here captured in narrowband mapped color by the Hubble Space Telescope, is an object of remarkable beauty and provides a glimpse of the ultimate fate of every sun-like star.

The Helix Nebula

The Helix Nebula (NGC 7293) is the nearest planetary nebula to the Sun, at a distance of about 650 light-years. The remnant of a dying, Sun-sized star, the nebula is composed of a series of concentric, expanding, shell-like structures. They are the surface layers of the star, material ejected during different phases of the star's death throes. The inner part of the nebula shows a series of cometary knots arranged like bicycle spokes, pointing away from the central hot star. Cometary knots are seen in other planetary nebulae, and they each are several times the size of our Solar System, much too big to be comets.

The cometary knots are thought to be formed when a hot stellar wind of gas plows into the colder shells of dust and gas previously ejected by the doomed star. The collision causes the gaseous mixture to become unstable (known as a Rayleigh–Taylor instability) so that it fragments into large clumps, which we see as the comet-like knots. These droplets are then blasted by the searing radiation from the newly exposed core of the dying star, which has a temperature of 100,000 degrees C. At this temperature, most of the radiation from the star comes in the form of ultraviolet light, which makes the distended and ejected material of the star fluoresce red and green, like the rarified gas in an advertising sign. However, among the stars, these colors advertise the presence of hydrogen and oxygen.

The Cometary Knots of the Helix

The knots in the Helix Nebula have long been a puzzle, but with the superb resolution of the Hubble Space Telescope some aspects of mystery have vanished. The individual knots are about as large as the Solar System itself but have a mass about that of Earth and are made of dusty gas; their heads are completely opaque and have the brownish hue of molecular clouds. They are shaped by the intense stellar wind from the central star, and their lifetime, like that of the Helix Nebula itself, is likely to be short.

The Helix Nebula

This composite image of the colorful Helix Nebula is about half a degree across (about the size of the full Moon) and was taken with the Advanced Camera for Surveys aboard the NASA/ESA Hubble Space Telescope and the 4-meter telescope at Cerro Tololo Inter-American Observatory in Chile. The object has such a large angular size that both telescopes were needed to capture a complete view.

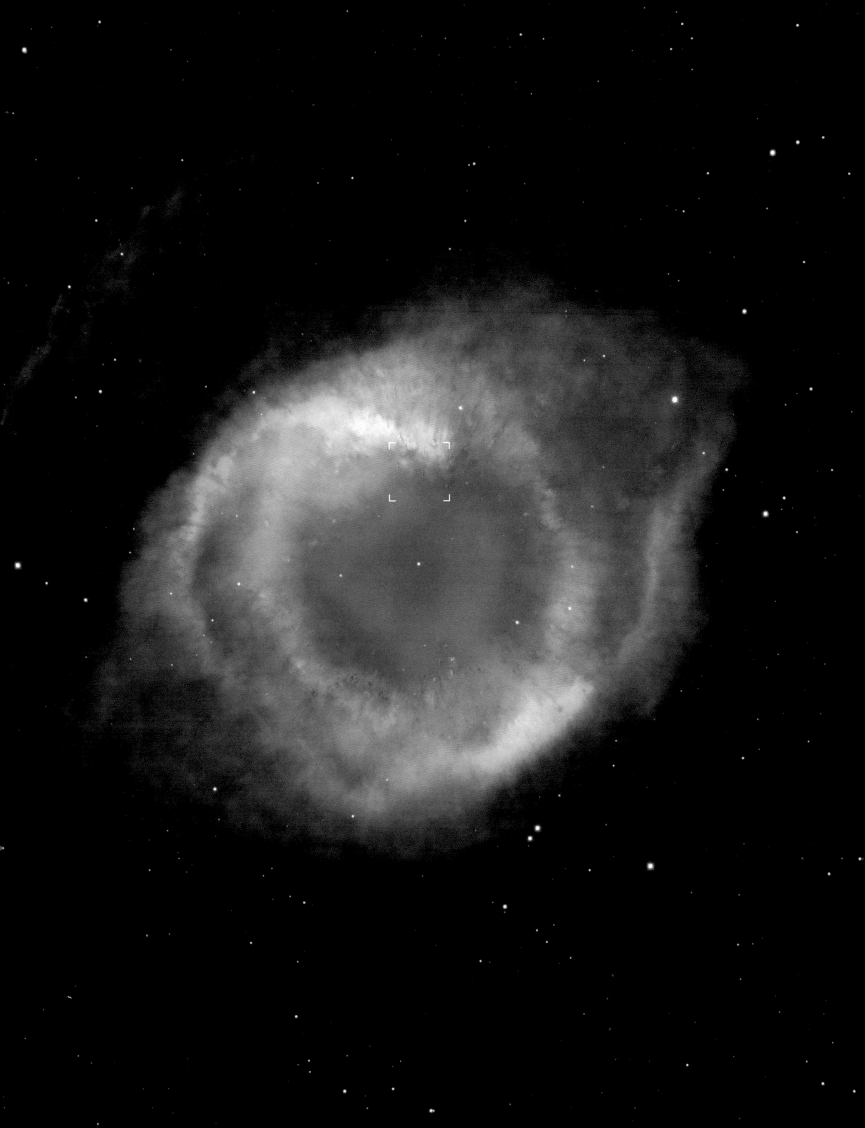

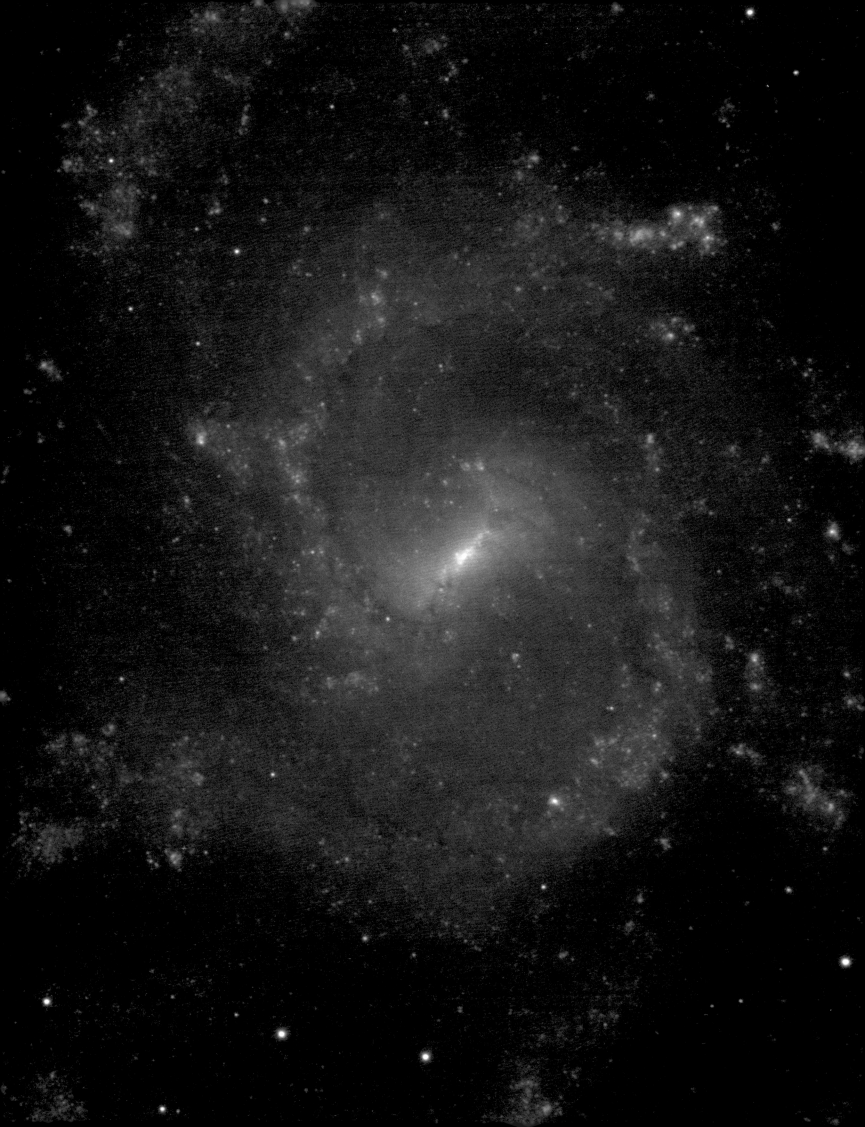

NGC 7424

NGC 7424 is a magnificent grand-design barred spiral galaxy discovered by John Herschel during his time at the Cape of Good Hope in the 1830s. He noted that it is very large and very faint. However, much of the detail seen in the photograph would not have been noticed, even by the most careful visual observer. The galaxy is seen almost face-on and is about 100,000 light-years across and 40 million light-years away. NGC 7424 has dimensions similar to that of the Milky Way, although with a central bar that is probably more pronounced. As in the Milky Way, many young star clusters are visible, scattered along the delicate spiral arms.

NGC 7424 is home to the fascinating supernova SN 2001ig, discovered by the Australian amateur astronomer Reverend Bob Evans, who has discovered over 40 supernovae in a similar number of years. The suddenly bright star was unusual, and over time seemed to transform itself from a Type II to a Type I supernova. Confused at first, astronomers concluded that a Wolf–Rayet progenitor star with a massive companion was probably responsible for the peculiar changes observed as SN 2001ig evolved. The story of SN 2001ig has enhanced our knowledge of the various processes that characterize supernovae in general.

Magnificent Spiral NGC 7424

The beautiful multi-armed NGC 7424 is seen almost directly face-on. Located at a distance of roughly 40 million light-years in the constellation Grus (The Crane), it is an example of a grand-design galaxy. It has many ionized star-forming regions as well as clusters of young and massive stars.

NGC 7793

NGC 7793 is an intriguing spiral galaxy 13 million light-years away in the direction of the constellation of Sculptor and is a member of the sparse Sculptor Group of galaxies. This cluster includes a number of dwarf galaxies and four other bright galaxies that appear in these pages, NGC 253 (p. 184), NGC 247 (p. 182), NGC 300 (p. 188), and NGC 55 (p. 176). The Sculptor Group is the nearest cluster of galaxies to the Local Group, which includes the Milky Way, Messier 31, the Magellanic Clouds, and a host of smaller entities. Although it is a defined as a group, and the galaxies appear together in the sky, the Sculptor Group is really a loose cloud of galaxies forming a cigar-shaped filament extending 20 million light-years along our line of sight. This collection, along with the Canes Venatici complex and the Local Group, appear to form a loose filament of the Virgo supercluster that extends over a distance of 33 million light-years.

NGC 7793 is another galaxy whose optical appearance causes it to be classified as "flocculent," with rather patchy, ill-defined spiral arms, similar to NGC 3521 (p. 90) and NGC 6744 (p. 160).

Wide-field View of NGC 7793

The chaotic spiral galaxy NGC 7793, as observed with the FORS instrument attached to ESO's Very Large Telescope at Paranal. This wide-field image shows the galaxy's transition from flocculent structure to a loose arrangement of radially symmetric spiral arms towards the nucleus, and is based on data obtained through blue, green, infrared and H-alpha filters.

Spiral Galaxy NGC 7793

This image shows NGC 7793, a member of the Sculptor Group. It has a chaotic spiral structure, unlike the class of grand design spiral galaxies. The image shows how difficult it is to identify any particular spiral arm in these chaotic structures, although it is possible to guess at a general rotating pattern. NGC 7793 is located about 13 million light-years away.

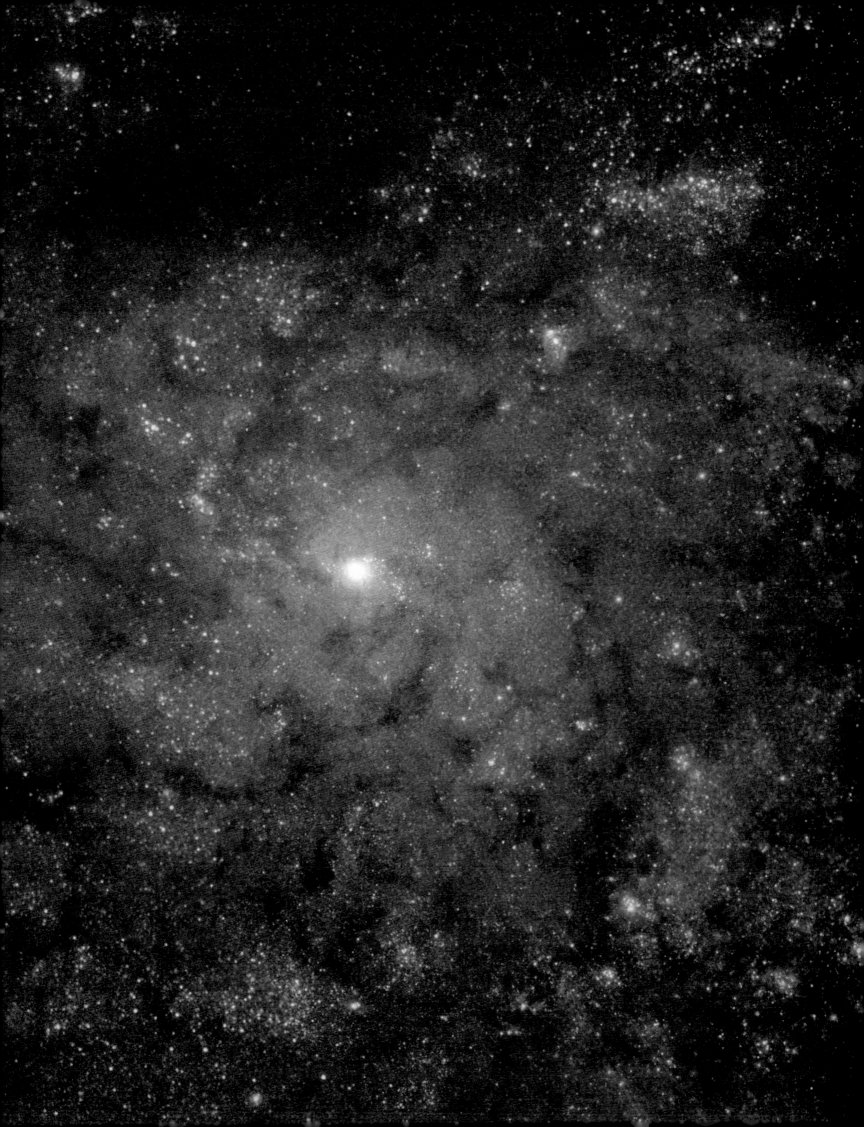

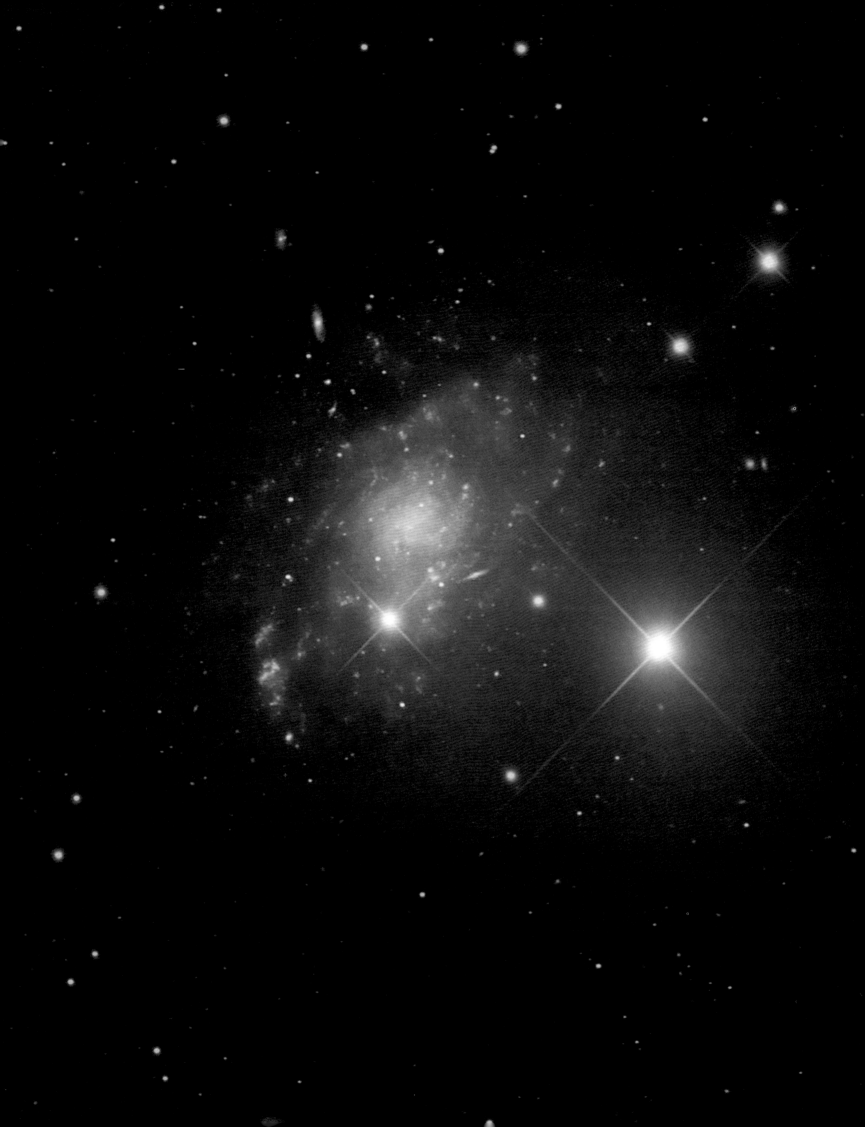

NGC 45

NGC 45 is remarkable for its faintness and is one of lowest surface-brightness spiral galaxies known in the local Universe. It may be an outlying member of the nearby Sculptor Group. The galaxy moves away from us with a recession velocity of about 500 kilometers per second, significantly larger than the average of the group, which is about 250 kilometers per second. The typical distance of the galaxies in the Sculptor Group from us is about eight million light-years, while NGC 45 is at about twice this distance. These discrepancies cast some doubt on its membership in the Sculptor Group.

Despite these doubts and qualifications NGC 45 is unusually small for spiral galaxy, with a diameter of about 30,000 light-years, and it is also quite rare, in that it exists without any obvious companions to stir up star formation. The stars are mostly organized in broad, ill-defined spiral arms inclined about 55 degrees to the line of sight, and there is no obvious dust or central bulge. In such low surface brightness galaxies, the mass is dominated not by the stars but by the invisible dark matter.

Faint NGC 45

NGC 45 is so faint and its dust content so low so that distant galaxies can easily be seen through its transparent disk. The bright foreground star has a magnitude of 6.5 (just visible to the unaided eye) and this makes closer investigations of NGC 45 difficult.

NGC 55

The nearest large galaxy to the Milky Way is the Large Magellanic Cloud, which we see from a distance of 170,000 light-years. It is inclined to our line of sight by about 40 degrees. Magellanic-type galaxies — lopsided spiral galaxies with an offset central bar — are quite rare, so we are lucky to have such a close view of such an unusual specimen.

For purely statistical reasons, edge-on galaxies are also rare, so we are especially fortunate to have in NGC 55 an example of a nearby Magellanic-type galaxy seen edge-on. NGC 55 is a member of the Sculptor group and much more distant than the LMC, at a distance of about six million light-years. As with others in that group (especially NGC 300, see p. 188) it is close enough for us to see it resolved into individual stars. With images made with a large telescope, the central regions look very much like the Milky Way as seen with an ordinary camera and lens.

In the Sculptor Group, the galaxies are few in number and well separated in space. It is probably for this reason that NGC 55 is not rich in star-forming regions, because it is not interacting with any nearby companion galaxies. This is unlike the Large Magellanic Cloud, which is stirred up by encounters with both the Milky Way and the Small Magellanic Cloud. If we could see the Large Magellanic Cloud edge-on it would likely be somewhat deformed by its relatively recent interactions with its near neighbors.

Edge-on galaxy NGC 55
The irregular galaxy NGC 55 is a member of a prominent group of galaxies in the southern constellation of Sculptor. The galaxy is about 70,000 light-years across, distinctly smaller than the Milky Way.

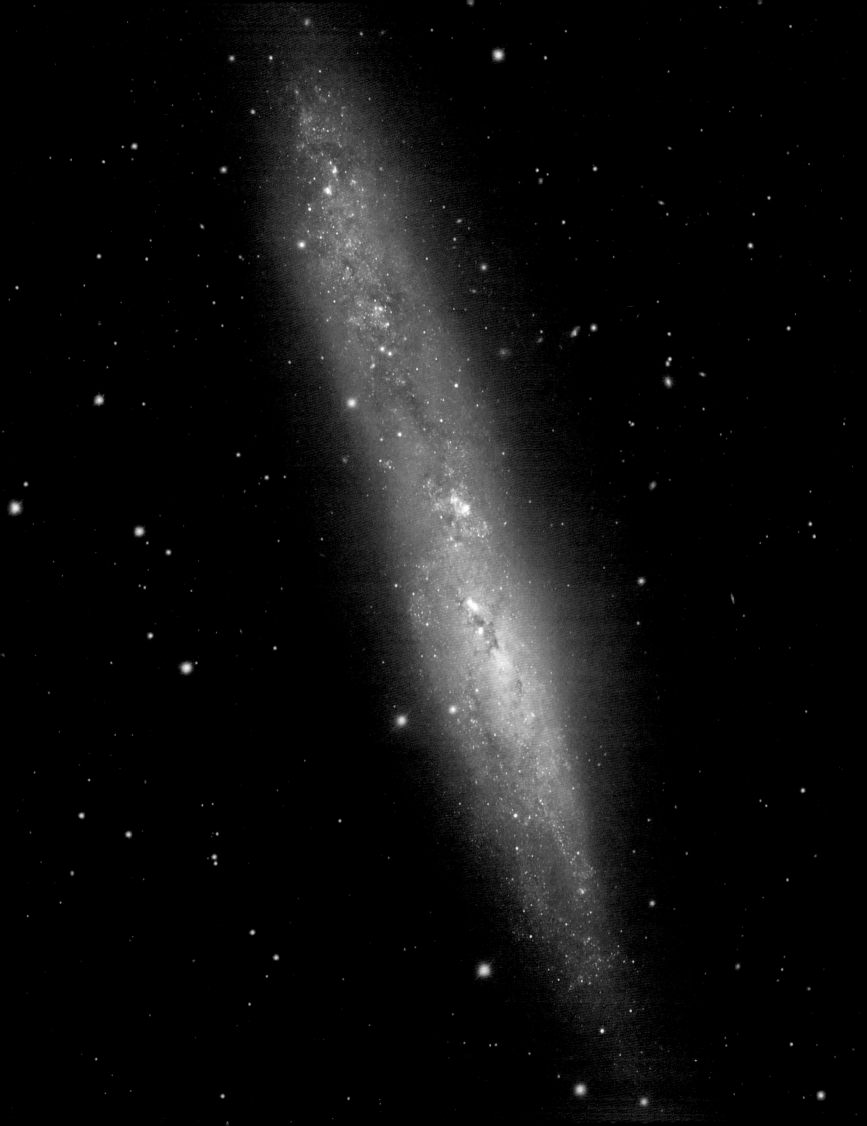

47 Tucanae

47 Tucanae, also known as NGC 104, is the second brightest globular cluster in the sky and is visible to observers south of the Tropic of Capricorn near the (unrelated) Small Magellanic Cloud at some time every clear night of the year. It is at about the same distance as Omega Centauri (16 000 light-years) and a magnitude fainter, but still hazy compared to a normal star. However, it presents a quite different appearance when seen in a telescope. Unlike Omega Centauri, 47 Tucanae is strongly condensed towards the center, so if it is the nucleus of a galaxy stripped of its stars by the Milky Way, it was probably a nucleated dwarf galaxy.

The concentrated light of one million stars packed into a volume of space 120 light-years across makes the heart of 47 Tucanae a very crowded place. If the Solar System were transported to the center of the cluster, the integrated starlight would fill the sky with stars and there would be no night. Also within the expanse of 120 light-years there are 20 or more millisecond pulsars and the X-ray binary stars from which these evolve. Here, too, are a similar number of blue stragglers, first described by Alan Sandage in 1953. These mysterious stars received their name because when their colors are plotted on the color–magnitude diagram that charts the path of stellar evolution, they appear to be "straggling" away from the main sequence of normal stars. They are probably formed from collisions and mergers of lower mass stars. While 47 Tucanae is clearly an ancient cluster, it is far from being the dead heart of a long-vanished galaxy.

47 Tucanae

The concentrated light of one million stars packed into a volume of space 120 light-years across makes 47 Tucanae the second brightest globular cluster in the sky, surpassed only by Omega Centauri.

The Cartwheel Galaxy

The Cartwheel Galaxy (ESO 350-40) was noted by Fritz Zwicky in 1941, but wide-field images of it on early survey plates from the UK Schmidt Telescope were so intriguing that it was soon studied in detail using the Anglo-Australian Telescope.

Lying about 500 million light-years away in the constellation of Sculptor, the cartwheel shape of this galaxy is the result of a violent galactic collision about 300 million years ago. A smaller galaxy has passed right through a large disk galaxy and produced shock waves that swept up gas and dust — much like the rings of waves produced when a stone is dropped into a lake — and the ripples have sparked regions of intense star formation (appearing blue). The bright, outermost ring of the galaxy, which is 1.5 times the size of our Milky Way, marks the shock wave's leading edge. This object is one of the most dramatic examples of the small class of ring galaxies, and it is a great laboratory for studying supersonic collisions between and within galaxies.

Astronomer Bob Fosbury, who led the European Hubble group, the Space Telescope-European Coordinating Facility (ST-ECF) when it closed in 2010, was responsible for much of the early research into the Cartwheel Galaxy along with the late Tim Hawarden — including giving the object its very appropriate name.

The Cartwheel Galaxy Imaged with Hubble
This image of the Cartwheel Galaxy was produced by reprocessing a Hubble dataset from 1994. The reprocessing has brought out more detail in the image than ever before. The remarkable features of this galaxy are the results of a violent galactic collision, either with one of the two small companion galaxies or yet another galaxy that lies off the edge of the image.

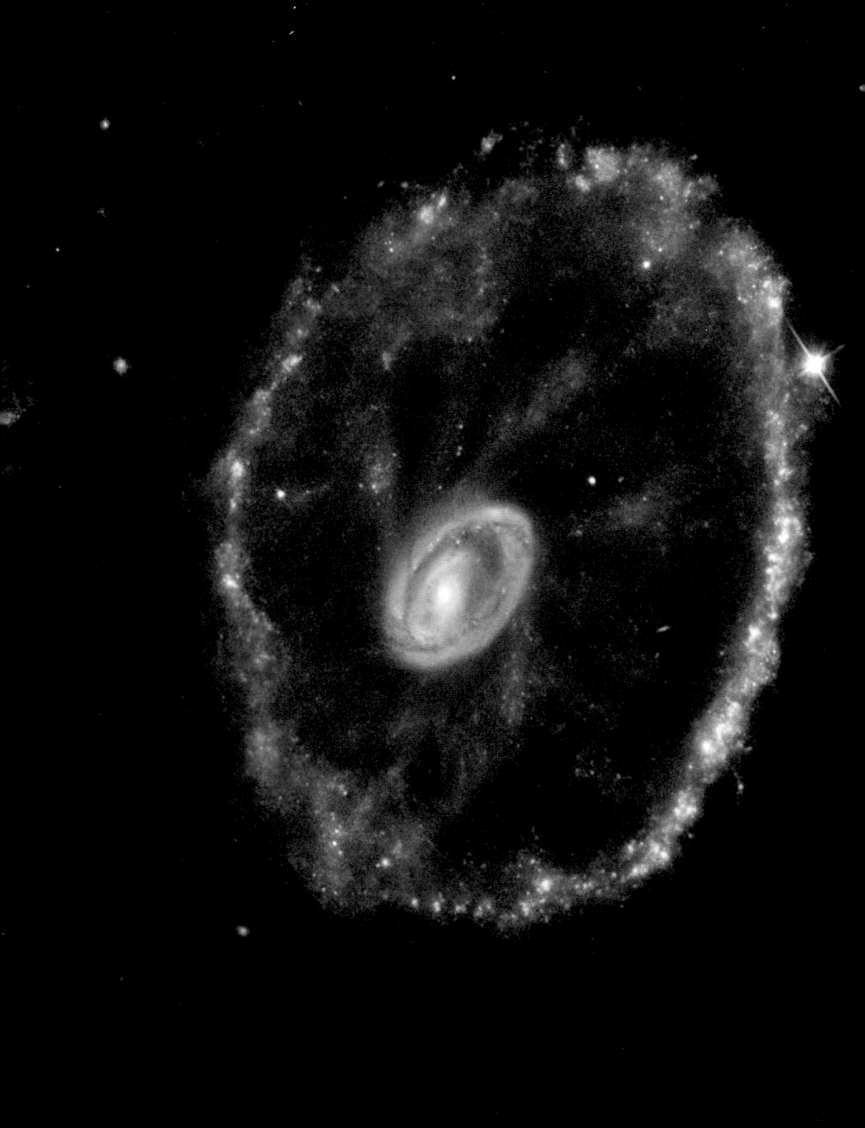

NGC 247

NGC 247 is a dwarf galaxy seen inclined at an angle of about 75 degrees to the line of sight and is a member of the nearby Sculptor Group. The constellation is close to the South Galactic Pole, so the galaxies of the Sculptor Group are seen in a field almost devoid of bright stars. Despite its unfavorable inclination, NGC 247 can be seen to have two main spiral arms where a modest amount of star formation is occurring. The star formation rate can be found from the infrared brightness and the intensity of the radiation from the emission nebula, and in NGC 247 it appears to be equivalent to the creation of a solar-mass star every ten years. For comparison, the Milky Way produces about 70 such stars in ten years.

Dwarf galaxies are defined by their relatively small size and mass and are the most common type of galaxies within groups and clusters, greatly exceeding the number of "normal" spirals and ellipticals. In one standard scenario of cosmic evolution, galaxies are built up by the hierarchical merging of smaller galaxies into larger ones. As the most common type of galaxy in the Universe, dwarf galaxies are thought to be representative of simple, small primordial galaxies unchanged over billions of years. However, the stellar population of NGC 247 shows clear evidence of ongoing, if modest, star formation and it is quite possible that it is itself the result of mergers.

NGC 247

This image of NGC 247 reveals the fine details of this highly inclined spiral galaxy and its rich backdrop. The spiral galaxy NGC 247 is one of the closest spiral galaxies in the southern sky. In this new view from the Wide Field Imager on the MPG/ESO 2.2-metre Telescope, many of the galaxy's component stars are clearly resolved, and glowing pink clouds of hydrogen, marking regions of active star formation, can be made out in the loose and ragged spiral arms. Apart from the main galaxy itself, this view also reveals numerous others far beyond NGC 247. In the upper right of the picture three prominent spirals form a line and still farther out, far behind them, many more galaxies can be seen, some visible through the disk of NGC 247.

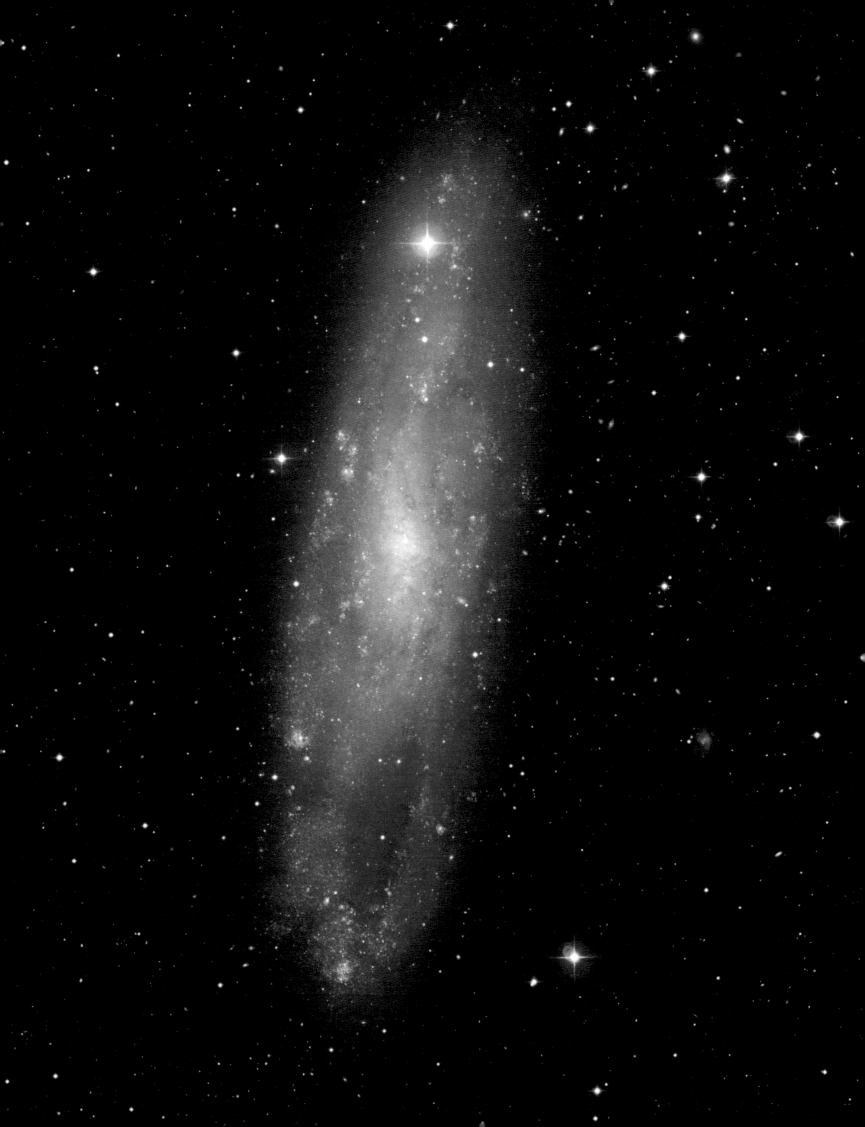

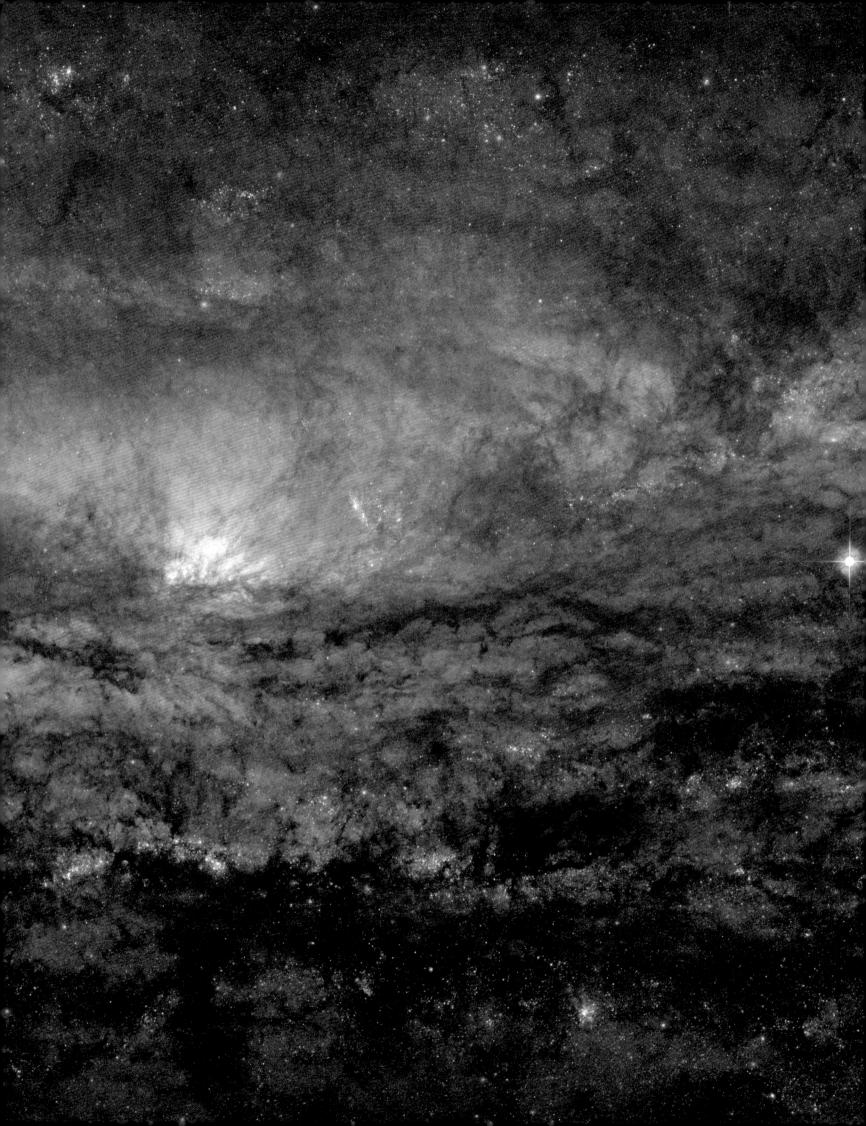

NGC 253

NGC 253 is the brightest member of the Sculptor Group of galaxies. Despite being a widely scattered group, this is a true physical association of galaxies whose prominent members include NGC 247 (p. 182), NGC 300 (p. 188), and NGC 55 (p. 176). NGC 253 is a typical starburst galaxy, which implies a high rate of star formation. It is seen almost edge-on and is about 13 million light-years distant. As might be expected in a starburst galaxy, dust dominates the picture, obscuring the prominent central bar that is seen in infrared images. This dust is seen in silhouette against light from the spiral arms. The very bright central part of this galaxy also shows evidence of a violent burst of star formation that began some 30 million years ago. Unlike the light from the central regions of more normal spiral galaxies, which contain older, cool stars, the conspicuous yellow-orange color of the center of NGC 253 seen here is the dust-attenuated light of young, luminous blue stars rather than of the older and fainter yellow population. NGC 253 undoubtedly also hosts an older population of stars around its nucleus, but its presence is dimmed by the dust.

The Sculptor Galaxy

This image shows a small part of the eastern half of NGC 253, and was specially made from five images obtained from the Hubble Legacy Archive. It reveals the extreme dustiness of the galaxy, which is the more obvious because we see it highly inclined to our line of sight. The galaxy glows at 7th magnitude, on the threshold of naked-eye visibility; it is easily seen in binoculars, and in a small telescope NGC 253 looks like a bright elongated silvery streak, about 20 arcminutes long on the sky — almost the width of the Moon. This may account for its alternative name, the Silver Coin Galaxy.

The Small Magellanic Cloud

The two Magellanic Clouds and the Milky Way have a long history of mutual interaction, which has profoundly affected the structure and star-forming history of all three galaxies. The Small Magellanic Cloud (SMC) is about 200,000 light-years from the Sun, and about 75,000 light-years from the LMC — very close by galactic standards. It contains about half as many stars as the LMC and is slightly more distant than its larger companion, which makes it rather more difficult to see with the unaided eye. Its visible extent spans over 7000 light-years, again less than the LMC, and careful observations of the proper motions of its stars show that it is stretched out along the line of sight, a truly irregular galaxy.

Optically, its structure is rich in star-forming regions, young star clusters, and supernova remnants, all indicators of sustained and active star production over the last few million years. The SMC is an important object in astronomical history. It was by measuring the brightness of stars in this galaxy from photographic plates that Henrietta Leavitt discovered the period–luminosity relation of Cepheid variables. This was a key observation that eventually allowed the distances of nearby galaxies to be determined for the first time.

The Magellanic Clouds, as with other irregular dwarf galaxies, are rich in gas and dust, and because of their interactions with each other and the Milky Way, they exhibit higher than normal levels of star formation. Astronomers have traced the star-forming history of the SMC and have concluded that approximately half of the stars that ever formed in the SMC are older than 8.4 billion years.

The Small Magellanic Cloud
The Small Magellanic Cloud and its bigger companion the Large Magellanic Cloud are dwarf galaxies that interact with the Milky Way. This spectacular image emphasizes the main, vivid red star-forming regions. The most prominent objects are the star-forming region LHA 115–N66 (left of center, p. 190), the globular cluster NGC 362 (left), and the impressive foreground globular cluster 47 Tucanae (p. 178) at the top.

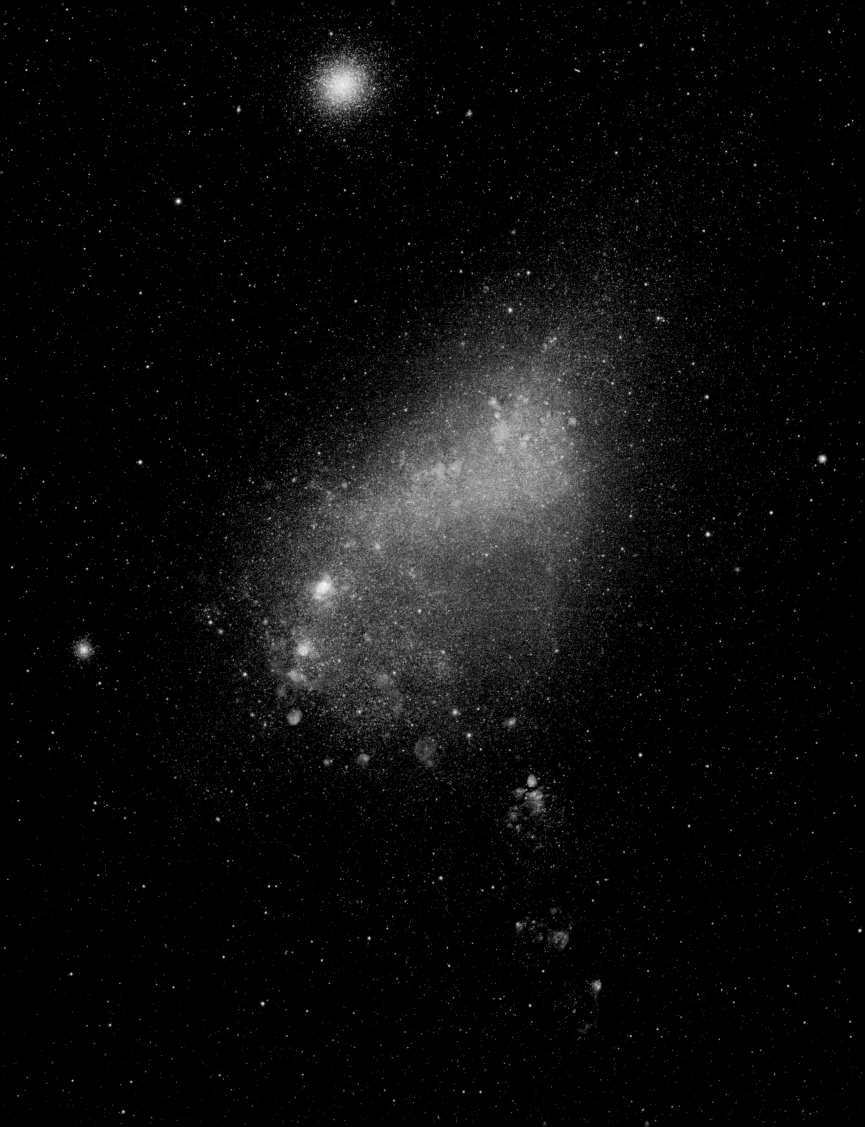

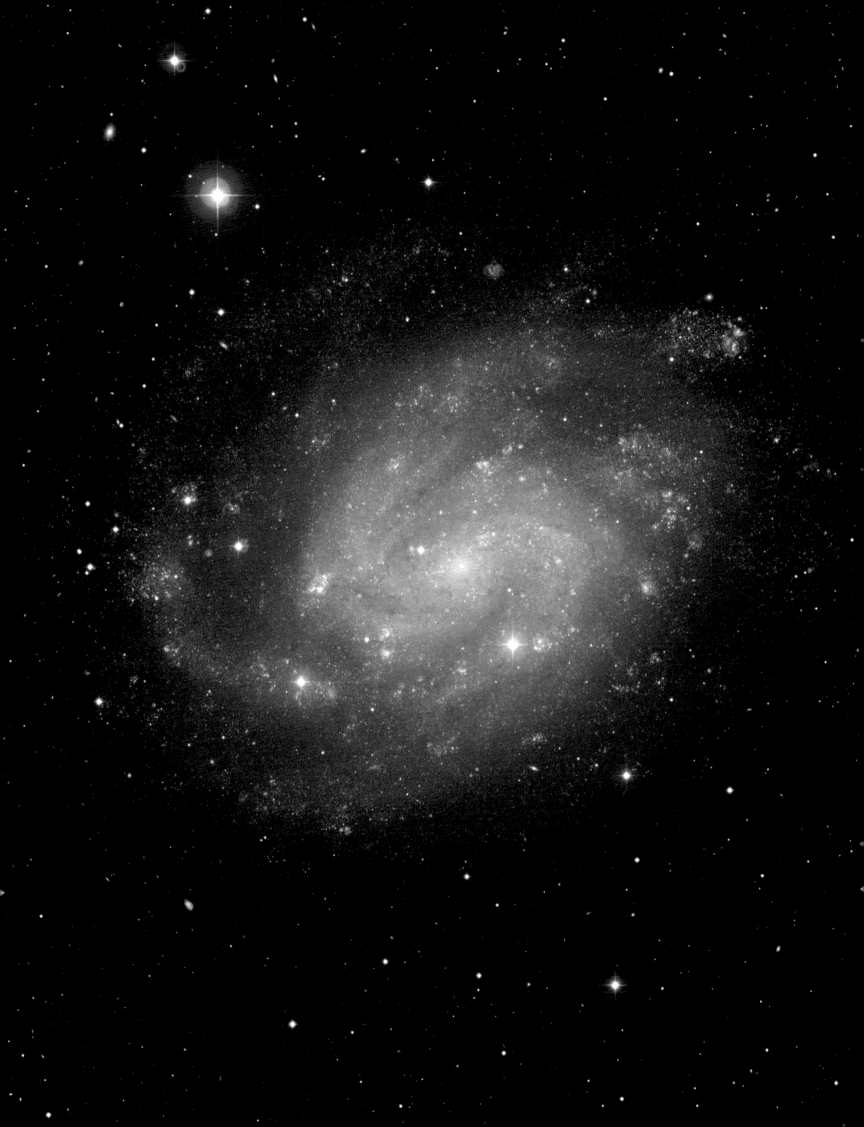

NGC 300

The Sculptor Group is the nearest group of galaxies to the Local Group and is dominated by five major spiral galaxies including NGC 300, NGC 253 (p. 184), NGC 247 (p. 182), NGC 55 (p. 176), and NGC 7793 (p. 172). It also contains some 20 dwarf galaxies.

NGC 300 is a relatively low surface-brightness galaxy, seen nearly face-on, and, like NGC 55, is in the foreground of the cluster, at a distance of six million light-years. The galaxy has very ill-defined spiral arms with a scattering of pink star-forming regions, some of them quite massive. The arms of the galaxy are well resolved into stars by large ground-based telescopes and are seen to be greatly extended on deep photographs. Although the galaxy is superficially similar to the better-known Messier 33 in the northern sky, its stellar disk is quite old, in contrast to Messier 33.

The outer regions of NGC 300 have a very high mass-to-luminosity ratio, suggesting that a massive halo of dark matter governs the rotation curve of the outer disk. Less deep color images reveal a rather weak central bulge and, most unusually, a very compact and distinctive nucleus. This has recently been found to host an equally unusual binary X-ray source, which appears from its X-ray spectrum to be a Wolf–Rayet star in orbit around a black hole.

NGC 300

This deep, 50-hour exposure taken with the MPG/ESO 2.2-metre Telescope in Chile reveals the structure of the galaxy in exquisite detail. NGC 300 lies about six million light-years away and appears to be about two thirds the size of the full Moon in the sky. NGC 300 is one of the closest spiral galaxies in the southern skies, but it is faint and difficult to find in binoculars.

NGC 346 and LHA 115–N66

LHA 115–N66, or N66, is the brightest star-forming region in the Small Magellanic Cloud, a dwarf satellite galaxy of the Milky Way. At its center we find NGC 346 — the open star cluster that illuminates this vast nebula complex spanning almost 200 light-years. The stars of NGC 346 are young, having formed only a few million years ago.

A torrent of radiation from the hot stars in NGC 346 eats into the denser areas surrounding it, creating a fantastical sculpture of dust and gas. The dark, intricately beaded edge of the ridge, seen in silhouette, is particularly dramatic. It contains several small dust globules that point back towards the central cluster, like windsocks caught in a gale (also see the pillars in Messier 16, p. 148).

Energetic outflows and radiation from hot young stars are eroding the dense outer portions of the star-forming region, exposing new stellar nurseries. The diffuse fringes of the nebula prevent the energetic outflows from streaming directly away from the cluster, leaving instead a trail of filaments marking the swirling path of the outflows.

Recent X-ray investigations have revealed that superheated gases permeate the region of N66 and were likely left over from an ancient supernova event many thousands of years ago.

Young Stars Sculpt Gas With Powerful Outflows in NGC 346
This Hubble Space Telescope view shows LHA 115–N66, one of the most dynamic and intricately detailed star-forming regions in space, located 210,000 light-years away in the Small Magellanic Cloud. At the center of the region is the brilliant star cluster NGC 346. LHA 115–N66 exhibits a dramatic structure of arched, ragged filaments with a distinct ridge surrounding NGC 346.

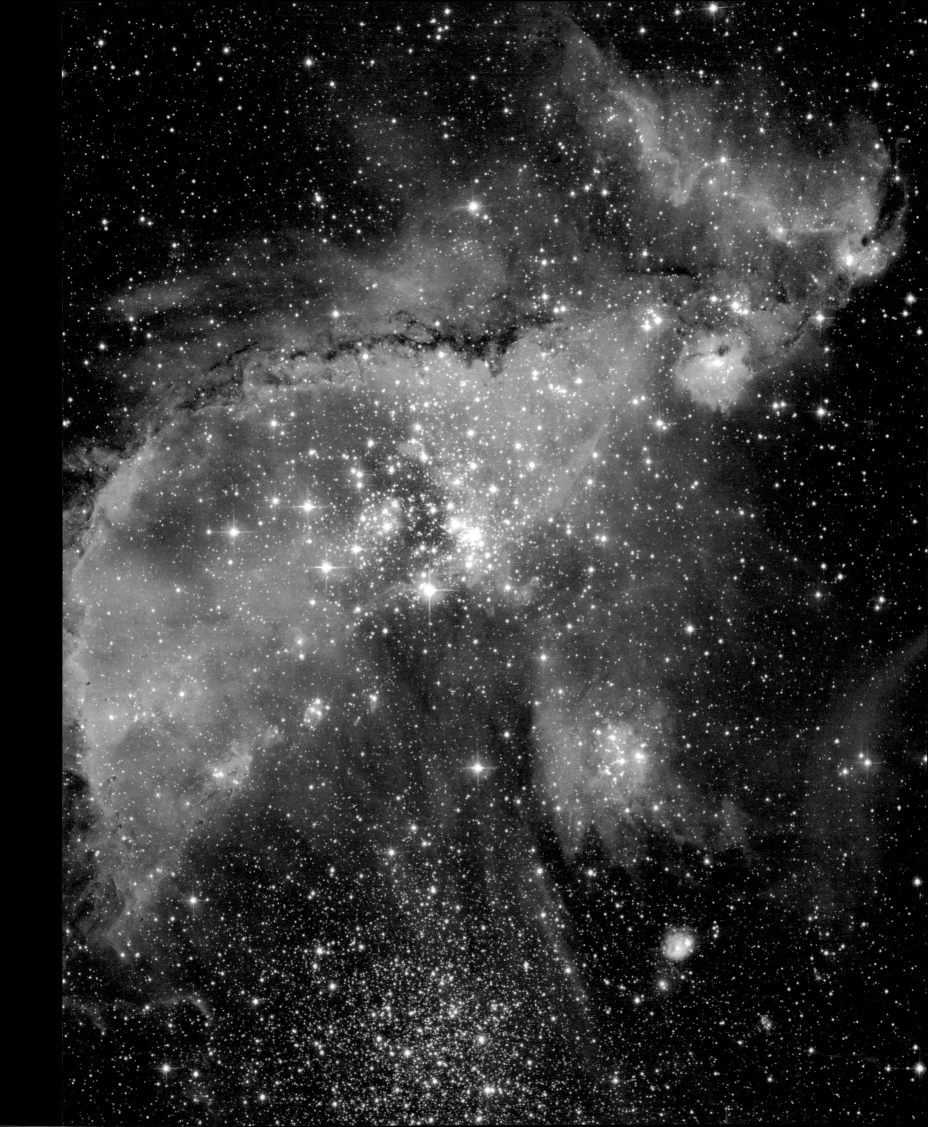

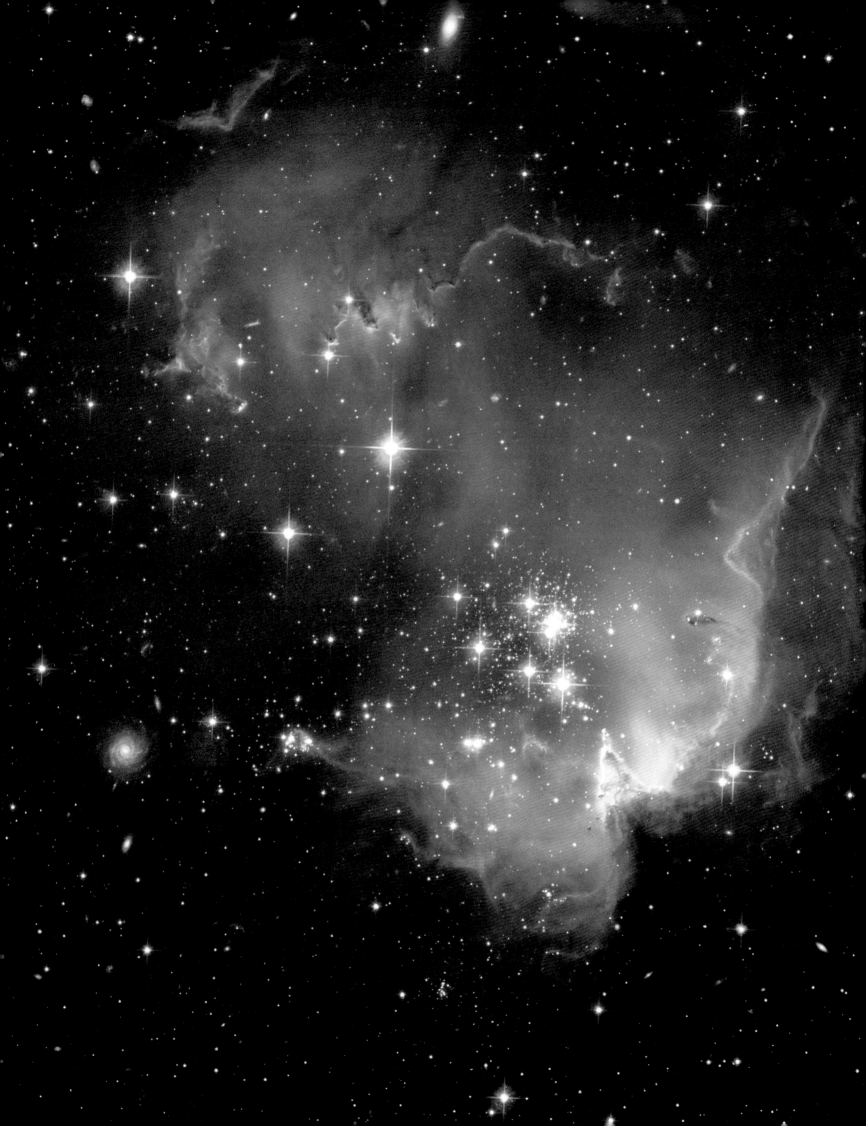

NGC 602 and LHA 115–N90

NGC 602 is a delicate gathering of young stars in the Small Magellanic Cloud, about 200,000 light-years distant. The sparkling star cluster appears suspended in the curved embrace of veils of dust and gas, which reflects the light from the stars and is at the same time being molded by it. The energy blazing out from its handful of newly-formed stars is shaping the nebula known as LHA 115–N90 and eating into the dusty material that produced them. These few hot giants are born with many lightweight siblings that are part of the same cluster, but that will far outlive the most luminous stars. These are Sun-like stars, destined for a life measured in billions of years, while their more lustrous brethren will vanish as supernovae in a few tens of millions of years. As these explode and disappear so will all traces of the surrounding gas, leaving a cluster of long-lived stars in the Small Magellanic Cloud, seemingly untouched by their surroundings. Far beyond, and at the fringes of the gas and the star cluster, numerous background galaxies can be seen, some of them spirals like the Milky Way. Although most of them are much more massive than the Small Magellanic Cloud, they seem insignificant in the face of the foreground drama.

NGC 602 and LHA 115–N90

This image from the Hubble Space Telescope shows LHA 115–N90, one of the star-forming regions in the Small Magellanic Cloud. LHA 115–N90 is located in the wings of the Small Magellanic Cloud, in the constellation of Tucana, approximately 200,000 light-years away from the Earth. The high energy radiation blazing out from the hot young stars in the central cluster, NGC 602, is eroding the outer portions of the nebula from the inside, as the diffuse outer reaches of the nebula prevent the energetic outflows from streaming away directly from the cluster. Magnificent sinuous pillars of dust point towards the hot blue stars and are the telltale signs of this type of erosion.

Messier 77

Messier 77, also known as NGC 1068, is an archetypical example of a Seyfert type II galaxy and is the brightest galaxy of its class. Galaxies of this type are named for the American astronomer Carl K. Seyfert (1911–1960) who, in 1943, was the first to describe their characteristics. He noted their brilliant, star-like nuclei with a strong and distinctive emission-line spectrum. The nature of the spectrum implies that the gas that is producing it is traveling at a very high velocity, probably as an accretion disk around a black hole. However, Seyfert died long before black holes — or even accretion disks — became a common topic of conversation among astronomers.

Messier 77 is a large, very luminous galaxy (as usually befits a Seyfert type II) seen almost face-on, and with its faint outer spiral arms, it extends up to 170,000 light-years across. Although the luminosity of Seyferts in visible light is not particularly unusual for spiral galaxies, their total luminosity including radio, X-ray, and especially infrared energy is over one hundred times that of a normal galaxy. They are believed to be nearby, low-luminosity versions of the same kind of phenomena that characterize the distant quasars and may be a transitional state between black hole-powered quasars and normal galaxies.

Messier 77 as seen with Hubble

Messier 77 (NGC 1068), is one of the brightest nearby active galaxies. It is located in the constellation of Cetus (The Whale) at a distance of about 60 million light-years and is one of the biggest galaxies in Messier's catalog. In visible-light images, NGC 1068 looks like a fairly normal barred spiral galaxy. The core of the galaxy, however, is not only very luminous to the eye but also in ultraviolet and X-ray light. A black hole with a mass equivalent to approximately 100 million stars like the Sun is required to account for the nuclear activity in NGC 1068.

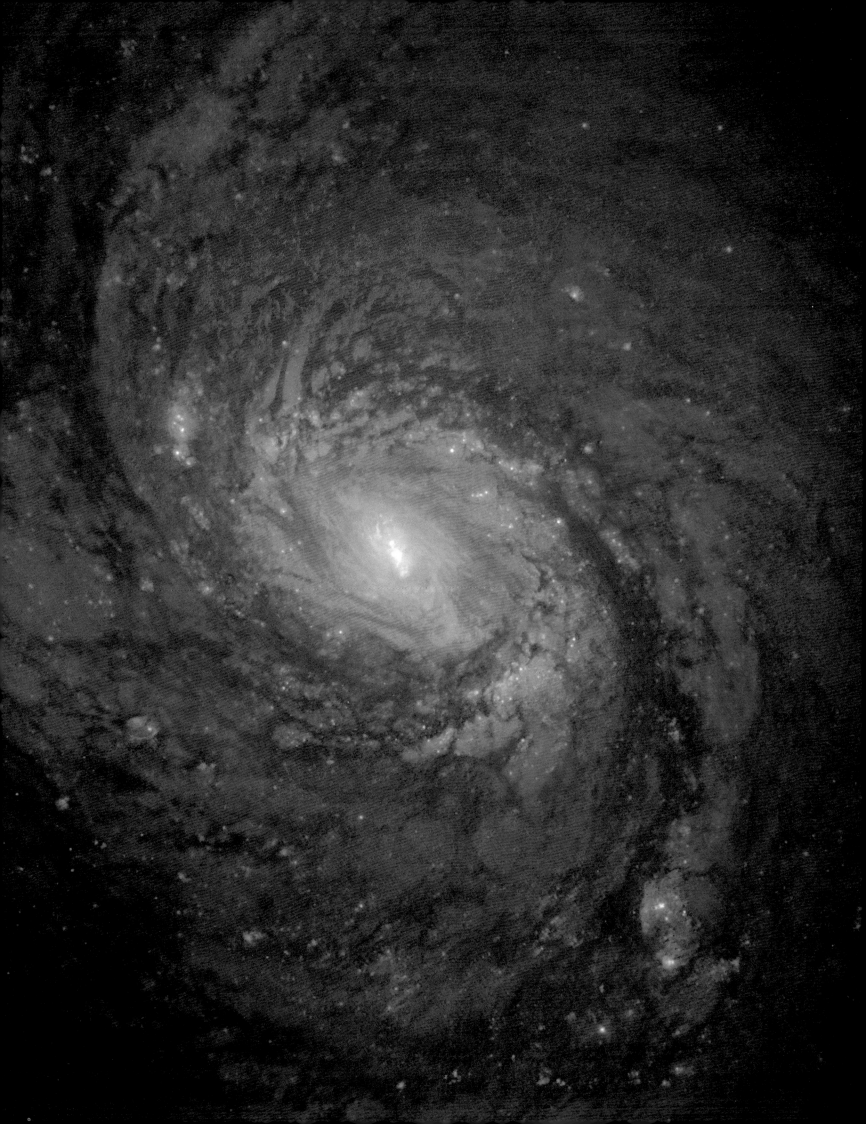

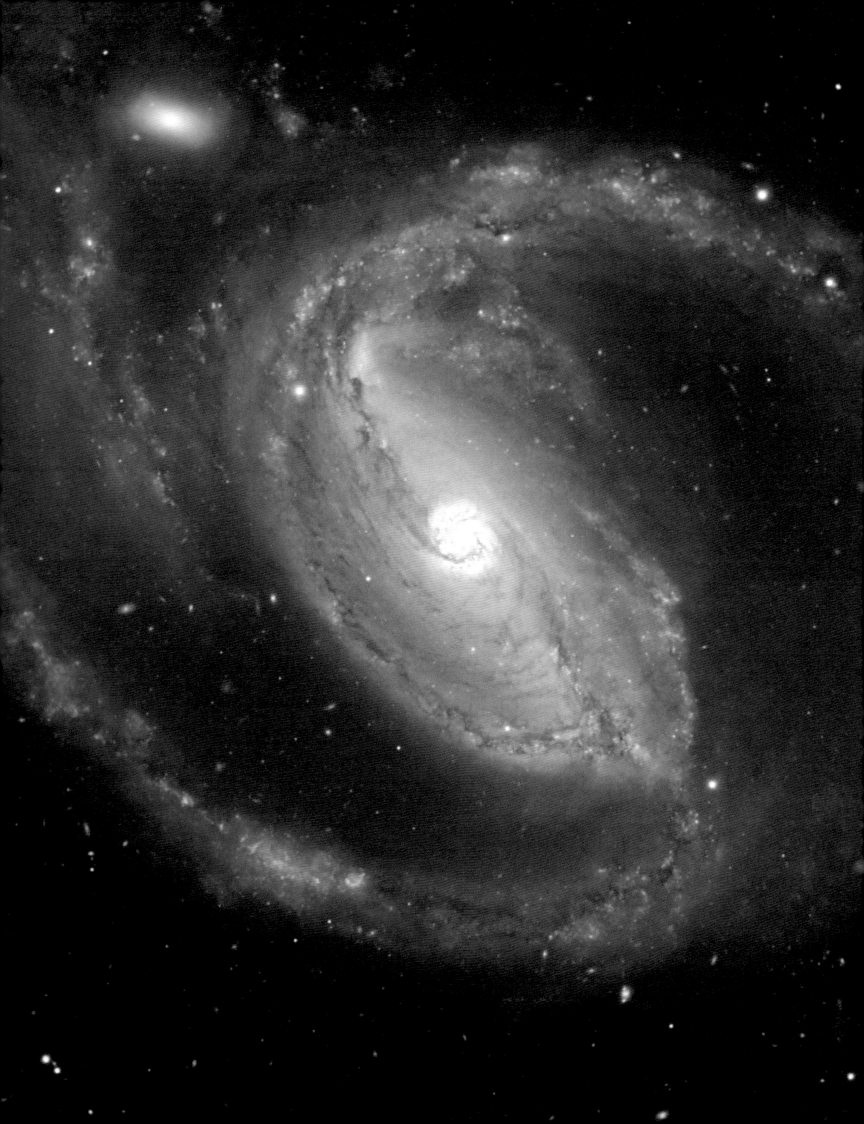

NGC 1097

Two galaxies — the Seyfert galaxy NGC 1097 in the constellation of Fornax (The Furnace), and its much smaller companion, the elliptical galaxy NGC 1097A, visible in the top left, both about 50 million light-years away — are locked in a galactic embrace. There is evidence that NGC 1097 and NGC 1097A have interacted in the recent past.

Although NGC 1097 seems to be wrapping its companion in its spiral arms, this is no gentle motherly giant. The larger galaxy also has four faint jets — too extended and faint to be seen in this image — that emerge from its center, forming an X-shaped pattern, and which are the longest visible-light jets of any known galaxy. They are thought to be the remnants of a dwarf galaxy that was disrupted and cannibalized by the much larger NGC 1097 a few billion years ago.

These unusual jets are not the galaxy's only intriguing feature. As previously mentioned, NGC 1097 is a Seyfert galaxy, meaning that it contains a supermassive black hole in its center. However, the core of NGC 1097 is relatively faint, suggesting that the central black hole is not currently swallowing large quantities of gas and stars. Instead, the most striking feature of the galaxy's center is the ring of bright knots surrounding the nucleus. These knots are thought to be large bubbles of glowing hydrogen plasma varying in size between 750 and 2500 light-years across, ionized by the intense ultraviolet light of young stars, and they indicate that the ring is a site of vigorous star formation.

NGC 1097
The distinctive central star-forming ring of NGC 1097 is clearly seen in this image, and the addition of numerous bluish clusters of hot, young stars dotted through its spiral arms make NGC 1097 an intriguing object on photographs.

NGC 1232

NGC 1232 is considered to be a giant among galaxies, more than double the size of the Milky Way, with a diameter of about 200,000 light-years. We see it almost face-on in the rambling southern constellation of Eridanus, at a distance of some 70 million light-years. Many young star clusters populate its numerous, sweeping spiral arms, which appear to fade into a central bar. NGC 1232 has a companion galaxy, NGC 1232A, that is also seen in this image, seemingly at the tip of a spiral arm. Abrupt acute angles in the outer spiral arms of NGC 1232 hint at tidal influences, perhaps from NGC 1232A or other earlier galactic interlopers, long since devoured. NGC 1232 is a member of the Eridanus cluster of galaxies, along with the magnificent barred spiral NGC 1300 (p. 202).

NGC 1232 and its Companion

The large, striking spiral galaxy NGC 1232 and its distorted companion NGC 1232A. The pair is located roughly 70 million light-years away in the constellation of Eridanus. Billions of stars and dark clouds of dust are caught up in this beautiful gravitational swirl. The bluish spiral arms with their many young stars and star-forming regions make a striking contrast to the haze of older, yellowish-red stars in orbit around the nucleus.

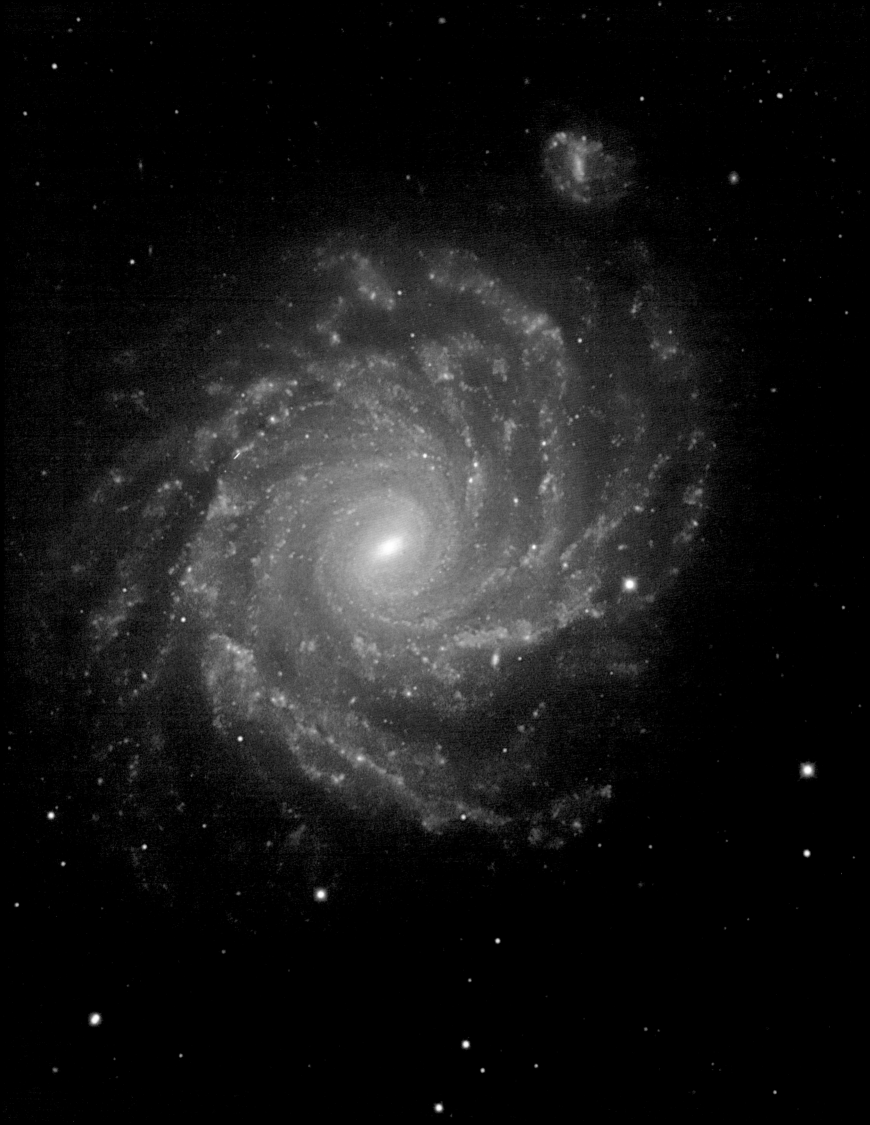

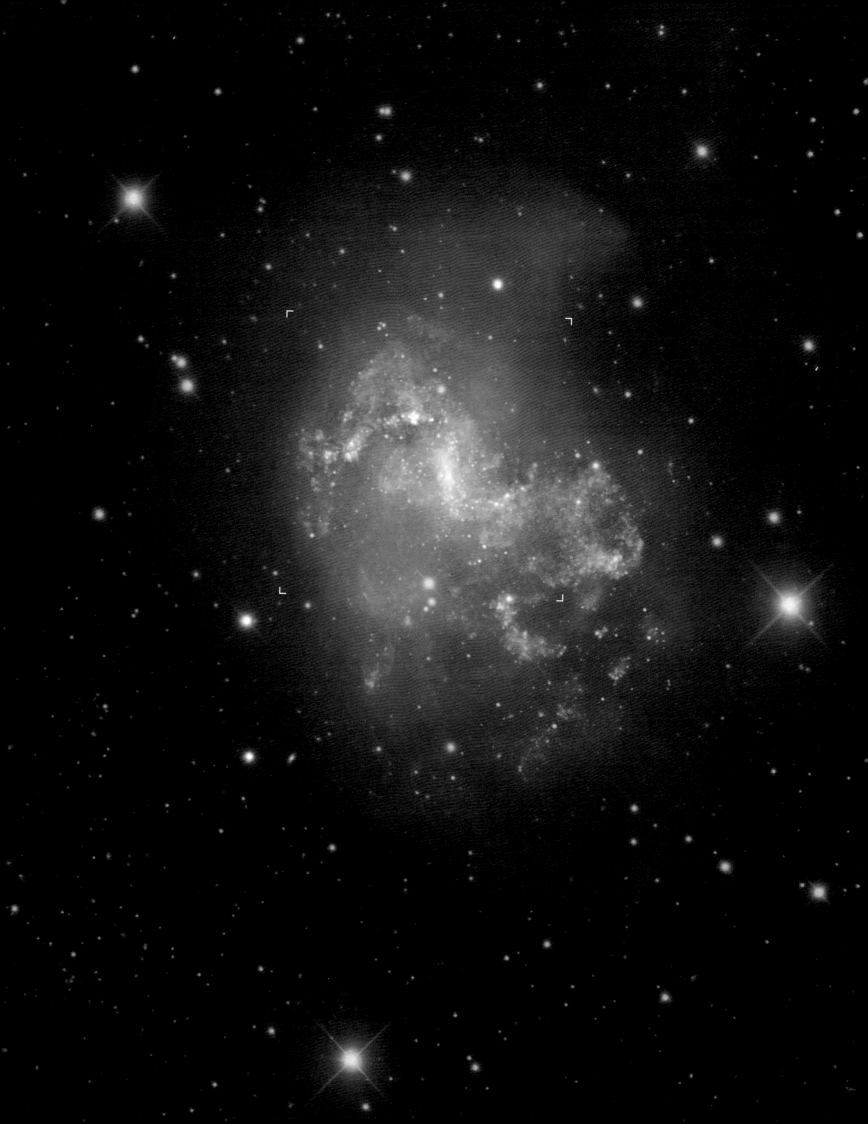

NGC 1313

NGC 1313 shares many features with the Large Magellanic Cloud, the gravitationally disturbed dwarf galaxy orbiting the Milky Way. Like the LMC, it has a weak central bar, mostly devoid of emission nebulae, and two ill-defined spiral arms with extensive signs of star formation. The arms are populated with clusters of hot young stars, well away from the main body of the galaxy, as in the Large Magellanic Cloud. However NGC 1313's prolific rate of star formation marks it out as a starburst galaxy; while the Large Magellanic Cloud is a vigorous producer of stars, it does not qualify as a starburst galaxy. In the Large Magellanic Cloud the vigorous star formation is the result of its interaction with the Small Magellanic Cloud and with the Milky Way. But NGC 1313 is isolated, alone, and about 15 million light-years away in Reticulum (The Reticle — telescope cross-hairs), one of the least distinguished of the southern constellations. It is a very disturbed galaxy, and no one seems to quite understand it — not a traditional spiral galaxy, but an intriguingly complex star-making machine.

The Central Parts of NGC 1313

The very active state of this galaxy is very evident from the image, showing many star-forming regions. Many cocoons of gas, inflated and etched by successive bursts of star formation, are visible. The green nebulae are regions emitting the green light of ionized oxygen and likely harbor clusters with very hot stars. The appearance of NGC 1313 suggests it has seen troubled times, its spiral arms look lopsided and star-forming regions are scattered all over them. This image was made using several narrow parts of the visible spectrum, including the light of oxygen and hydrogen, augmented with broadband blue, red, and invisible infrared. Although very useful scientifically, combinations like this cannot be used to make a true-color image, which is why the appearance of the inset image is so different from the main photograph.

Disturbed NGC 1313

This wide-angle view of NGC 1313 shows just how disturbed this galaxy is, despite not having any obvious neighbors that could have caused all this turmoil.

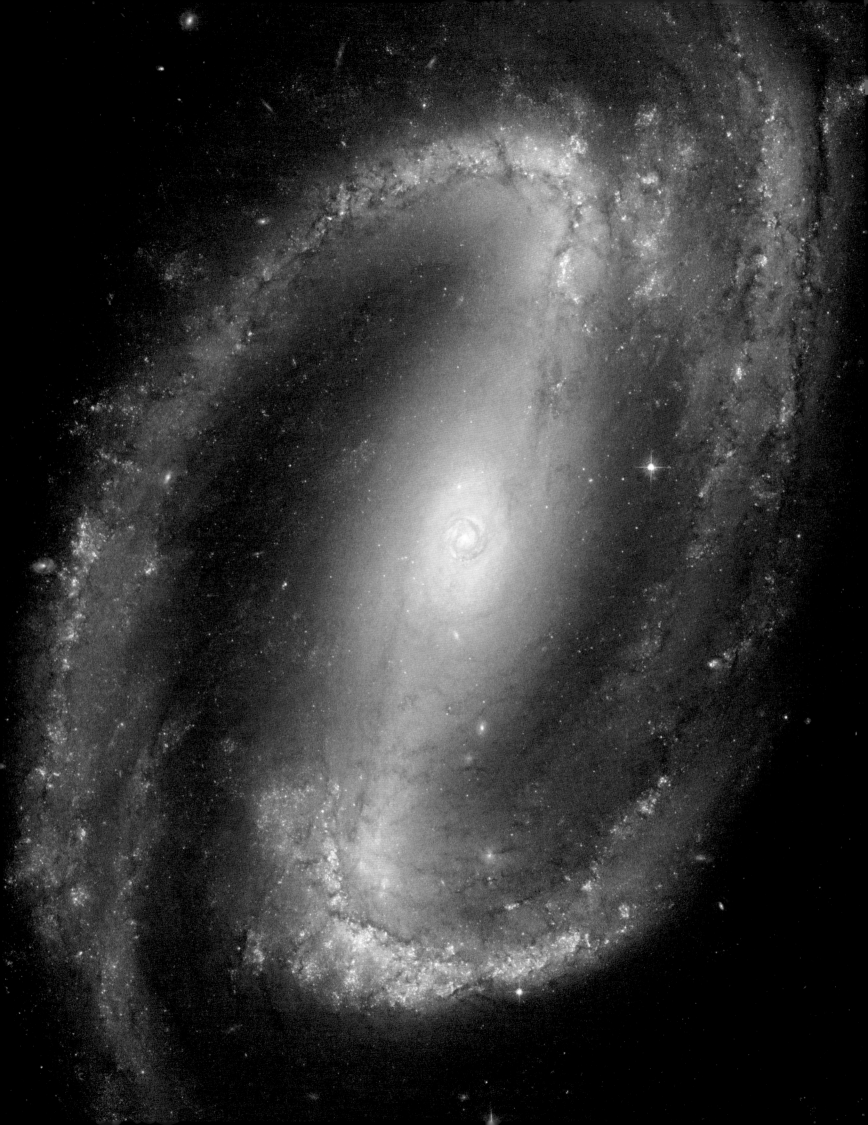

NGC 1300

NGC 1300 is part of the Eridanus Group of galaxies, and we see it from a distance of some 70 million light-years. The galaxy is considered to be prototypical of barred spiral galaxies. Barred spirals differ from normal spiral galaxies in that the arms of the galaxy do not spiral all the way into the center but are connected to the two ends of a straight bar of stars containing the nucleus at its center.

NGC 1300 is seen inclined to our line of sight at about 50 degrees. It has a structure very much like NGC 1365 (p. 206), which has a rather similar inclination (40 degrees). However the spiral arms are spread wider in the latter galaxy — if the values for the inclination are correct.

Within the central region lies a small but distinct spiral structure extending over about 3300 light-years and converging onto the central bar. The dynamics of bars in galaxies suggest they may be involved in the formation of rings close to the nucleus. A redistribution of matter with gas flowing centrally from the disk may explain the formation of the structures we are seeing in the core of NGC 1300.

NGC 1300 with Hubble

The spectacular Hubble Space Telescope portrait of NGC 1300 reveals a wondrous degree of detail within the spiral arms and compact core of this impressive galaxy. Blue and red supergiant stars, star clusters, and star-forming regions are well resolved across the galaxy, and dust lanes trace out fine structures in the disk and bar. Other conspicuous features visible in the image include a multitude of well resolved star-forming regions populating the outer parts and a variety of distant background galaxies, some even seen through the galactic disk.

NGC 1316

NGC 1316 is also known as Fornax A, the strongest radio source in that constellation and an outlier of the Fornax cluster of galaxies. In an optical telescope of modest size there is not much to see, merely a pair of bright, similar-looking galaxies, where the more southerly of the two, NGC 1316, is larger and brighter than its companion NGC 1317. In a larger telescope, NGC 1316 is seen to have patches of dust scattered across the face of the galaxy, and its smaller companion shows hints of a spiral structure. With the superior resolution of an orbital telescope like Hubble, NGC 1316 appears to be randomly sprinkled with numerous dust clouds with no obvious origin or pattern. And yet this seemingly innocuous galaxy, 60 million light-years away, is a powerful radio source. Why?

The key ingredient, as in so many peculiar galaxies, is that NGC 1316 is the result of an on-going merger. To add to the interest, NGC 1316 is clearly interacting with NGC 1317. On a much larger scale, radio observations reveal a pair of emission lobes extending over half a degree beyond the optical structure; this is a larger angular size than the full Moon. All this suggests a rich merger history, especially considering the complex series of shells and loops seen on deep, wide-angle images. NGC 1316 is much more interesting than the first impression of a galaxy besmirched by a few unusual dusty blemishes.

Wide-field Image of NGC 1316 and NGC 1317

NGC 1316's violent history is evident in this wide-field image showing a bewildering variety of gravitational features — faint ripples, loops, and plumes immersed in the galaxy's outer envelope — tenuous relics of interactions with other spiral galaxies spread over the last few billion years.

NGC 1316 seen with Hubble

Surprisingly complex loops and blobs of cosmic dust lie hidden in the giant elliptical galaxy NGC 1316. This image is made from data obtained with the Hubble Space Telescope and reveals the dust lanes and star clusters of this giant galaxy that suggest it was formed from a merger of two gas-rich galaxies. The complicated scatter of dust lanes and patches are thought to be the remains of the interstellar medium associated with one or more of the spiral galaxies swallowed by NGC 1316.

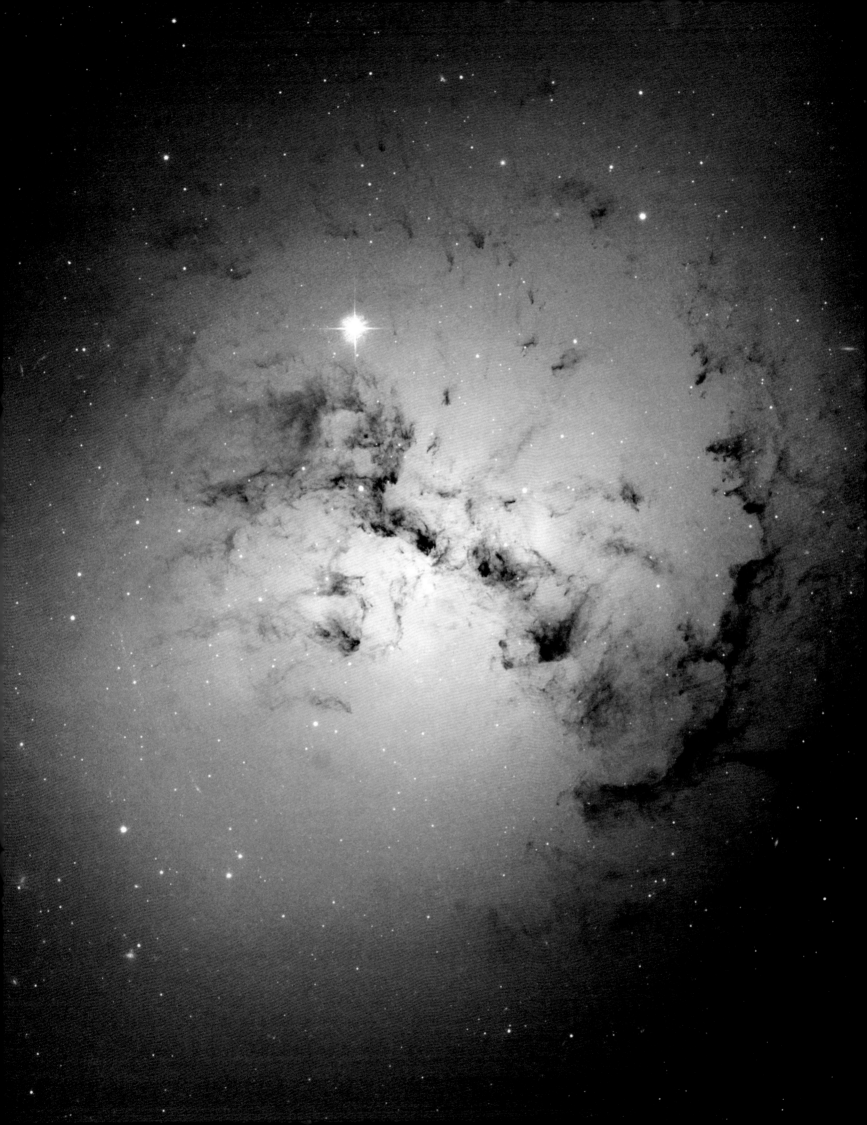

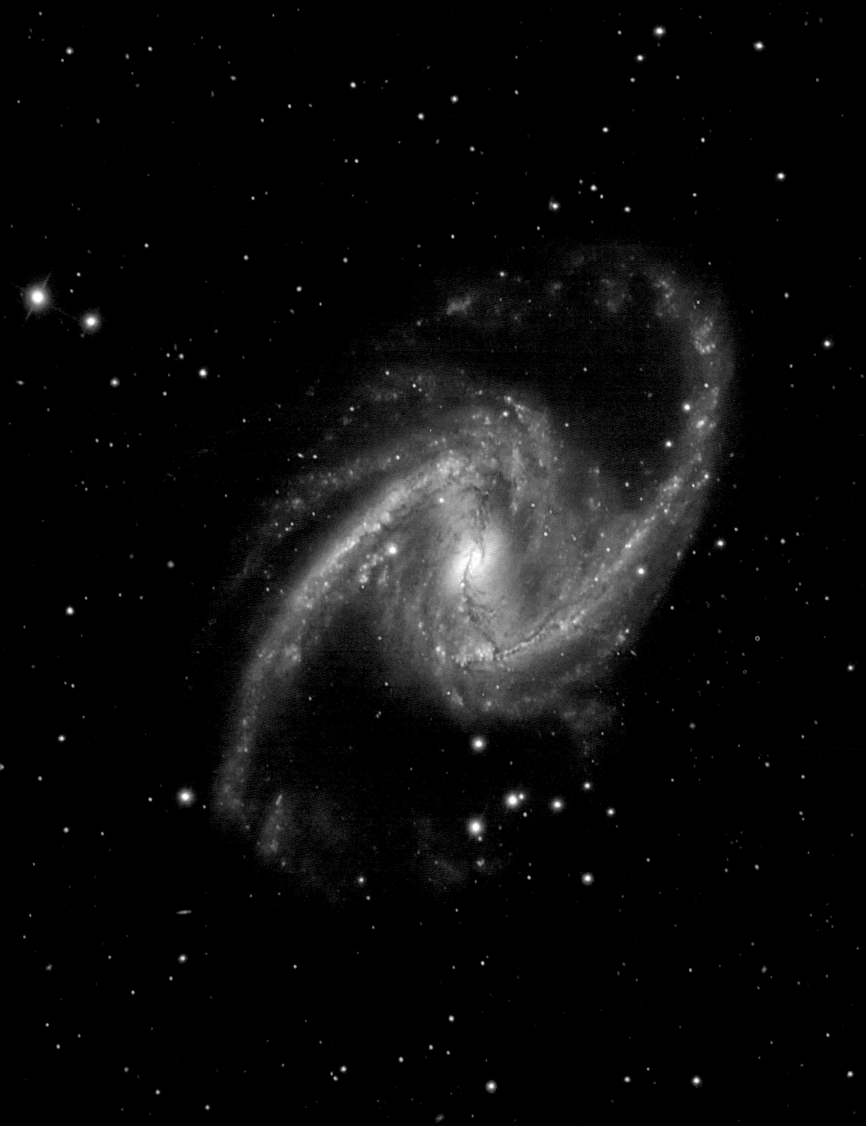

NGC 1365

NGC 1365 is a big galaxy, located in the Fornax Cluster of galaxies about 60 million light-years away. Its strikingly symmetrical spiral structure extends over 200,000 light-years, roughly twice the size of the Milky Way, itself no modest collection of stars. At the distance of NGC 1365 this is half the diameter of the full Moon in the sky. The most striking thing about NGC 1365 is its long bar bisected by dust lanes that disappear into the bright central nucleus. This galaxy is well oriented, so we see it as one of the finest examples of a barred spiral system. Barred spirals are common; it is thought that the bar represents the most stable state for a spiral galaxy.

The bright center of the galaxy is believed to be due to huge amounts of superhot gas ejected from the ring of material circling a central supermassive black hole. Young, luminous hot stars, born out of the interstellar clouds, give the arms a prominent appearance and a blue color. The bar and spiral pattern rotates, with one full turn taking about 350 million years.

NGC 1365, a Great Barred Spiral Galaxy

NGC 1365 is truly a giant of the sky. It is one of the best known and most studied barred spiral galaxies and is sometimes nicknamed the Great Barred Spiral Galaxy because of its strikingly perfect form, with the straight bar and two very prominent outer spiral arms. Closer to the center there is a second spiral structure and the whole galaxy is laced with delicate dust lanes. This galaxy is an excellent laboratory to explore how spiral galaxies form and evolve. Astronomers are keen to understand the complex flow of material within the galaxy and how it affects the reservoirs of gas from which new stars can form. The huge bar disturbs the shape of the gravitational field of the galaxy, and this leads to regions where gas is compressed and star formation is triggered. Many huge young star clusters trace out the main spiral arms, and each contains hundreds or thousands of bright young stars that are less than ten million years old.

Books about the Southern Sky

Atlas of the Southern Night Sky, Steve Massey and Steve Quirk, 2010, second edition (New Holland Publishers: Australia). Well-illustrated guide to the southern sky, with 100 star charts, photographs by amateur astronomers, and information about telescopes and accessories.

The Southern Sky Guide, David Ellyard and Wil Tirion, 2008 (Cambridge University Press: Cambridge).

A Walk through the Southern Sky: A Guide to Stars and Constellations and Their Legends, Milton D. Heifetz and Wil Tirion, 2007 (Cambridge University Press: Cambridge).

Explorers of the Southern Sky: A History of Astronomy in Australia, R. and R. F. Haynes, D. F. Malin, R. X. McGee, 1996 (Cambridge University Press: Cambridge).

Astronomical Objects for Southern Telescopes, E. J. Hartung, Revised and illustrated by David Malin and David Frew, 1995 (Melbourne University Press: Melbourne).
An indispensable source of information for observers of southern sky, with vivid descriptions and an extensive bibliography.

Astronomy of the Southern Sky, David Ellyard, 1993 (HarperCollins: Pymble, N.S.W.).
An introductory-level popular book about observing and making sense of the night sky, especially the southern hemisphere.

Under Capricorn: A History of Southern Astronomy, David S. Evans, 1988 (Adam Hilger: Bristol).
An excellent history of the development of astronomy in the southern hemisphere, with a good bibliography that names original sources.

The Southern Sky: A Practical Guide to Astronomy, David Reidy and Ken Wallace, 1987 (Allen and Unwin: Sydney).
A comprehensive history of the discovery and exploration of the southern sky, from the earliest European voyages of discovery to the modern age.

Exploring the Southern Sky, S. Laustsen, C. Madsen and R. M. West, 1987 (Springer-Verlag: Berlin, Heidelberg).
This comprehensive pictorial atlas from the European Southern Observatory made views of the southern skies available to many an armchair astronomer and today gives a good baseline reference for the state of astronomical photography 25 years ago. Free PDF for download: http://www.eso.org/public/products/books/exploring_the_southern_sky/

Astronomical Institutions in the Southern Hemisphere, 1850–1950, David S. Evans, 1984, in *Astrophysics and Twentieth Century Astronomy to 1950*, ed. O Gingerich, Vol. 4A of The General History of Astronomy (Cambridge University Press: Cambridge).

Results of Astronomical Observations made during the Years 1834, 5, 6, 7, 8, at the Cape of Good Hope; being the completion of a telescopic survey of the whole surface of the visible heavens, commenced in 1825, Sir John H. F. W. Herschel, 1847 (Smith, Elder: London).
Lucid, colorful, wordy, but fascinating descriptions and drawings of his southern hemisphere observations. Copies occasionally appear on auction sites and with specialist book dealers.

Colours of the Stars, David Malin and Paul Murdin, 1984 (Cambridge University Press: Cambridge).
A comprehensive and understandable book about the astrophysics of color.

A View of the Universe, David Malin, 1993 (Cambridge University Press: Cambridge).
Lavishly illustrated photographic exploration of the southern skies.

Object List and Figure Credits

Cover, M42: ESO/J. Emerson/VISTA. Acknowledgment: Cambridge Astronomical Survey Unit

Frontispiece, NGC 602: NASA/ESA Hubble Space Telescope/R. Gendler

p. 9, The Southern Cross: ESO/Y. Beletsky

p. 10, M42: ESO

p. 13, The Southern Cross: Akira Fujii

p. 14, Corsali's Crux drawing: National Library of Australia

p. 17, Centaurus A: Main image: Australian Astronomical Observatory; upper left: James Dunlop; lower right: John Herschel

p. 21, Great Comet of 1882: South African Astronomical Observatory

p. 22, The Large Magellanic Cloud: H.C. Russell

p. 24, Messier 31: W.C. Miller/D. Malin/Caltech

p. 26, E-ELT: ESO

p. 26, SKA: SPDO/TDP/DRAO/Swinburne Astronomy Productions

pp. 28–29, The Southern Sky: S. Brunier/ESO

pp. 30–31, Orion deep field: R. Gendler

pp. 32–33, NGC 1531–1532: R. Gendler, J.E. Ovaldsen, A. Hornstrup, ESO/IDA

pp. 34–35, NGC 1672: NASA/ESA Hubble Space Telescope/R. Gendler

p. 36, N11 overview: R. Gendler, R. Hannahoe

p. 37, N11 detail: NASA, ESA, HST, Jesus Maiz Apellaniz (Instituto de Astrofisica de Andalucia, Spain)

pp. 39, NGC 1909: R. Gendler

p. 40, LHA 120–N44: ESO

p. 41, N44: Gemini South/Travis Rector (University of Alaska Anchorage)

pp. 42-43, Large Magellanic Cloud: R. Gendler

p. 45, Orion Nebula: ESO/J. Emerson/Vista/R. Gendler

pp. 46–47, Trapezium: NASA/ESA Hubble Space Telescope/R. Gendler

p. 48, SN1987A: NASA/ESA Hubble Space Telescope/R. Gendler

p. 49, SN1987A: Hubble Heritage Team (AURA/STScI/NASA/ESA)

p. 50, NGC 1999: R. Gendler

p. 51, NGC 1999 detail: NASA/ESA and the Hubble Heritage Team (STScI)

pp. 53, Tarantula Nebula: ESO

p. 54, Tarantula Nebula Center: ESA/NASA/ESO and Danny LaCrue

p. 55, Tarantula Nebula RMC 136 grouping: NASA, ESA, and F. Paresce (INAF-IASF, Bologna, Italy), (University of Virginia, Charlottesville), and the Wide Field Camera 3 Science Oversight Committee

p. 56, Flame and Horsehead Nebula: ESO/J. Emerson/Vista/R. Gendler

p. 58, Horsehead Nebula and NGC 2023: R.J. GaBany

p. 59, Horsehead: ESO

pp. 61, M78: ESO and Igor Chekalin

p. 62, Monoceros R2 Association IR: ESO/J. Emerson/Vista/R. Gendler

p. 63, NGC 2170: R. Gendler, R. Hannahoe

pp. 64–65, IC 2177 and NGC 2327: R. Gendler

pp. 66–67, NGC 2359: Star Shadows Remote Observatory and PROMPT/UNC

pp. 68–69, CG4: David Malin (AAO)

p. 70, NGC 2442 overview: ESO

p. 71, NGC 2442: NASA/ESA Hubble Space Telescope/R. Gendler/ESO

pp. 72–73, NGC 2440: NASA, ESA, and K. Noll (STScI)

p. 74, NGC 2467: NASA, ESA, and Orsola De Marco (Macquarie University)

p. 75, NGC 2467: ESO

pp. 76, Toby Jug Nebula: R. Gendler

p. 78, Pencil Nebula: NASA/ESA and the Hubble Heritage Team (STScI/AURA)

p. 79, Vela Supernova Remnant: R. Gendler

pp. 80–81, NGC 2997: R. Gendler

pp. 82–83, Carina Nebula region: R. Gendler, Stephane Guisard

pp. 84–85, Carina Nebula: R. Gendler/ESO, R. Hannahoe

pp. 85, Carina Nebula Narrowband: N. Smith and NOAO/AURA/NSF

pp. 86, WR 25 and Tr 16: NASA, ESA, and Jesus Maiz Apellaniz (Instituto de Astrofisica de Andalucia, Spain)

p. 87, Mystic Mountain: NASA, ESA and M. Livio and the Hubble 20th Anniversary Team (STScI)

pp. 89, NGC 3293: R. Gendler

pp. 90–91, NGC 3521: NASA/ESA Hubble Space Telescope/R. Gendler

p. 92, NGC 3603: NASA, ESA and the Hubble Heritage Team (STScI/AURA)-ESA/ Hubble Collaboration

p. 93, NGC 3576: Ken Crawford

pp. 94–95, NGC 3621: R. Gendler

p. 96, Thackeray's Globules: NASA/ESA and the Hubble Heritage Team STScI/AURA

p. 97, IC 2944: Ken Crawford

p. 98, NGC 4038–4039: NASA, ESA, Hubble Heritage Team (STScI/AURA)-ESA/Hubble Collaboration, Acknowledgement: B. Whitmore (STScI) and James Long (ESA/Hubble)

p. 99, NGC 4038–4039: R. Gendler

pp. 100–101, M104: NASA/ESA and the Hubble Heritage Team STScI/AURA

pp. 102–103, The Coalsack: Akira Fujii

p. 104, NGC 4755: ESO/Y. Beletsky

p. 105, NGC 4755: Johannes Schedler

pp. 106, NGC 4945: R. Gendler, R. Hannahoe, and ESO/IDA/C. Thone

p. 108, Centaurus A: ESA/Hubble, NASA

p. 109, Centaurus A: ESO/WFI, MPifR/ESO/APEX/A. Weiss et al, NASA/CXC/Cfa/R. Kraft et al.

pp. 110, Omega Centauri: ESO/INAF-VST/OmegaCAM. Acknowledgement: OmegaCen/Astro-WISE/Kapteyn Institute

pp. 112–113, NGC 5189: Gemini South/Travis Rector (University of Alaska Anchorage)

p. 114, M83: ESO

p .115, M83 detail: NASA, ESA, and the Hubble Heritage Team (STScI/AURA)

pp. 116–117, NGC 5426–5427: Gemini Observatory

pp. 118–119, Milky Way Center: R. Gendler

pp. 120, IC 4592–4601: R. Gendler, J. Misti, S. Mazlin

pp. 122, Rho Ophiuchi Nebula: David Malin (AAO)

p. 124, NGC 6164–6165: Gemini Observatory/ Travis Rector (University of Alaska Anchorage)

p. 125, NGC 6164–6165: R. Gendler

pp. 126–127, NGC 6188–6193: R. Gendler, M. Pugh

pp. 128, Dark Tower: R. Gendler

pp. 130, NGC 6302: NASA, ESA and the Hubble SM4 ERO Team

pp. 132–133, NGC 6334: ESO

pp. 134–135, Milky Way: Stephane Guisard/ESO

p. 136, Pismis 24: NASA, ESA and Jesús Maíz Apellániz (Instituto de Astrofísica de Andalucía, Spain)

p. 137, NGC 6334: R. Gendler

pp. 138, M7: R. Gendler

p. 140, M20: NASA/ESA and Jeff Hester (ASU)

p. 141, M20: R. Gendler

p. 142, M8: ESO

p. 143, M8 detail-left: ESO/IDA/R.Gendler/U.G. Jørgensen, K. Harpsø

p. 143, M8 detail-right: NASA, ESA & A Caulet (ST-ECF,ESA)

p. 144, NGC 6559: CFHT & Coelum/J.-C. Cuillandre & G. Anselmi

p. 145, NGC 6559: R. Gendler

pp. 146-147, NGC 6589–6590: R. Gendler

p. 148, M16: Left image: David Malin (AAO), ESO/M. McCaughrean and M. Andersen (AIP). Right image: NASA, ESA, STScI, J. Hester and P.Scowen (ASU)

p. 149, M16: Russell Croman

p. 150, M17: ESO/INAF-VST/OmegaCAM. Acknowledgement: OmegaCen/Astro-WISE/Kapteyn Institute

p. 151, M17: ESO

pp. 152–153, NGC 6529 and Barnard 86: Travis Rector/ University of Alaska Anchorage and NOAO/AURA/NSF

pp. 154–155, M22: NASA/ESA Hubble Space Telescope/R. Gendler

pp. 157, M11: R.J. GaBany

pp. 158–159, NGC 6726: ESO

pp. 161, NGC 6744: R. Gendler

pp. 162, NGC 6769–6770–6771: ESO

pp. 165, NGC 6822: R.Gendler/ESO

pp. 166–169, Helix Nebula: NASA, ESA, C.R. O'Dell (Vanderbilt University), M. Meixner, P. Mc Cullough, G.Bacon (STScI)

pp. 170, NGC 7424: Gemini Observatory, Travis Rector (University of Alaska Anchorage), Stuart Ryder (AAO), R. Gendler

pp. 172, NGC 7793 overview: R. Gendler

pp. 173, NGC 7793: NASA/ESA Hubble Space Telescope/R. Gendler

pp. 174, NGC 45: R. Gendler

pp. 177, NGC 55: R. Gendler

pp. 178, 47 Tucanae: R. Gendler

pp. 180–181, Cartwheel Galaxy: ESA/Hubble, NASA

pp. 183, NGC 247: ESO

pp. 184–185, NGC 253: NASA/ESA Hubble Space Telescope/R. Gendler

pp. 187, Small Magellanic Cloud: Stanislav Volskiy

pp. 188–189, NGC 300: ESO

pp. 191, NGC 346 & LHA 115–N66: NASA, ESA, and A. Nota (ESA/STScI, STScI/AURA)

pp. 192, NGC 602 & LHA 115–N90: NASA, ESA, Hubble Heritage Team STScI/AURA-ESA/Hubble Collaboration

pp. 194–195, M77: NASA/ESA Hubble Space Telescope/R. Gendler

pp. 196, NGC 1097: ESO/R. Gendler

pp. 198–199, NGC 1232: ESO/IDA/R. Gendler/A. Hornstrup

p. 200, NGC 1313: R. Gendler

p. 201, NGC 1313: ESO

pp. 202, NGC 1300: NASA, ESA, Hubble Heritage Team STScI/AURA

pp. 204, NGC 1316: Martin Pugh

pp. 205, NGC 1316: NASA, ESA, Hubble Heritage Team STScI/AURA

pp. 206, NGC 1365: R. Gendler

pp. 220, The Orion Nebula: ESO/R. Gendler

Index

Symbols

30 Doradus — 52, 54. *See also* Tarantula Nebula
47 Tucanae — 167, 179, 186

A

AAT. *See* Anglo-Australian Telescope
active galactic nucleus — 107
Advanced Camera for Surveys — 35, 168
Alighieri, Dante — 12
Allen, David — 77
Alnitak — 57, 60
Alpha Centauri — 18
Anglo-Australian Observatory — 8
Anglo-Australian Telescope — 17, 25, 69, 180, 219
Antares — 77, 83, 122, 135
Antennae Galaxies — 99, 116
Antlia — 81, 83
APEX — 109
Apis — 14
Apus — 14
Ara — 14, 126
Arago, Francois — 19
Argentine National Observatory — 19
Argo Navis — 14, 31
Arp 271. *See* NGC 5427
Astrographic Catalogue — 21

B

Baade's Window — 152
Baade, Walter — 152
Barnard 33 — 58
Barnard 40 — 121
Barnard 86 — 152
Barnard 303 — 144
Barnard, E. E. — 129, 130, 144, 164
Barnard's Galaxy. *See* NGC 6822
Barnard's Loop — 38
barred spiral galaxy — 35, 70, 115, 160, 171, 194, 198, 203, 207

Bayer, Johann — 14, 111
Bernes 157 — 159
Bessel, Friedrich Wilhelm — 18
black hole — 35, 95, 100, 107, 108, 109, 111, 135, 189, 194, 197, 207
Blue Horsehead. *See* IC 4592
blue stragglers — 179
Bok, Bart — 96, 143
Bok Globules — 92, 96
Brisbane, Thomas Makdougall — 17
Bug Nebula. *See* NGC 6302

C

Canis Major — 19, 64, 65, 66
Cape of Good Hope — 8, 12, 16, 18, 19, 20, 85, 171, 209
Cape Photographic Durchmusterung — 21
Carina — 12, 14, 19, 31, 85, 86, 88
Carina Nebula — 8, 19, 74, 83, 84, 85, 86, 88
Carte du Ciel — 21, 23
Cartwheel Galaxy — 180
Cat's Paw Nebula — 132, 136
Centaurus — 12, 14, 19, 83, 96
Centaurus A — 17, 18, 107, 108, 109
Centaurus group — 107
central bulge — 28, 35, 95, 135, 175, 189
Cepheid variable — 23, 95, 164, 186
Cerro Tololo 4-m Blanco Telescope — 25
Cerro Tololo Inter-American Observatory — 168
CG 4 — 69
Chameleon — 14
Chandra X-ray Observatory — 95, 109
Coalsack — 8, 12, 83, 103
Common, Ainslee — 20, 21
Cone Nebula — 63
Cook, James — 8, 16, 17
Cordoba Observatory — 19
de Corsali, Andrea — 12
Crux — 8, 9, 12, 14, 19, 83, 96, 103, 104
Cursa — 38

D

Daguerre, Louis — 19
Danish 1.54-metre Telescope — 32
Dark Tower — 129
Dawes, William — 8
Dias, Bartolomeu — 12
Dirkszoon Keyser, Pieter — 14
Dixon, Jeremiah — 16
Dorado — 14, 35
Double Cluster in Perseus — 65
Dreyer, J. L. E. — 21
Dun Echt Observatory — 20
Dunlop, James — 8, 16, 17, 18, 19, 107, 112
dwarf galaxy — 115, 164, 179, 182, 197, 201

E

Eagle Nebula — 148, 149, 151
E-ELT. *See* European-Extremely Large Telescope
emission nebula — 58, 88, 92, 122, 126, 129, 130, 136, 140, 147, 148, 151, 182
Encke's Comet — 17
Eridanus — 32, 38, 198, 203
ESO 350-40. *See* Cartwheel Galaxy
Eta Carinae — 22, 84, 85, 86
European Extremely Large Telescope — 26
European Southern Observatory — 7, 25, 26, 29, 44, 57, 58, 63, 104, 111, 132, 135, 151, 159, 172
Evans, Bob — 171

F

Flame Nebula — 57, 60
Flamsteed, John — 15
flocculent galaxy — 91, 160, 172
Fornax — 167, 197, 204, 207
Fosbury, Bob — 180
Francois Arago — 19

G

da Gama, Vasco — 12
Gauss, Carl — 19
Gemini South Telescope — 25, 41, 125
Giant Magellan Telescope — 26
Gill, David — 19, 20, 21
globular cluster — 15, 155, 179, 186
Gould, Benjamin A. — 19, 21, 23
Gould's Belt — 12, 18, 19, 21
grand-design spiral — 81
Great Barred Spiral Galaxy. *See* NGC 1365
Great Comet of 1882 — 19, 21
Great Melbourne Telescope — 22
Green, Charles — 8
Grubb, Howard — 21
Grus — 14, 171
Gum 55. *See* Dark Tower
Gum Nebula — 78

H

Halley, Edmond — 8, 15, 16, 17, 111
Haro, Guillermo — 51
Hartley, Malcolm — 129
Hawarden, Tim — 180
Helix Nebula — 73, 167, 168
Henderson, Thomas — 18
Henize, Karl — 36
Henry, Paul — 21, 77, 209
Henry, Prosper — 21
Herbig, George — 51
Herbig–Haro objects — 51, 60, 140, 159
Herschel, Caroline — 51
Herschel, John — 8, 17, 18, 19, 20, 22, 51, 70, 85, 86, 104, 111, 112, 132, 139, 140, 143, 151, 155, 171, 209
Herschel, William — 19, 51, 116
Homunculus Nebula — 85, 86
Horsehead Nebula — 44, 57, 58, 60, 121, 126
Hourglass Nebula — 143
de Houtman, Frederick — 14
Hubble Space Telescope — 26, 35, 36, 48, 51, 54, 55, 63, 70, 73, 74, 78, 92, 95, 96, 99, 115, 130, 140, 143, 148, 155, 167, 168, 180, 185, 190, 193, 194, 203, 204
Hydrus — 14, 107

I

IC 434 — 58
IC 1274 — 144
IC 1283 — 147
IC 1284 — 147
IC 2118. *See* NGC 1909
IC 2177 — 64, 65
IC 2220. *See* Toby Jug Nebula
IC 2944 — 96
IC 4592 — 121
IC 4601 — 121
IC 4703. *See* Eagle Nebula
IC 4715 — 147
IC 4812 — 159
IC 4842 — 163
IC 4845 — 163
Indus — 14
interacting galaxies — 32, 99, 163
irregular galaxy — 43, 103, 176, 186

J

James Webb Space Telescope — 26
Jewel Box Cluster — 8, 88, 104, 148

K

kappa Crucis, — 104
Kapteyn, J. C. — 21
Keyhole Nebula — 22, 84, 85
Keyser, Pieter Dirkszoon — 14
Kitt Peak National Observatory — 25

L

de Lacaille, Nicolas — 8, 15, 16, 85, 88, 115
Lacaille, Abbé de. *See* de Lacaille, Nicolas
Lagoon Nebula — 135, 142, 143, 144
Large Magellanic Cloud — 16, 22, 36, 41, 43, 48, 52, 160, 164, 176, 186, 201. *See also* Magellanic Clouds
La Silla Observatory — 25, 32, 159
Leavitt, Henrietta Swan — 23, 186
LHA 115–N66 — 186, 190
LHA 115–N90 — 193
LHA 120–N11 — 36
LHA 120–N44 — 36, 41
LMC. *See* Large Magellanic Cloud
Local Group of galaxies — 43
Lynds, Beverly — 129
Lynds' Dark Nebula 1630 — 60

M

Maclear, Thomas — 18
Magellan, Ferdinand — 8, 12
Magellanic Clouds — 8, 12, 14, 16, 19, 22, 23, 28, 31, 41, 43, 103, 172, 186. *See also* Large Magellanic Cloud, Small Magellanic Cloud
Malin, David — 8, 77
Mars — 16
Mason, Charles — 16
Meathook Galaxy. *See* NGC 2442
Mees, C. E. Kenneth — 25
Melbourne Observatory — 22
Mensa — 16
Mercury — 15
merger — 35, 70, 91, 163, 204
Messier 8. *See* Lagoon Nebula
Messier 11 — 122, 156
Messier 16 — 88, 148, 149, 151, 190
Messier 17 — 151
Messier 20. *See* Trifid Nebula
Messier 22 — 155
Messier 31 — 25, 43, 116, 164, 172
Messier 33 — 43, 91, 189
Messier 42. *See* Orion Nebula
Messier 77 — 194
Messier 78 — 60
Messier 83 — 81, 95, 107, 114, 115
Messier 104. *See* Sombrero Galaxy
Messier, Charles — 140, 156
Milky Way — 8, 12, 19, 22, 28, 31, 32, 36, 41, 43, 51, 52, 66, 69, 74, 81, 83, 85, 91, 92, 96, 99, 100, 103, 107, 111, 115, 116, 119, 121, 122, 130, 132, 135, 136, 139, 143, 144, 147, 151, 152, 155, 156, 160, 164, 167, 171, 172, 176, 179, 180, 182, 186, 190, 193, 198, 201, 207
Milky Way Center — 135
Miller, Bill — 25

Monoceros — 63, 64, 65

Monoceros R2 — 63

MPG/ESO 2.2-metre Telescope — 41, 60, 70, 74, 109, 182, 189

Mt. Stromlo Observatory — 22

Murdin, Paul — 77

Musca — 14, 112

N

Nebula. *See* emission nebula, reflection nebula, planetary nebula

NGC 45 — 175

NGC 55 — 172, 176, 185, 189

NGC 104. *See* 47 Tucanae

NGC 247 — 172, 182, 185, 189

NGC 253 — 107, 115, 172, 185, 189

NGC 300 — 172, 176, 185, 189

NGC 346 — 190

NGC 362 — 186

NGC 602 — 2, 193

NGC 1068. *See* Messier 77

NGC 1097 — 197

NGC 1097A — 197

NGC 1232 — 198

NGC 1232A — 198

NGC 1300 — 35, 198, 203

NGC 1313 — 201

NGC 1316 — 204

NGC 1317. — 204

NGC 1365 — 35, 203, 207

NGC 1531 — 32

NGC 1532 — 32

NGC 1672 — 35

NGC 1761 — 36

NGC 1909 — 38

NGC 1999 — 51

NGC 2023 — 57

NGC 2024. *See* Flame Nebula

NGC 2064 — 60

NGC 2068. *See* Messier 78

NGC 2100 — 52

NGC 2170 — 63

NGC 2327 — 65

NGC 2335 — 65

NGC 2343 — 65

NGC 2359 — 66

NGC 2440 — 73

NGC 2442 — 70

NGC 2467 — 74

NGC 2644. *See* Cone Nebula

NGC 2736. *See* Pencil Nebula

NGC 2997 — 81

NGC 3293 — 88, 148

NGC 3372. *See* Carina Nebula

NGC 3521 — 91, 160, 172

NGC 3576 — 92

NGC 3603 — 92

NGC 3621 — 95

NGC 4038. *See* Antennae Galaxies

NGC 4039. *See* Antennae Galaxies

NGC 4755. *See* Jewel Box Cluster

NGC 4945 — 107

NGC 5128. *See* Centaurus A

NGC 5139. *See* Omega Centauri

NGC 5189 — 112

NGC 5236. *See* Messier 83

NGC 5426 — 116

NGC 5427 — 116

NGC 6164 — 125, 126

NGC 6165 — 125

NGC 6188 — 126

NGC 6193 — 126

NGC 6231 — 129

NGC 6302 — 130

NGC 6334. *See* Cat's Paw Nebula

NGC 6357 — 135, 136

NGC 6520 — 152

NGC 6530 — 143

NGC 6532. *See* Lagoon Nebula

NGC 6559 — 144

NGC 6589 — 147

NGC 6590 — 147

NGC 6611. *See* Messier 16

NGC 6618. *See* Messier 17

NGC 6656. *See* Messier 22
NGC 6726 — 159
NGC 6727 — 159
NGC 6744 — 91, 160, 172
NGC 6744A — 160
NGC 6769 — 163
NGC 6770 — 163
NGC 6771 — 163
NGC 6822 — 164
NGC 7293. *See* Helix Nebula
NGC 7424 — 171
NGC 7793 — 91, 160, 172, 189

O

Omega Centauri — 8, 15, 111, 179
Omega Nebula. *See* Messier 17
open cluster — 88, 92, 129, 143, 152, 156
Ophiuchus Molecular Cloud — 122
Orion — 8, 11, 19, 38, 57, 58, 60, 121, 126
Orion B Molecular Cloud — 60
Orion Nebula — 2, 11, 21, 44, 46, 51, 52, 57, 63, 74, 85, 86, 220
Oschin Schmidt Telescope — 25

P

parallax — 15, 16, 18, 20, 23
Paranal Observatory — 44, 135
Parkes Radio Telescope — 26
Pavo — 14, 160, 163
Pencil Nebula — 78
period–luminosity relation — 164, 186
Phoenix — 14
Pipe Nebula — 135
Pismis 24 — 136
Pismis, Paris — 136
Plancius, Petrus — 14
planetary nebula — 73, 112, 125, 130, 155, 168
Ptolemy — 14, 111, 139
pulsar — 78
Puppis — 14, 19, 31, 69, 74, 78
Pyxis — 31

R

radio astronomy — 18
Rayet, Georges A. — 66
R Coronae Australis — 159
reflection nebula — 38, 51, 57, 60, 63, 69, 77, 122, 135, 140, 159
Reticulum — 16, 201
Rho Ophiuchi — 122, 135
Rho Ophiuchi Nebula — 122
Rigel — 38
RMC 136a — 54, 55
RMC 136a1 — 55
Royal Observatory at the Cape of Good Hope — 20
Rümker, Carl — 8, 17
Russell, Henry Chamberlain — 21

S

Sagittarius — 83, 92, 119, 135, 139, 142, 143, 144, 147, 151, 152, 155, 164
Sagittarius Star Cloud — 119
Sandage, Alan — 179
Schmidt, Bernhard — 23
Schmidt Telescope — 23, 25, 69, 129
Scorpius — 19, 77, 121, 122, 129, 130, 132, 135, 139
Sculptor — 167, 172, 176, 180
Sculptor Galaxy — 185
Sculptor Group — 172, 175, 176, 182, 185, 189
Serpens Cauda — 148
Seyfert, Carl K. — 194
Seyfert galaxy — 194, 197
Shapley, Harlow — 23, 155
Silver Coin Galaxy. *See* NGC 253
Small Magellanic Cloud — 2, 43, 103, 167, 176, 179, 186, 190, 193, 201
SMC. *See* Small Magellanic Cloud
Smyth, Charles Piazzi — 18, 26
Snake Nebula — 135
Sombrero Galaxy — 100
Southern African Large Telescope — 25
Southern Cross. *See* Crux
South Galactic Pole — 167, 182
Space Telescope-European Coordinating Facility — 180

spiral galaxy — 69, 70, 81, 91, 95, 108, 112, 115, 135, 160, 163, 171, 172, 175, 182, 194, 198, 201, 207

Spiral Planetary Nebula. See NGC 5189

Square Kilometer Array — 26

star formation — 32, 35, 36, 38, 43, 51, 52, 70, 74, 81, 88, 92, 99, 108, 115, 116, 126, 160, 164, 175, 180, 182, 185, 186, 197, 201, 207

star-forming region — 36, 41, 52, 63, 92, 96, 129, 140, 143, 151, 159, 186, 190

supernova — 41, 48, 52, 55, 99, 115, 139, 156, 171, 193

Supernova 1987A — 48, 52

Supernova 2001ig — 171

supernova remnant — 78

Swan Nebula. See Messier 17

Sydney Observatory — 22

T

Tarantula Nebula — 36, 43, 52, 54, 55

Taurus — 19

Tebbutt, John — 8

Terra Australis Incognita — 16

Thackeray's Globules — 96

Thor's Helmet. See NGC 2359

Toby Jug Nebula — 77

Trapezium. See Trapezium Cluster

Trapezium Cluster — 2, 44, 46

Triangulum Australe — 14

Trifid Nebula — 135, 140, 143, 144

Trumpler 16 — 86

T Tauri star — 60

Tucana — 14, 193

U

UK Schmidt Telescope — 69, 129, 180

Uranometria — 14

Uranus — 17

V

Van den Bergh, Sidney — 63

VdB 69 — 63

VdB 93 — 65

Vela — 14, 19, 31, 78

Venus — 16

Very Large Telescope — 25, 26, 58, 104, 159, 172

Vespucci, Amerigo — 12, 43

Virgo — 83, 116, 172

VISTA telescope — 44, 57, 63, 132

VLT. See Very Large Telescope

VLT Survey Telescope — 111, 151

Volans — 14, 70

VST. See VLT Survey Telescope

W

Whiteoak, John — 25

Wide Field Camera 3 — 55

Wide Field Planetary Camera 2 — 54

Wild Duck Cluster. See Messier 11

Witch Head Nebula. See NGC 1909

Wolf, Charles J. — 66

Wolf–Rayet star — 41, 66, 125, 171, 189

X

X-rays — 51, 108

Z

Zwicky, Fritz — 180

About the Authors

Robert Gendler

Robert is an American amateur astrophotographer whose skill has earned him international acclaim. He was featured in the PBS documentary, *Seeing in the Dark*, by Timothy Ferris, who called Gendler *"one of the great astrophotographers in all of history."* Robert is known among fellow astrophotographers as a pioneer who is always exploring ways to push the available technology beyond its limits. He has published two books on astrophotography. The first, *A Year in the Life of the Universe* (Voyageur Press, 2006), was published in four languages (English, Spanish, Polish, and Greek). His latest astrophotography book, *Capturing the Stars: Astrophotography by the Masters* (Voyageur Press, 2009) highlights the work of the most accomplished astronomical imagers in the world. Gendler received the Hubble Prize for contributions to astrophotography at the Advanced Imaging Conference in San Jose, California, in 2007. Robert lives in Avon, Connecticut, with his wife and two children. His work can be viewed at www.robgendlerastropics.com

Lars Lindberg Christensen

Lars is an award-winning science communication specialist who heads the European Southern Observatory's education and Public Outreach Department, where he is responsible for public outreach and education for the VLT, La Silla, for ESO's part of ALMA, E-ELT and ESA's part of the Hubble Space Telescope. He obtained his Master's degree in physics and astronomy from the University of Copenhagen, Denmark, and has more than 100 publications to his credit, most of them in popular science communication and its theory. He has written several books on popular science and science communication and these have appeared in English, Finnish, Portuguese, Danish, German, Korean, Slovenian, Japanese, and Chinese. Lars is Press Officer for the International Astronomical Union (IAU) and founder of the ESA/ESO/NASA Photoshop FITS Liberator project, and the executive producer and director of two astronomy documentaries.

David Malin

David has been involved in scientific imaging for almost all of his working life. In the 1960s he worked for a large international chemical company in the north of England, where he founded and ran a laboratory that used physical methods such as microscopy and X-ray diffraction techniques to solve problems in pure and applied chemistry. The enabling technology for many of those techniques at that time was photography. In 1975, he was recruited as a photographic scientist for the newly commissioned Anglo-Australian Telescope (AAT) in Australia and turned his attention to larger and more distant things. At the AAT he developed several new photographic techniques that led to some significant astronomical discoveries. The same processes also allowed the creation of some of the first three-color images of astronomical objects in 1978, and these photographs have been widely published and used by David and others to explore and explain the astonishing beauty of the objects of the night sky. The additive three-color process is now universally used by both amateur and professional astronomers alike. Only the detector has changed.

David is now retired but still actively involved with the AAO. He lives in Sydney with his wife Phillipa, where they enjoy their three children and numerous grandchildren.

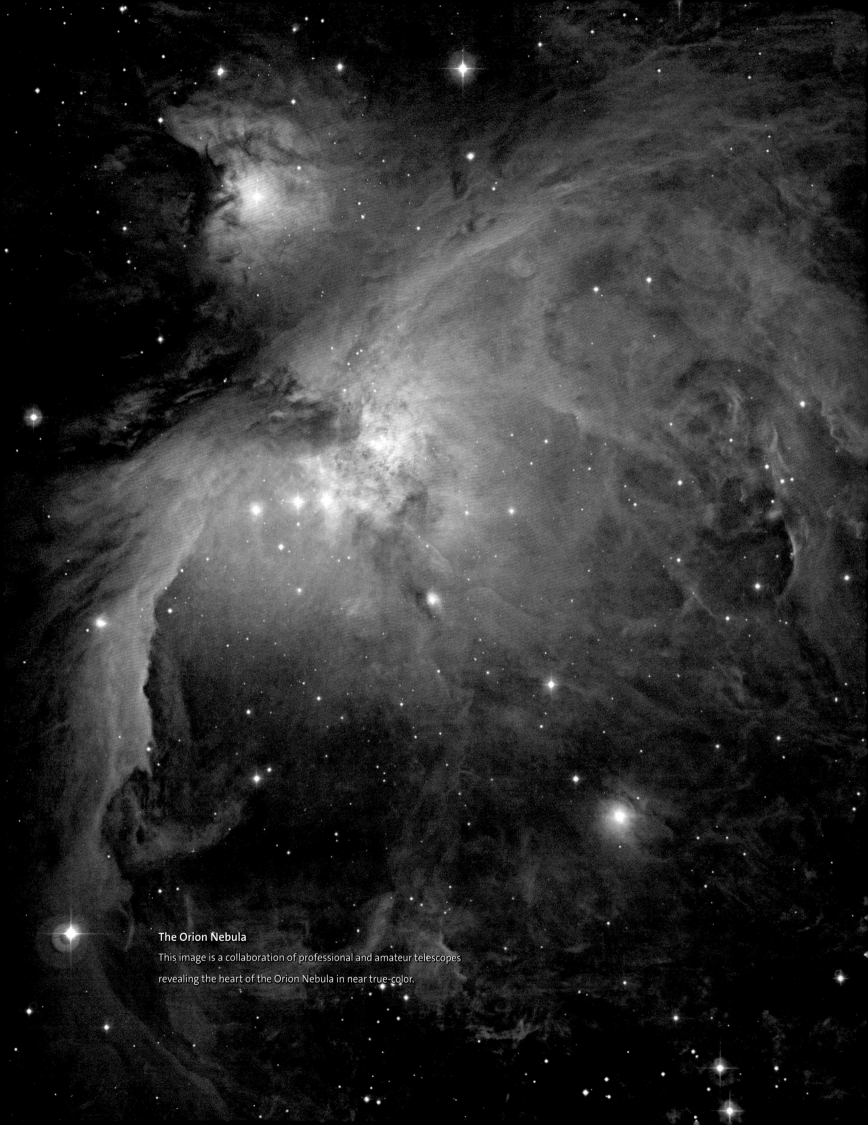

The Orion Nebula
This image is a collaboration of professional and amateur telescopes revealing the heart of the Orion Nebula in near true-color.

Printed in the United States of America